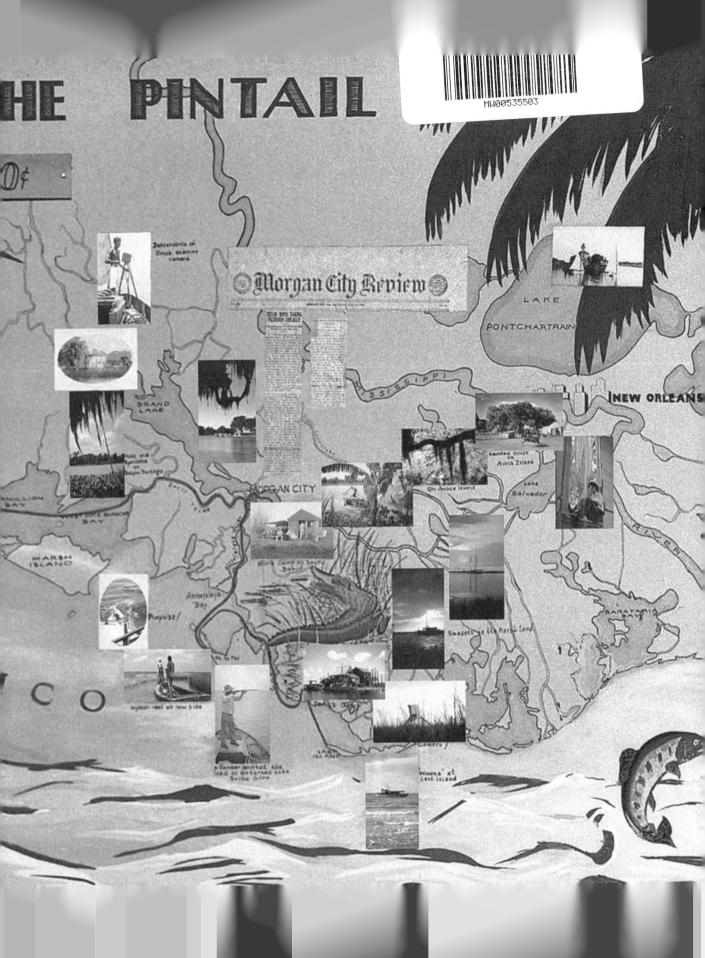

HE PINTAIL

0¢

CRUISE OF THE
PINTAIL

THE HILL COLLECTION
HOLDINGS OF THE LSU LIBRARIES

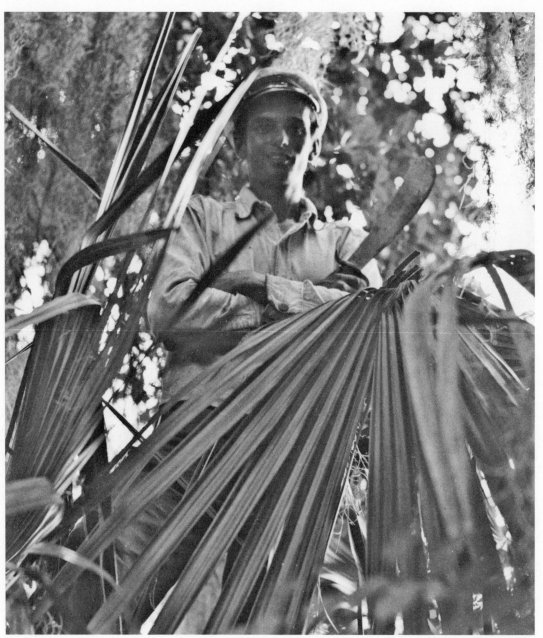

Fonville in the swamp

A JOURNAL

CRUISE OF THE PINTAIL

FONVILLE WINANS

Edited by ROBERT L. WINANS

Commentary by JAMES R. TURNER

LOUISIANA STATE UNIVERSITY PRESS ✦ BATON ROUGE

Published by Louisiana State University Press

Copyright © 2011 by Louisiana State University Press

Photographs © 2011 by Robert L. Winans

All rights reserved

Manufactured in the United States of America

FIRST PRINTING

DESIGNER: *Mandy McDonald Scallan*

TYPEFACE: *Minion Pro*

PRINTER AND BINDER: *Thompson-Shore, Inc.*

Library of Congress Cataloging-in-Publication Data

Winans, Fonville.

 Cruise of the Pintail : a journal / Fonville Winans ; edited by Robert L. Winans ; commentary by James R. Turner.

 p. cm.

 ISBN 978-0-8071-3985-1 (cloth : alk. paper) — ISBN 978-0-8071-3983-7 (pdf) — ISBN 978-0-8071-3984-4 (epub) — ISBN 978-0-8071-3986-8 (mobi)

 1. Winans, Fonville—Diaries. 2. Winans, Fonville—Travel—Louisiana—Atchafalaya River Watershed. 3. Boats and boating—Louisiana—Atchafalaya River Watershed. 4. Motorboats—Louisiana—Atchafalaya River Watershed. 5. Atchafalaya River Watershed (La.) —Description and travel. I. Winans, Robert L. II. Title.

 GV776.L82A879 2011

 797.109763—dc22

 2011012285

To Fonville's fans and friends

CONTENTS

PREFACE

There are three books so far written and published about Fonville Winans (1911–1992), the now famous Louisiana photographer: Myron Tassin's inadequate *Nous Sommes Acadiens = We Are Acadians* (1976), Ben Forkner's *Cajun: Fonville* (1991), and—the best of the three—Cyril E. Vetter's *Fonville Winans' Louisiana: Politics, People, and Places* (1995), with a foreword by James Carville and an afterword by C. C. Lockwood. There is Melisse Campbell's good but unpublished term paper, "Photo by Fonville." Campbell, like another accomplished Baton Rouge storyteller, Ruth Laney, published several thorough and well-documented stories of our "daring Valentino," Fonville. There have been countless magazine and newspaper articles written about Fonville and his work in photography, cooking, bicycling, mushroom hunting, and movie making. So what is the angle this time? Well, it just so happens that little has been done in Fonville's own words. Fonville began earnestly and remarkably keeping journals—or diaries, as he called them—when he was twelve or thirteen years old. He kept these records well into his young adulthood. What is more, he wrote well. He was literate, sensitive, and even, as we like to say, seems to have written between the lines. And he took, as many now know, marvelous pictures while he was doing it. The two, his words and his photographs, needed uniting. So that is what his son Robert Lewis "Bob" Winans has done here.

A few years ago Dotsie Leblanc approached Bob with a copy of a diary given to her by Fonville before his death in 1992. Dotsie was hoping to complete her book on Grand Isle, Louisiana, and a sort of retrospective of the late Louisiana painter George Blattny, aka Geo. Izvolsky, who depicted the windswept island with Fonville. It seems they were gadding about with brush, canvas, paint, camera, and diaries at the same time (1932–1934). Dotsie wanted permission from Bob, as the executor of Fonville's estate, to print excerpts from the diary. As Bob reviewed the diary again, he could not help but see the direct connection between his own extensive files of his father's early Louisiana photos and Fonville's own words about his adventures in French Louisiana. Voilà.

Bob asked his sister, Meriget Winans Turner, and me for our thoughts and suggestions about a publisher. Bob had recently returned from his own adventures in far-off California, and we had enjoyed a happy reunion in the backwoods of wVernon Parish. We all were retired. I had taught at LSU in Baton Rouge and had several good experiences with editors and associates of the LSU Press. Plus, we were all aware that Fonville's long and colorful career was closely associated with the capital city of Baton Rouge. We therefore recommended contacting LSU Press. Soon I found myself writing to bridge the parts of the book together and helping with a few other matters. Meriget, her dear brother, and I all adored Fonville. Here was an opportunity to add a new and valuable chapter to his life. It was simple and it was complex. Margaret Lovecraft of LSU Press made it easy, as we suspected she might.

It should be mentioned that Fonville didn't think much of these early photographs from south Louisiana. In fact, Fonville revisited them only reluctantly in the late 1960s. Here is what happened. While standing and balancing on his bicycle in the summer of 1967, Fonville fell over and promptly broke his leg. It was a bad break and essentially crippled him for a year. During that time, there was much less income from his studio and a good bit of time to kill. In the back of his studio on Laurel Street in downtown Baton Rouge were these old, dusty negatives that he had not looked at in decades. When Fonville was first able to hobble around, he pulled them down and made a few studio prints. The curator of the Old State Capitol in Baton Rouge encouraged him to have a show of some of these photographs. The show ran February 15–March 22, 1968, and was a success. Fonville wasn't convinced that all the fuss was warranted, and little else was done until Bob along with Bob's wife, the late Vivian Winans, saw greater potential for these photographs. Around 1983 they insisted that Fonville increase the exposure of these iconic images so that the public could enjoy them. Bob and Vivian went to work doing just that.

Fonville had assigned titles and dates to only about 50 percent of the photos. Thus after the age of seventy and with the help of his son, Fonville began to try and remember the titles he had originally assigned and the proper dates. Fonville's memory proved to be unreliable at times, and so we must warn that some of the details accompanying the photographs may not be totally accurate. Yet we know that Fonville's intent if not his memory was true. It is a tribute to Bob and Vivian that these wonderful and almost forgotten photos were in a sense rescued and have now been championed for these thirty years, ultimately finding their way into this, Fonville's own account of his remarkable beginning in Louisiana.

We decided to leave Fonville's spellings and other idiosyncrasies in these jour-

nals alone. He was a young and busy man in 1932, and we are lucky even to have these documents to peruse. It would not be right to change them because the charm would be weakened. We hope you will enjoy his website (www.fonvillewinans.com) when you have finished with his adventures on the *Pintail.* And we hope that you will see through this remarkable marriage of his words and images, the lost land of Louisiana and the boy now gone who so carefully made this record.

James R. Turner, FAAR, FASLA
Fleeta Springs, January 1, 2011

CRUISE OF THE
PINTAIL

PROLOGUE

What boy is unmoved in the face of true adventure? As the Great Depression overwhelmed families and its blanket of hopelessness fell over the South, young people sought relief wherever they could. In the 1920s and 1930s there was a feast of new media tantalizing the imagination; Frank Buck and Buck Rogers built mythologies too compelling for many youngsters to ignore. First there came illustrated pamphlets to scour, Jack London's spellbinding books and next those delicious, cheap comic books, and then, finally, the "silver screen"—painted with dramas for an audience starving for adventure in a world of wonder and away from a world of dreariness. The radio, too, featured dramas that told of a life of brave deeds, science fiction, and ordinary people doing extraordinary things.

One hero of the silver screen was Buster Crabbe, who starred in the primitive, film-adventure version of Edgar Rice Burroughs' Tarzan of the Apes. The thrill makers sought real jungle sets that Louisiana could supply like no other area north of the Orinoco and the Amazon. Tarzan fought the good fight against evil and braved the challenges of an untainted wilderness. He was like Rousseau's natural, undiluted human: smart, good-looking, creative, and virtuous. Boys were transported to the steaming jungle and its exotic canopy of derring-do.

Three boys that had a few remarkable adventures under their belts were now young men who needed to move on into adulthood. It was 1932 and they were lucky. They were twenty-one years old, and they were in that transitional zone between dependence on adoring parents and departure to the humdrum of the real world and a life on their own. They needed to start making a living, but they yet needed to try to fulfill their dreams and to polish and promote their reputations, their desires for fame and glory. This before they got too awfully serious about the real world. And who knows, perhaps their foolhardiness, courage, and skills could be transformed into a paying proposition? Thus freedom was to hold the line against growing up too quickly. It was what young men everywhere know perhaps subconsciously—that steady employment and real freedom are incompatible. So they undertook an adventure they

could barely afford, in a twisted jungle they could barely imagine, in a boat barely more than Bogart's "African Queen," for the higher purpose of combining the two forces of young manhood: thrilling adventure and becoming millionaires. Their leader was Fonville Winans, first mate was Bob Owen, and second mate was Don Horridge.

In time the story of our first and second mates became lost to history, but Fonville's story became part of Louisiana's list of legacies. As many readers will know, Fonville Winans became a rather famous photographer, and this diary of his adventures in south Louisiana comes alive with his early attempts to make a go and to record a remarkable era of Louisiana history.

Fonville was a precocious youth, full of mischief and curiosity. At the age of fourteen or so, he took all his savings to buy a watch and settled instead on a camera. He bought the film and other supplies on credit. Not long after, he took a picture from the roof of a downtown building in his hometown of Fort Worth. In a local competition it won first place and a $15 prize—an enormous sum. He was hooked on the power of the little box to record compelling images and on the idea of people paying him real money for the trouble. He paid off his loan, finished high school, and set off with his friend Clyde Carmichael to California in a Model T Ford. Amazingly, he kept a journal and wrote to his mother telling about each day's activities. He took pictures along the way. They made it to California and back, limping on their rims into Fort Worth some six months later. The pictures didn't amount to much, but the adventure got under his skin and he remained keen to discovery for the remainder of his life.

When you read his Louisiana diary, you will come to know not only a fascinating bit of history but the literate and sensible story of a very bright and forthright man of promise. He tells his story simply, correctly, enchantingly. It is not expanded upon unnecessarily, nor is it too brief. Where did this literary talent come from? How was it possible that a youngster from Fort Worth could be so positively compelling? Is history in the Louisiana swamps and on the barrier islands and reefs ever sung with more innocent and intelligent observations? When I read the diaries I am enthralled, living there on Grand Isle or in the Atchafalaya, crossing at Morgan City and Berwick, imagining lives and events now long washed away, lost like the coastal land we sadly let slip into the Gulf of Mexico.

His mother was a homemaker and an accomplished musician; his father was a graduate civil engineer. His people were from an educated class, and in his ears must have rung the proper sounds of the King's English. His actions noted the courtesies that honor a refined family. He was a musician himself, especially with the saxophone and the clarinet. He learned to speak well, to write clearly, with directness and a bit of color, and to be a gentleman and a minor scholar about his researches. And he was quite a character from the earliest notes: tall, dark, and handsome. We expect that he was charming as well, cheerful and clever, an amazing combination for the uncharted bayous and coarse wharves of 1932.

His father, descendant of George Washington, was a serious and capable man of action. But the depression had left Lawrence Lewis Winans penniless. Finally, in 1931, he won a contract to build a bridge across Bayou Ramos near Morgan City. Fonville hired on as a carpenter's helper and was introduced for the first time to the vast Louisiana coastland. While working there with his father in Morgan City he found a leaking, rudderless boat with no motor called the Pintail, *and promised her he would return. He bought her for twenty-five dollars.*

Upon his return to Fort Worth with his father, he began rounding up his old buddies for a real adventure. His idea was to make a film that told the story of the coastal wilderness, its curious people, the scaled reptiles and other wild animals—the snake-infested, moss-laden landscape of south Louisiana. It was ambitious and risky, just the right combination for three youngsters from Texas who had stars in their eyes. They would make the movie, return to Fort Worth, show it to schools and clubs, maybe even Hollywood, and become rich and famous. Perfect.

About that time Fonville held down a job as photographer for the Fort Worth Telegram, *practice for the real thing. He planned the big journey, saved his money, bought supplies, and convinced his pals and their families of what a good idea this was. They took their old Model T, and finally were ready to go. Their families supplied matching shirts with* Pintail *embroidered above the pockets, and caps that looked like they belonged to officers on the deck of an ocean liner. They had their cameras, film, developing fluids, and bologna sandwiches. The dream of matching Cecil B. DeMille, topping Frank Buck, and adding to the knowledge of Alfred Russel Wallace was on its way to Louisiana. They even had extra pith helmets and jodhpurs for land roving and horseback riding. Louisiana had never seen anything like it.*

summer 1932

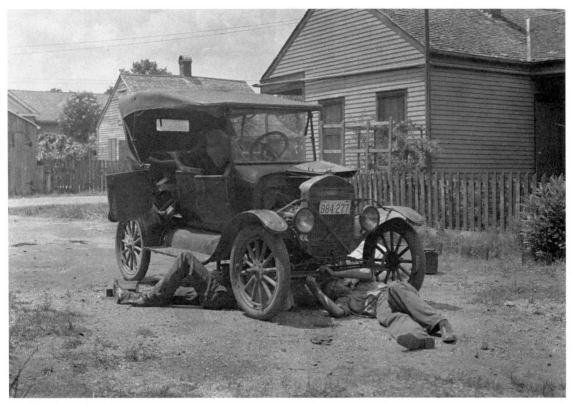

Repairing the old Model T

Tuesday, June 6th:

The day dawned bright and clear: a good omen for our projected cruise. Bob and I arose early, ate breakfast, packed the "T" model ford, and we're off at 8:30 o'clock, after bidding farewell to Bob's folks. Next we stopped at my house and told my folks goodbye, after which we continued on our way.

Just out of Dallas a rear casing came off and wrapped around the axle. Our first car trouble, but we soon had it fixed. Late in the afternoon we arrived in Marshall, Texas where Don Horridge lived. Don was to join us and complete the personnel of the expedition. We drove immediately to his home and found him there. As we were spending the night, he arranged an informal party for us.

Wednesday, June 7th:

Early this morning we left Marshall, bound for Morgan City, homeport of my boat, the "Pintail". All day long we traveled through hills and swamps and the farther south we got, the more enchanting became the country. We had watched the hills of pine blend into the moss-smothered swamps.

The *Pintail* at pier in Morgan City

Tonight we had difficulty in locating a place where we could roll up in our blankets and get some sleep. Soon weariness descended on us to such an extent that we deeply considered stopping by the roadside and sleeping in the ford, but a promising side road appeared in the glimmer of our lights and I hopefully drove down its winding way. It led through a mossy lane to the shore of a lake. A wild party was in progress at the camp on the shore. We turned off the road and pulled into a grassy park full of languidly draped oaks and spent the night, the moon lighting preparations for bed.

The *Pintail* on a trailer

Thursday, June 8th:

As the sun arose over the lake and filtered through the trees we got up and under way. After three miles a bearing burnt out. We limped noisily into Jeanerette, only a few miles, and inquired the price of a new installation. The garage attendant quoted a price of $3.85 which we considered too much so we installed the bearing ourselves for two dollars less.

Early in the afternoon we arrived at Morgan City, after crossing the Atchafalaya River on a ferry for 35 cents. We drove immediately to the Norman-Breaux lumber mill where the "Pintail" was in the care of Mr. Felix Breaux. He took us to where the "Pintail" was moored at the wharf. She looked very good to me despite the fact that she was messed up inside, needed paint, and had a dead battery. Nevertheless we soon had the ford battery installed and took a trail spin. The motor purred sweetly; I was satisfied. We loaded all our equipment on board, and leaving the ford at the mill for the time being, cruised down Bayou Boeuf into the Atchafalaya and came to rest at the Gulf gasoline dock, where a shower room was at our disposal. (We will remain here while getting ready for the cruise.)

Friday, June 9th:

Bought cooking utensils, groceries, rope, paint, and brushes, etc., the first thing this morning. Spent the day scrubbing and painting the boat. Rain in the afternoon halted our work. Had supper in a restaurant and spent the night sprawled on the dock. Mosquitoes worrisome.

Hyacinth-clogged bayou

Saturday, June 10th:

We put five gallons of gas in the boat this morning, and went up Bayou Boeuf to the mill. Here we painted and worked on the boat most of the day. Returned to Morgan City late in the afternoon and after supper promenaded the town and had some beer on tap.

Sunday, June 11th:

Today we decided to go up Bayou Ramos to Lake Paloudre but on arriving there, we found the entrance clogged with hyacinth and other water plants. We tried for an hour to wedge the boat through, but failing, we decided to fish instead.

The fish weren't biting so we pulled across the Bayou Boeuf, and going ashore through the swamp to some higher ground, we gathered half a bucket of blackberries. We were well raked by brambles before we got all we wanted.

Tonight we went in search of excitement in Berwick, just across the river from Morgan City, but found none. Instead, we took a short run around on the river before turning in on the dock.

Monday, June 12th:

Went to the mill in the boat to get the ford. Bob and Don drove it back to town while I returned in the boat.

In the afternoon we removed the shaft from the boat as it was rattling a little. It was pitted quite a bit, but was in sufficiently good condition to warrant our keeping it. Had canvas bunks made for the boat and used them tonight. They are very comfortable.

Tuesday, June 13th:

Took on gas and oil at noon and got under way for New Orleans. Travelled the rest of the day through tropically beautiful cypress swamps and spent the night in a canal which hugged the State highway.

Wednesday, June 14th:

Were cruising at dawn. Traveled mostly parallel to the highway. Bridges occurred frequently and we wasted lots of time waiting for them to open. I had to open one of them myself, as the attendant failed to put in an appearance on our signaling. It was a very clumsy affair that had to be pushed open by bracing one's self along a cleated runway. Approaching another bridge of the same type, I calculated that the clearance was sufficient to allow us to pass, but too late I discovered that it wasn't. The lowered mast was torn from its mounting by striking the bridge, but the damage was not serious and I soon had it repaired. We got off our course once and lost a little time. This night we spend at Lafitte, anchored snugly against the shore of Bayou Barataria. There are several houses, a store, and a ferry nearby.

Thursday, June 15th:

This morning we pulled across the bayou under a giant oak that grew on a clam shell mound. A little way up the shore was an ancient graveyard. The land back of the tree spread away in tropical softness and in that softness nestled a rambling old plantation house. On the shore, beneath waving curtains of Spanish moss, we built a campfire and prepared breakfast. (The generator on our gasoline stove is broken). After cleaning up the dishes and pans, Bob and Don fished while I climbed along the thick limbs of the oak taking pictures.

Pretty soon a small party of girls came frolicking along the bank and as they were all comely, we lost no time in getting acquainted. We spent several pleasant hours with them and bid them goodbye with the promise to look them up in Gretna, where they lived.

Our way up Bayou Barataria toward New Orleans, led past crude looking palmetto settlements, very crude when one considered they were only a few miles from the metropolis of the South, New Orleans. Where the bayou passage

terminated, and we put to port up the Harvey Canal, we saw one of the gigantic pumping stations that takes care of the drainage of New Orleans. Boats and houses appeared. With the glasses we could see New Orleans. It wasn't long before we were in the thick of noise and boats and soon arrived at the Harvey Canal locks on the Mississippi River. (This diary, up to this point, has been, at best, just a sketch. Now that our adventures have begun in earnest, I will continue in greater detail and with high regard for accuracy.)

This day we arrived at New Orleans after rising 16 feet in the Harvey locks to the level of the Mississippi and crossing over to the water front. A high wind and the treacherous eddies made the "Pintail" tip and toss like a cavorting horse. The shipping front of New Orleans is not at all hospitable to small boats that arrive there. Everywhere they land a dock patrolman appears with a warning to move on. Night was fast falling and in desperation I looked on the chart for an anchorage and found one down the river in the entrance of the Industrial Canal, which connects the Mississippi with Lake Ponchartrain. Some boys were swimming there and directed us to some piling that we might tie to near the bank. That we did, and soon a gang of river urchins had gathered around to witness our preparations for the night. Several of them scuttled aboard and ordering them ashore had no permanent results, for as soon as our backs were turned they were right back.

The stern of the "Pintail" was tied to a piling in the canal, and her bow was securely tied to a pipe jutting from the bank. Our persecutors finally conceived the idea of untying our bow line and dragging the "Pintail" ashore, and did almost succeed in getting the bow on a mud bank before I jumped ashore and regained possession of the rope. While ashore, I overheard a group of them plotting an oyster shell shower for our express discomfort during the wee hours, so when I returned aboard I was thinking hard for a way to disappoint them. Bob had our quinine ready and passed around a cup of water to aid in swallowing. The schemers watched this ritual intently. Finally the leader blurted out, "For what you take doze peels, uh?" And that gave me the idea I wanted.

"Malaria!", I answered pointedly.

"Malaria!, ver' bad?"

"Yes. We got it in the swamps. One of us got it first, then the mosquitoes gave it to the rest of us. So you see, IF A MOSQUITO SHOULD BITE ONE OF US THEN BITE ONE OF YOU, WELL, THEN YOU'D HAVE MALARIA TOO!"

My point floated home and our friends on the levee vanished into the night air. Still, not trusting to that ruse, we untied the "Pintail" and retired to the opposite side of the channel.

Friday, June 16th:

Returning to the river this morning we cruised back to the New Orleans water

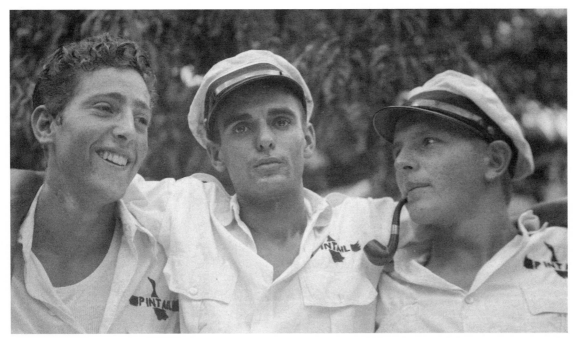

Crew of the *Pintail*

front to continue our search for safe anchorage and finally located in a conveyor slip of a wharf, but not after sundry red tape with dock patrolmen and other officious persons. Then, thinking we were securely located, we sauntered into Old New Orleans dressed in the "Pintail" uniforms. We wandered along deserted street ways beneath fancy grilled balconies, then up and down the crowded, main thoroughfare, Canal Street.

Suddenly I remembered that a great uncle of mine lived here. Arthur Yancey is his name. I phoned him, and on his invitation, we took a cab there for twenty-five cents. He was waiting on a screened gallery to greet us. I had never met him before, but he made us at home by recounting his adventures along the gulf coast while pursuing the shrimping industries many years ago. When we departed, he invited us to return on the morrow for lunch. This time the taxi discharged its three adventure-inflated passengers in the old French Market place.

It was near the waterfront where all the ships from foreign countries discharge their produce, including all the tropical fruits. Whole blocks were crowded with little stalls blending into each other and proprieted by blubbering, bargaining, yet picturesque and quaint, foreigners. We stopped at one of these stalls and purchased a dozen red bananas, the first ones we had ever seen. We liked them but later learned that they were the frying kind, and sold for ten cents per dozen. We had paid twice that much!

French Market

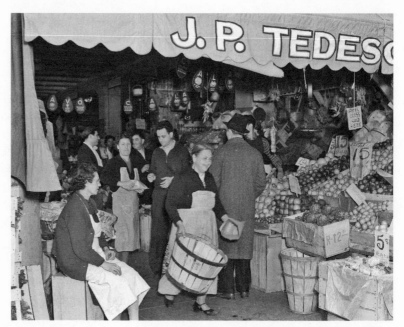

"Produce Stall," French Market

"Chicken for Sale"

A commotion occurred in the crowd and in a moment a sprinting stevedore sped from the scene, a negro girl in close pursuit with a club in hand. The pair vanished amid a chorus of hoarse laughter. A loiterer remarked loudly that the girl was out to collect a debt, and again the coarse laughter swelled through the crowd. But in a moment, all was forgotten and once more business was paramount.

Farther along a fat, disheveled and shawled old woman and a bloated Italian were having words over a cucumber. The woman succeeded in wresting the vegetable from him finally, and named her price. The vendor threw up his hands with a despairing gesture calling it a bad bargain, and went about arranging his display while the woman shuffled to the next stall to start another harangue.

Loud talk and laughter permeated the whole market place intermixed with jumbled curses and foreign languages. We were all eyes and ears as we threaded through this theatrical bit of Old New Orleans.

Late in the afternoon we found ourselves resting from our explorations in a park, in the center of which is a large bronze statue of Henry Clay. Here we lay on the mossy lawn beneath the canopy of an unfamiliar tree and ate candy and browsed through the pages of "Fabulous New Orleans" and "Lafitte, The Pirate," by Lyle Saxon, which my great uncle had kindly lent to us.

A myriad of pigeons strutted about the grounds and often came quite close to inspect us. Being so brave, they enjoyed many bites of our candy, such as we

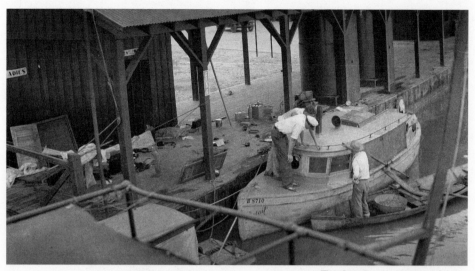

The *Pintail* at dock in New Orleans

thought we could spare. Many children, too, played among the pigeons. They ran and laughed and played hide-and-go-seek. They were French children who lived among the lacy, iron balconies in the neighborhood, the park serving them as front yard and playground.

Bob and I wanted to go to Gretna, just across the river from New Orleans, to call on the girls we had met down on Bayou Barataria and Don wanted to stay in New Orleans. We admitted it was a long walk to the Jackson St. ferry, but he finally consented to go with us. Three ferry tickets for a dime and we crossed over to Gretna. We phoned one of them, Doucet Cherebonier (now Mrs. Robert Pascal of Baton Rouge).* She was home and told us to come right on over, telling us that she lived a mile up the highway from town. Straightway, Don refused to go another inch, and started for the ferry to return to New Orleans. Bob and I walked the mile. Doucet met us at the door and had us in. After casual conversation, during most of which we all compared differences in our respective dialects, her father came in to join us. He was an interesting man to talk to and was very interested in our expedition. We also met Vic, Doucet's brother, who drew us a crude, but detailed chart of our proposed trip to Grande Isle, on the coast.

Vic drove us to the Algiers ferry, opposite where the "Pintail" was anchored, and bid us goodnight with the promise that he would call for us the next day and drive us over the city of New Orleans. I gave him the address of my uncle's house, where we would have lunch, and he said he would be there at 3:00 P.M. sharp.

* This phrasing was added to the diary at a later date by Fonville. —Ed.

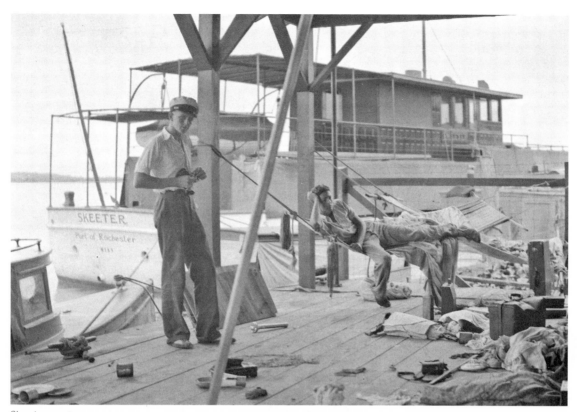
Sleeping quarters

Back at the boat we found that Don had cleaned her up and had had arguement with dock officials. It seems that a mistake had been made in letting us have that moorage, as gasoline launches are prohibited from docking under wharf roofs. We would have to move. I had the carburetor dismantled for repairs but that made no difference with the official. We must move. So, improvising a repair the best I could we backed into the seething Mississippi in the black of the night and spun down-stream with the current, past looming hulks of ships and warehouses. Finally, as the line of ware houses broke, I helmed into the swift current and drew up alongside a row of piling. A patrolman directed us to protected anchorage between the piling and the dock and demanded $1.60 wharfage fee. We paid off, glad to be freed of docking troubles. After tieing the boat securely we went ashore for sandwiches and beer, returning shortly to go to bed.

Saturday, June 17th:
The early booming of the Catholic clocks awakened me, and I promptly awak-

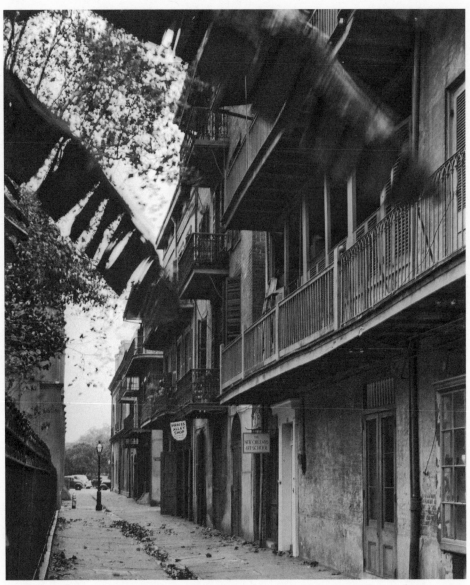

"Pirate's Alley"

ened Bob and Don, for today was the day set for us to begin with our motion picture filming, the primary purpose of this expedition.

Fairly early we were on the streets, uniformed and with camera in hand. All through the quaint French section we made moving pictures, including the famous Cabildo where the almost fabulous Lafitte was held captive for a time during the height of his piratical career.

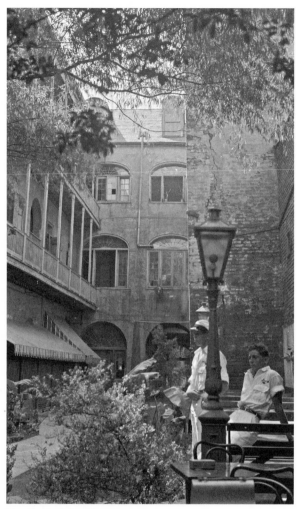
The Court of Two Sisters

As we wandered up and down the quaint, narrow streets we could catch glimpses through open doorways of flagstone patios. Palmettoes, banana palms, potted plants and trailing vines. Even royal palms added color and splendor to these musty courtyards. Sometimes we stole down the darkened corridors and entered. A quiet, resplendent atmosphere prevailed. I almost expected ghosts to emerge from the arched courtyard doors, and stroll about in frilled costumes. The sunlight filtered weakly into these places and only remained during high noon to shine directly into the gloom of the courts.

At the courtyard of the "Two Sisters", which has been converted into a very picturesque beer garden, we took some pictures and enjoyed a very refreshing mug

French Quarter gate

of beer. The courtyard is scattered with tables and is shaded by a tropical tangle of palms and weirdly shaped trees. Next door rises the drab wall of Roark Bradford's home. He is the famous writer of Negro dialects. Across the street, at 612 Royal, is one of the residences of Lyle Saxon, a renowned writer who paints in words the lore and history of the Crescent City as well as that of the pirates that infested the bayou webbed marshes and islands of the gulf coast.

The court of the Palm is poorly lighted, but most beautiful in its half-gloom. It is entered from the street through a broken out panel in a large doorway and through a spacious hall, or driveway. In the center of this courtyard grows a tall palm tree and as it curves gracefully upward its umbrella spread obliterates the sky overhead, forming a lacy roof.

Other courts we visited and photographed, but they did not vary greatly. In the afternoon we returned to the boat dead tired. A bath after supper in the muddy Mississippi refreshed us somewhat. A stroll again after dark through the French quarter proved of no especial interest, so we soon returned to bed aboard the "Pintail".

Monday, June 19th:

Leaving Don at the boat in capacity of launderer, Bob and I set forth with camera to continue the motion picture exploits. We were running short of money, so we stopped at the Whitney Bank with a Letter from Bob's dad, which was supposed to enable us to draw some money. The bank had no record of Mr. Frederick's signature and therefore turned us down flat. This was almost a calamity, but not quite. We could get to Grande Isle on what we had left.

From the bank we went to the post office and called for the mail. Bob had a letter from his mother and I, much to my pleasant surprise, had one from Mrs. Moses. Imagine my greater surprise when I found a crisp, new, ten dollar bill enclosed!

We made photographs along Canal Street, then returned to the boat. Uniforms were drying along the mast, and Don was still washing. After a bite to eat we made preparations to continue with the filming of the French Market place. I set my motion picture camera on its tripod and erected it on the wharf. Underneath it I laid my films and still camera and returned to the boat for a few moments. When again I climbed onto the wharf, my still camera was gone. Stolen! Our expedition minus a valuable piece of equipment. The dock patrolman had warned me. I should have been more wary. The wharves are overrun with dopeheads who will stoop to anything to have a shot of morphine. My camera will probably sell to some "fence" for fifty cents. It cost $37.00. But I couldn't let a stolen still camera halt my filming with the movie camera. So we went to market to get some pictures. The whole place was in an uproar and steeped in confusion. Many excellent shots resulted.

Bob and I went to the custom house this morning to purchase some charts of the area we were interested in, and as we pored over the charts the custom house man took a personal liking to us and gave us some inside information on the things to be seen in the city.

So tonight we went slumming again, this time through the infamous French district [Storyville]. Arrived at the edge of the zone, we sought information from one of the policemen who happen to be stationed at regular intervals throughout the district. We learned that the district is eight blocks wide and thirteen blocks long and that therein operated approximately twenty-five hundred women.

The law, while lenient in some ways, is very strict. The girls are forbidden to set foot from their doorways after dark and they must wear black clothing behind the shuttered doors and windows. The doors are to be kept closed and hooked at all times. The streets are narrow and dark and dirty. The houses are flush with the

sidewalks and form solid walls from block to block. There is a doorway about every four or five strides and just as many windows. As we walked along these infamous streets, we could catch glimpses of dark girls lurking behind the half closed shutters. They called softly to us, whispering entreaties, and one was daring enough to step momentarily from her doorway in very scant attire. I've never seen or heard of anything like this district. It is quite famous for its sheer brazenness. I would not have believed it existed in such a manner had I not seen for myself.

Back at the boat we all took a swim in the Father Mississippi, then retired for the night.

Tuesday, June 20th:

While Bob and Don busied themselves with chores around the boat, I went to the post office to send some film to the processing laboratory in Kansas City, and also to call for some negatives that I had left for development in some photo shop. For two hours I walked street after street in search of that photo shop before I located it. This part of the city is very confusing, and every street and intersection looked the same to me. The place was on Chartre St. and even now I wonder if I could find it again. With business completed I returned to the boat.

It was about noon or after that we opened some beans and tomatoes and manufactured some cold soup, after which Bob and Don went shopping for groceries and I ironed uniforms. The gasoline truck arrived and I put on board thirty gallons of fuel, almost filling our tanks.

At four o'clock we got under way up the river to the Harvey locks. The current in the river made the boat very hard to control, and to harass us further, the gasoline line became clogged, causing the motor to miss terribly and even stop dead frequently. So strong was the current against which we plyed that our progress at full speed could not have been more than four miles per hour. We finally arrived at the locks with a dead motor and floated in. As the giant gates began to close I went to work on the motor. By the time we had dropped eight feet I had the line cleared and the carburetor fixed. Eight more feet down and the opposite gates opened. The motor started perfectly and we continued down the Harvey canal past the highway bridge, and drew up to the wharf there.

I phoned Doucet (she was expecting us and had her crowd ready for the boat ride we had promised). They would be right over.

The boat ride was down the canal a short distance and back as they had to return in time for their supper. After bidding them goodbye, we set out on our way to Grande Isle. We traveled on until after dark, going probably twelve miles before arriving at a fork in the waterway. Being at loss as to which branch to follow, we threw the anchor ashore and went to bed.

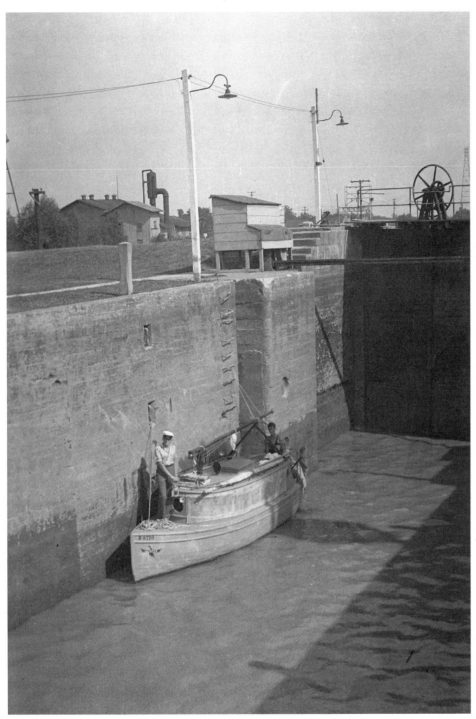

The Harvey Locks

Wednesday, June 21st:

During the night we fought mosquitoes and mumbled naughty words and were glad when came the dawn. Boats passing during the night proved which was the right canal to navigate, so we continued on our way to the pirate country. For miles and miles, after passing the small bayou town of Barataria, the shores were thickly settled. We landed at one place and purchased bread and eggs. Soon the settlements thinned out and disappeared, giving place to a vast reach of marsh and not long afterwards we ran into Barataria Bay steering east for a beacon. Manilla Village could be seen to the starboard, a clump of red camps with low, red roofs. On reaching the beacon we steered south by southeast into a waving and glimmering sea. When the next beacon appeared we could see the lighthouse on Grande Terre Island, rearing its dazzling head into the blue distance. When abreast of Grande Terre, we steered for a beacon on Grande Isle and entered Bayou Rigaud, Grande Isle's only port. There we were informed that Bayou Rigaud was too shallow to continue in, and that we would have to go around Manilla point to get to the government wharves where we have been advised to dock while at the isle. The wharf proved to be a runway of planks supported by poles driven in the mud. The whole affair was very crazily constructed and about to tumble down every other span. There are three sheds close on shore connected to the pier by a board walk. Along the pier were moored several shrimping luggers. We tied up about the middle of this rambling pier, at the end of the line of luggers. On landing, the first sight to greet us were ten dead sharks laying on the walk. Their average length was about three or four feet.

We fished until dark, after which we walked to "town" through dark and sand-rutted lanes. A dance was in progress there in a newly constructed pavillion. Later we returned to the boat and went to bed.

Thursday, June 22nd:

This morning we arose early and caught a mess of sea crabs, which I prepared for breakfast. My method of cooking them is very acceptable to our palates: first, the crabs are boiled alive, and the delicate, sweet meat is picked out. Then I prepare a brown gravy with onions, a dash of salt, pepper, hot sauce, and catsup. Into this I pour and mix the crab meat and allow to simmer for a few moments. And this dish is really good.

Bob and I set out ashore after a while at cleaning the dishes. You see, Grande Isle is the name of a post office more so than a town, for there really isn't any town. The island averages a mile in width and is eight miles long. It is inhabited by a very strange group of people who are peculiar to the island. These people are known to outsiders as "the natives". They are very sensitive to inquiries for descendants of Lafitte and his followers. Their complexions are generally very dark and it is very easy to discern the mixture of castillian and dark blood. Hence, their sensitivity

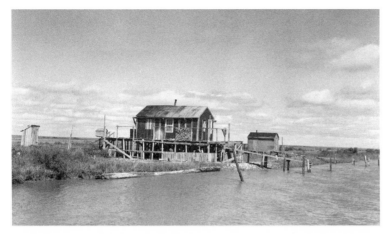

Marsh camp

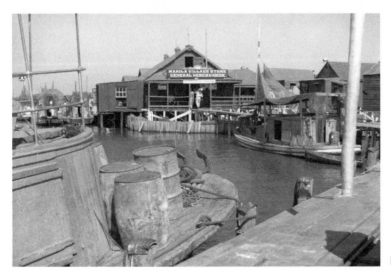

Manila Village store exterior

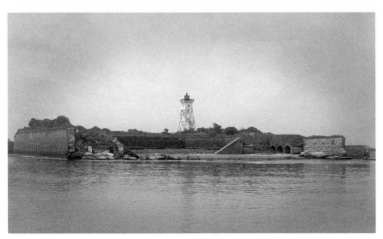

Grand Terre lighthouse from boat

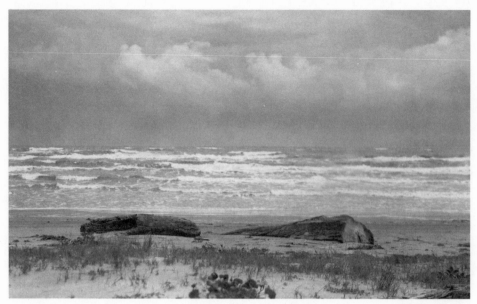

Grand Isle beach

toward lineage questions. Born and raised on the island, these natives live in dilapidated houses that are scattered indifferently beneath the sea blown and knarled oaks that cover most of the higher ground. This wooded section is a veritable tropical garden. Everywhere the tall oleanders are in profuse bloom. Tresses of Spanish moss seem to blot out the sky and the tall Spanish daggers are guarding delicate clusters of white, wax-like blossoms.

So Bob and I walked into town, the post office, and inquired for mail. The mail boat comes to the island three times a week and late tomorrow will be the next time we might inquire. With that, we made our acquaintance with the proprietor of this general store and post office. His name is Mr. Ludwig. And so well does he fit in with the atmosphere of this strange, semi-tropical island, that he is a character, such a character as I had always pictured in my mind as being boss of a tropical isle. Bald headed and torpid, a once good looking face, now rather loathsome, a very much accentuated waistline, he was forever wearing an opened night shirt in place of the conventional type of shirt. So much at the present for Mr. Ludwig, who speaks more French than English.

We bought some crackers and went to the beach for a swim. Having our suits on under our uniforms, we divested ourselves of said uniforms and walked into the surf. The high swells from the gulf were breaking about a hundred feet out. As they rose formidably in front of us we would either dive through them or abreast of them. Continually experimenting with these combers we had a very excellent time

of it. Occasionally one of us would step on a crab and it would remind him to get off by taking a scissor hold on whichever toe was the most convenient. There were other people in bathing, too, and we became talkative with a young lady and her mother who happened to be staying the summer on the isle. While putting on our uniforms over our swimming suits our new found acquaintances started to leave in their car, but pulled alongside where we were dressing and asked if they might take us to wherever we might be going. Next they asked if we would care to join them in eating some boiled shrimp. We accepted gladly and drove to the boat to pick up Don, who had remained at the boat to wash clothes.

At their camp we met a friend of theirs, Dan Hall, a tall, dark chap of about seventeen years. I almost forgot to mention the daughter that was driving. She hadn't been in bathing. Her name is Marian; her sister's Helen. Their last name sounds like "Fuqua", but I know it is not spelled that way.

We enjoyed some very good eats and played cards afterwards. Later we all returned to the beach for more swimming and frollicking in the waves.

They gave us some water from their cistern as we had been unable to obtain any elsewhere due to the drought that had already lasted two months. The five gallon container was so heavy that it took all three of us, rotating, to make a non-stop portage to the boat. After supper we went to bed.

Friday, June 23rd:

Bob stayed at the boat to catch up on some writing while Don and I, with a bucket of freshly caught crabs, set out for the camp of our newly found friends about ten thirty. While traversing through one of the picturesque lanes that threads throughout the wooded section and webs the whole isle, we came upon Marian and her mother going to Ludwig's store. Don continued on with the crabs while I joined them on their way to the store. We joined the others at the camp about forty-five minutes later and set about preparing our sea feast. I prepared the crab dish while Don cranked the ice cream freezer. And did we eat! Afterwards, we played cards for a while, then decided to explore the island. Lane after lane we threaded, past curious houses and strange flora. We came to the graveyard. It was a small one and partly over-ridden by the encroaching jungle.

Most of the inscriptions were in French. Small statues and images of the Mother Mary adorned the tombs amid the confusion of many wreathes of elongated black and white beads. Rustic little sties aided us across the many fences. Sometimes there was a quaint picket gate to open, which was covered with gray-green lichen. Mrs. "Fuqua" knew several of the natives and stopped to converse with them. One of them was particularly interesting. Her name is Miss Minnich. She must be over fifty years old because she vividly recalls the devastation wrought upon the isle in 1893 by a terriffic hurricane. Her hair is gray, she is slight built, rather goodlooking,

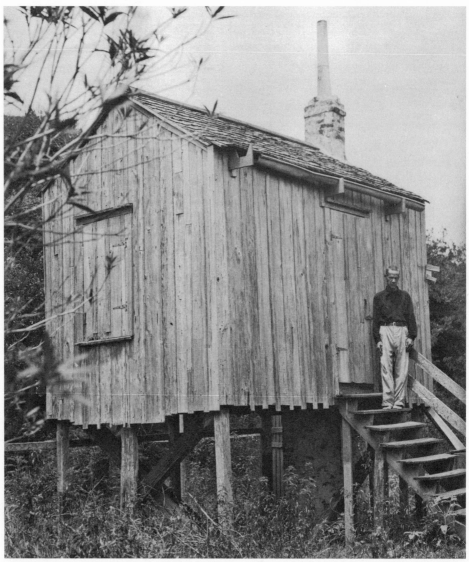

Shack on stilts

and is an interesting talker. We persuaded her to join us on our rambles and tell us more about the island. First, she showed us a freak of nature. It is an oak tree, fairly large (but not giant as are the general run of oaks on the isle), which had toppled over in the '93 hurricane and has continued to live ever since. Its roots, most of which are well in the air, bear limbs which are well covered with foliage. Travelling further, we came to the rear of the island, which is low and marshy and stretches far away from the trees to intermingle with the salt water of Bayou Rigaud. Here

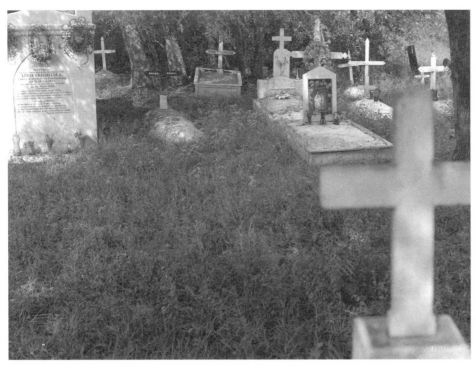
New Island graveyard

we came upon the original graveyard of the isle's first inhabitants. There remain only five or six tombs that have withstood the ravages of the storms. Several have crumbled and in one of them we could clearly discern a human skeleton, somewhat disarranged, beneath the pool of stagnant water. One grave only is completely intact. The date on the worn, wooden cross reads in French that the occupant was a Rigault born, and who died in 1865. It is the newest tomb there. Beyond this crumbling cemetery, a short distance is the first cistern that was constructed on the isle. It is also in ruins, and was built by the island's first occupant, Rigaud, who was one of Lafitte's Captains, so certain books have it. Miss Minnich, when asked if Lafitte had had any locations on the isle, flatly denied that he had even so much as set a foot here. He may have landed once or twice, though, she reluctantly admitted. The natives are very vehement when mention of pirates is made. They disclaim any descent from them and one seldom hears the name Lafitte mentioned here unless he mentions it himself.

And so on into the late evening, when Don and I started for the "Pintail". It was dark when we got there and Bob had already gone to bed. The mosquitoes had become very intolerable so we had to erect the netting before any of us could get any sleep at all.

Saturday, June 24th:

Dawn revealed a black cloud riding low. Suddenly a heavy deluge, like an ob-scuring fog, pelted down, and continued for two hours. All our bedding and other possessions were thoroughly soaked.

When the rain stopped we put everything to drying and boiled half a bucket of shrimp that we bought from a boat. The fishermen also had a large stingray in their net which they gladly gave to me for the asking. I made some moving pictures of it before killing it. Just after I killed it, it gave birth to four young, which I immediately arranged for photographing. Then, wanting to preserve them, I set out for the store to purchase some alcohol. None was to be obtained there, but someone remembered an old woman who lived not far away who owned and used an alcohol stove. There was a slight chance that she might sell me some. The proprietor dispatched a small girl on the errand and soon she returned with the alcohol. I paid her twenty-five cents for it, purchased three bars of candy, and returned to the boat. The young stingrays were swimming about in the pail of water I had left them in, but I soon had them pickled in the alcohol. I amputated the mother's tail and put it, too, into the jar with the youngsters. Also, into the jar went an oyster fish and a shrimp.

After dinner we put up the sail and enjoyed the brisk wind. We sailed around Panama Point to the East and end of the island, then entering the pass opposite Fort Livingston we passed through a large school of porpoise and sailed two miles into the gulf. The large swells gave us an exciting ride. It was growing late as we turned around, and running the motor, we returned to our moorage back of the island.

After dark I transformed the cabin of the boat into a photo laboratory to make prints from my negatives, but the impromptu light in the printer was to[o] weak to make any impression. However, I did make three prints with the aid of a flashlight. After that we went to bed.

Sunday, June 25th:

Before going to bed last night the "Fuquas" came down to inquire if they might not take us to the dance. We thanked them but decided that we had better stay here as all of our clothes were dirty.

It rained again this morning and inconvenienced us quite a bit, but when it stopped we put out crab lines to get our breakfast. By 10:30 we had caught five and at 11:00 we breakfasted.

Once more I converted the cabin into a dark room and printed more photo-graphs, but the prints turned brown in the developer. This may have been caused by traces of salt water. However, I will be able to get splendid prints from the negatives when I return home.

Don passed most of the day fishing, catching catfish and crabs. Bob washed some

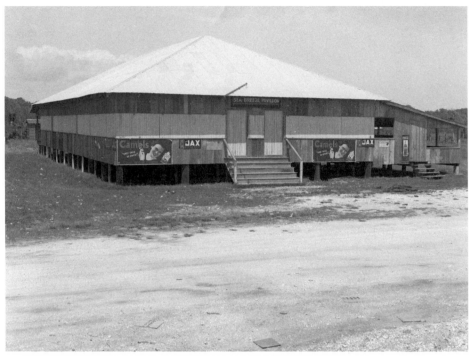

The Sea Breeze Pavilion

of his clothes and also tried fishing. So far, the only fishing I have done was the other morning when I threw out a gar line and pulled in one about four feet long. The thing didn't put up much fight. Bob landed one the same size shortly after I did.

We had dinner at 6:00. It consisted of fried hardhead (catfish), crab gravy, and lemonade. After dinner we cleaned up and went ashore, buying candy and strolling on the beach before going to our friend's camp. We joined them at playing cards, later repairing to the kitchen for food. When we departed we dropped in at the Sea Breeze pavillion where a rollicking dance was in full swing. A negro band set the cadence with wild, extemporaneous music. A circle of surging people had gathered around something interesting just outside the dance hall. We crowded through to see what all the excitement was about. It was something wild and weird to watch: a negro couple dancing. They were drunk with the rhythm and weaving about in fantastic gyrations, recreating fantasies of their primitive ancestors. Slow, convulsive, twisting, they advanced toward each other, sweat rolling down their serious brows. The crowd roared, then hushed. An old colored hag had emerged from the congestion. She caught the male exhibitionist by the sleeve and threw him to the ground, retreating as she did so. The man arose, unperturbed, and continued the dance.

Inside the pavillion scores of natives and a few excursionists milled around,

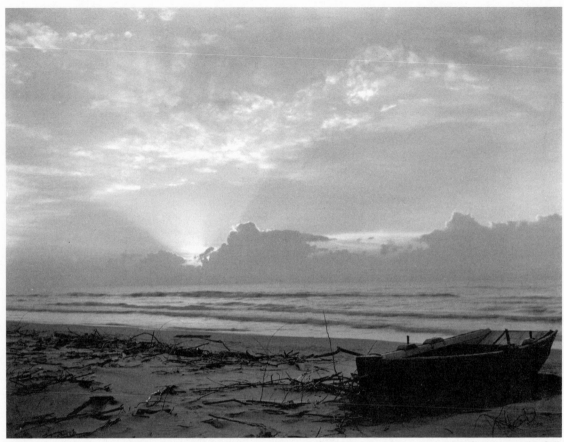

Sunrise over the Gulf

watching the dancing couples. Along the walls, on wood benches, sat the grand dames of the isle, gossiping in whispered French. The unpainted rafters were decorated with tresses of moss and gaily colored strings of artificial flowers. Small girls, from the ages of six to twelve, were dancing together as well as the older couples.

The crowd, itself, was interesting enough to watch, but we were tired. Besides, we (including our friends) were all going to Grande Terre island tomorrow to fish from the ruins of Fort Livingston, and consequently, should be getting to bed.

The lanes were inky tunnels as we stumbled our way back to the boat through the tiresome sand ruts.

Monday, June 26th:

We got up at 4:30 and watched the sun rise in glorious beauty through the piled up clouds over the island. By 8:30, after spending some time with breakfast, we pulled into Bayou Rigaud to pick up the rest of the party and thirty minutes later

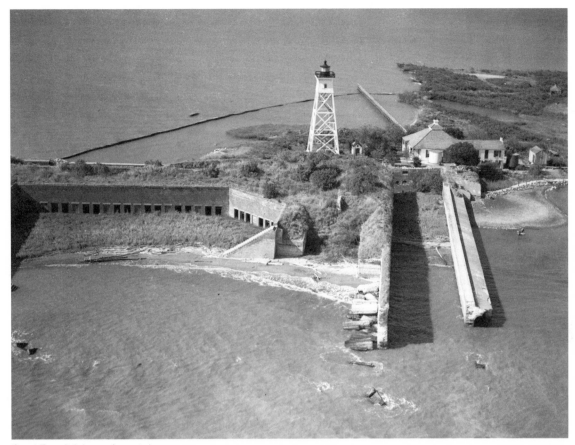

Grand Terre lighthouse from airplane

were docked at the lighthouse pier on Grande Terre. Several of us ascended the lighthouse stairs to the top where I set up my movie camera and made a few shots. The lighthouse is 77 feet high and affords an excellent view of the two islands. The whole of the country is a jumble of low marshy islands surrounded by shallow lakes and cut to pieces with twining bayous. To the south spreads the gulf in its blue expanse, and to the north stretches Grande Lake, or Barataria Bay. At the base of the lighthouse is a thicket of fruit bearing fig trees. On descending from the lighthouse we ate our fill of the luscious fruit. Everyone else fished while Bob and I wandered through the ruins making motion pictures.

At noon we all gathered on the porch of the lighthouse keeper's home and had our lunch, and after that we scattered again, some to fishing, others to exploring, and I with camera on shoulder, to stalk the pelicans that had settled in great numbers on a sand bar up the beach. I made some telephoto pictures of them, using a pair of binoculars mounted on the lens of the camera.

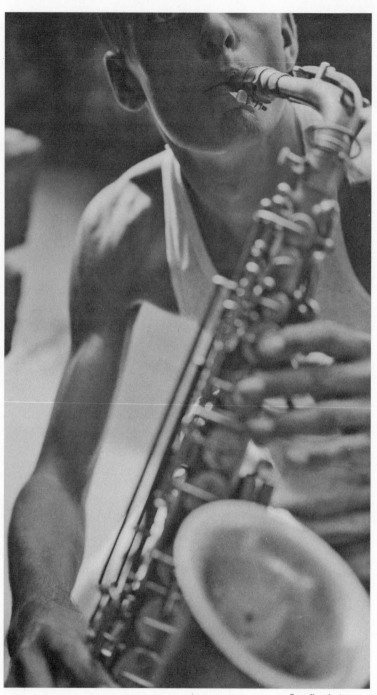

Fonville playing sax

Old graveyard

In the afternoon we all boarded the "Pintail" and returned to Grande Isle with our handsome strings of trout and sheephead, and tonight we had the fish fry of our lives. We simply gorged. After that I drove to the boat and returned with my saxophone. Bob, Mrs. Farquar, Don and Marian danced while I played what tunes I knew.

Wearied, we returned to the boat late and battled mosquitoes while erecting the net. Even then several dozen of them got trapped inside and gave us a restless night.

Tuesday, June 27th:

Slept late and did nothing until late afternoon, when Bob and I set out to make movies, leaving Don at the boat. After taking a few shots in the shaded and mossy lanes we arrived at the Farquar's camp. They were hanging out their wash and were soon leaving for Leeville. Would we go along? We declined with thanks and went to the beach where we made our next shots, then, turning back inland, we crossed the island to the old burial ground of the pioneers of Grande Isle. There remain only six or seven of the bleak tombs. Several of them have caved in with time; others show evidence of severe storms. Through a jagged opening in one of the tottering tombs

we peered and were startled to observe a brownish human skeleton lying beneath the seepage of brown water amidst its tumbled down and rotted coffin.

Returning to our landing, we found that the ever energetic Don had tidied the "Pintail" from stem to stern.

After supper we all went to the beach for a bath in the surf beneath the wan quarter moon, and returned soon to the boat. On our way to the boat we spent fifteen cents of our remaining twenty cents for candy, which we ate as we plodded along. The bunks were already up, the boat mosquito proofed, so we went immediately to bed for the best night's sleep since arrival at the island.

Wednesday, June 28th:

We didn't get up so early. I got up first, and finding it difficult to arouse Bob and Don, I untied the hammock ropes. Their discomfort did not allow further sleep so they got up and dressed.

In the afternoon Don and I went ashore, leaving Bob on board to catch up on his ledger work. We ran out of money yesterday, excepting a nickel, so in order not to be inconvenienced in eating matters until more money arrived, we carried Bob's shot gun along with us to a promising grocery store in the woods and established our credit for a week. We didn't hold up the man, we simply hocked the gun to him. Don and I went on through the lanes to the Farquar camp and found them all at ease in the front room. We wanted to go bathing and persuaded them to come with us. After swimming and returning to the camp, Mrs. Farquar made us a host of doughnuts. In addition to the very acceptable pastry, we had boloney sandwiches and bread and sirup. This put us at complete peace and satisfaction with the world. We saved some of the food for Bob, later driving to the boat for him and my saxophone. I played while they danced, then after a while we all went for a walk on the beach. Near the beach is a refreshment stand and dance floor. No dance was going on there, but the radio was on. We danced. The radio reception was awful but nevertheless, it was music. Marian and I spent most of the time experimenting with tango steps that I had shallow knowledge of.

We returned to the boat and to bed about ten thirty.

Thursday, June 29th:

We had arranged to go crabbing on the beach with the bunch this morning so as usual we showed up at the camp almost two hours late. We found Dan there alone, studying, and he said that the others awaited us at the beach. Arriving at the beach we could find no trace of them, and trusting that they would sooner or later put in an appearance, we started our crabbing operations. Crabbing is interesting and lots of fun, but we went about it the wrong way as we later learned. We tried scooping them up as they scuttled about on the sand beneath the surf. We used large nets

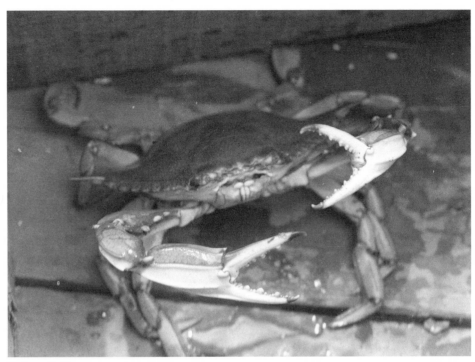

"Fighting Crab"

but we had very little luck. Presently the others arrived and showed us how and it wasn't very long until we had all the crabs we could use. We planted sticks, with baited lines attached in the surf not far from shore, running our sticks from time to time to shake the avaricious crabs from the bait into our nets. Crabs have a very low I.Q. and will often continue to hold to and eat the bait even after being dipped up into the net. When it finally occurs to them that they are captives they get very nasty and would just as soon take your finger as the bait, in fact, I believe the finger holds preference over the bait.

Soon I had a roaring fire going on the beach to leeward of a huge piece of drift-wood over which I hung a pail of salty gulf water. As soon as the water came to a boil we began dropping in the live crabs, one by one, until all of them were done to a beautiful red color. There were two dish pans full. Then we all sat in the surging waves of the beach and ate crabs to our heart's (or stomach's) content.

Mrs. Farquar and the girls soon returned to camp to begin preparations for a crab gumbo while we boys returned to catching more crabs.

So later in the day we had crab gumbo and did we put it away! None of us felt that he could look a crab in the face and keep his self respect for some time to come. All afternoon we loafed around the house, with the exception of another

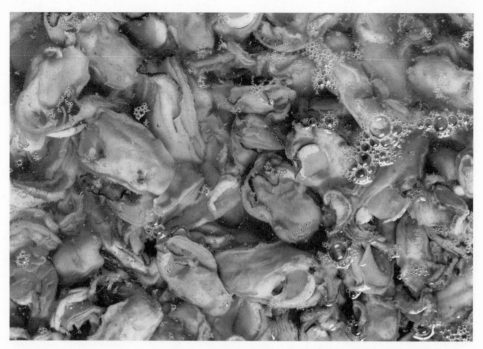

"Mmmmmmmmm, Oysters!"

swim in the surf, after which we returned to camp and made orange sherbet and feasted again.

The "Pintail" crew was again late to bed.

Friday, June 30th:

We arose at 7:00, had pancakes and coffee, then cleaned up the boat in preparation for taking the bunch out to the oyster beds for oysters.

They came to the dock a little after 11:00. We had bought five cents worth of shrimp prior to their arrival in order that we might fish as well as gather oysters on the reef.

A quarter mile from our dock we lowered the anchor into the oyster bed, baited our lines, and began our conquest for trout. Little fish took the bait and refused to get hooked. Once in a while a hard head was caught, but never a trout. In the marsh nearby lived the negro fisherman who took care of the beds, and the sight of us anchored there drew his attention. We hadn't yet begun to gather oysters, but nevertheless, the caretaker of the beds entered his pirogue and began paddling toward us. We thought we had better ask if he would sell us any oysters, rather than confiscating them without permission. He proved to be very friendly and suggested

that we gather all we wanted free of charge. With that I gave him several of the cigars that I had the forethought to purchase for just such purposes before leaving on the cruise. I had bought some quantity of them in Fort Worth for two cents apiece.

Mrs. Farquar and the girls retreated to the cabin top while we boys went inside and changed to our bathing suits. Marian already had on her suit so she joined us in diving and gathering the oysters, and it wasn't long before the stern deck was loaded with this particular species of mollusca.

Returned to the dock, Dan drove the girls to the camp while the rest of us remained to "shuck" the oysters. Don jarred them open with a hammer while Bob and I removed the contents. After several hours the process was completed, resulting in three fourths of a bucket full. We carried them to the camp and had fried oysters until it was almost disgraceful. Later we took a swim to work up another appetite which we later appeased with quantities of bread and sirup.

Saturday, July 1st:

Last night, while we slept soundly, the bunks collapsed. We dropped with the bunks, assuming various angles about the motor box and passageway. But the funny part of it was my dream. I dreamt that we were far out at sea and doing our best to keep afloat in a terrific storm. Very suddenly we felt the impact of a piece of driftwood driven against the hull and the boat began to fill with water. I tore frantically through the debris of the cabin and was about to catapult myself into the frothing ocean to keep from being dragged down with the boat. I was almost into the water when I realized what I was about. Bob and Don were in the bottom of the boat rubbing their heads and saying what the hell, and I saw that everything was calm and peaceful and that we were very safely anchored in our usual place in the rear of the island. Bob and Don realized that I had almost jumped out of the boat and when I told them of my dream they forgot all about their own discomfort and had hearty laughter while I felt silly and grinned. We didn't bother to fix the bunks but spent the rest of the night just about like we fell when the bunks gave way.

After pancakes and coffe[e] for breakfast we collected all our dirty clothes and washed them at the camp, going later for a swim.

On returning we had okra slumgullion, baked beans, boiled shrimp, and devil's food cake and coffee. Bob and Don did duty by the dishes while I played tunes on my saxophone.

When we reached the boat tonight a thick horde of mosquitoes encircled our heads. The bunks were broken, so I rigged our teester net on the cabin top and we slept there.

As the Fourth of July draws nearer, we notice that many people are beginning to come here by automobile and boat. Little dressing rooms of burlap and canvas

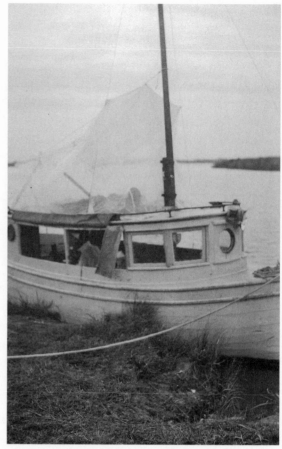

Pintail with teester net

are sprouting along the beach like mushrooms. Dance halls are being enlarged. The natives busy themselves piling the great logs of driftwood together for bon fires and cleaning up their boats for fishing parties. I guess we'll have a great Fourth.

Sunday, July 2nd:

The mosquitoes were a nuisance last night. We found a hole in the net this morning through which they swarmed upon us.

Several showers descended very unexpectedly and soaked all our clothing that was spread out on the deck of the lugger tied astern of us.

Before we left for dinner at the Farquar's, we cleaned up the boat and scrubbed the decks. We got there about nine-thirty, just after they had finished breakfast, and were put to work immediately shelling beans and doing other domestic things in preparation for dinner. These things accomplished, we all repaired to the beach for

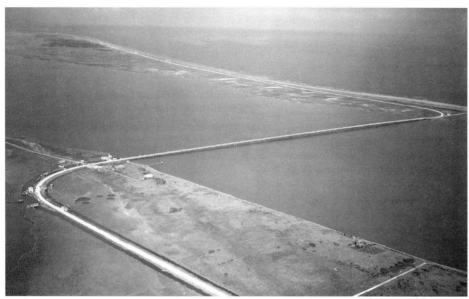

Grand Isle Bridge (Caminada)

swimming. The Fourth of July crowds littered the beach. Awkward white skinned people sunned themselves, sprawled akimbo among the dunes. Others swam or raced their autos up and down the stretch of clear beach. Imported traffic cops were busy. This was unusual. There had never been motor cars in such numbers on the isle before, in fact, Grande Isle was experiencing automobiles for the first time in history, the long Caminada bridge having been opened only a short time before. Prior to the government's snaking a long road down through the almost impenetrable marshlands and building the bridge to span the intervening water, Grande Isle was accessible only by boat. Now, the thrum of Cadillacs mingle strangely with the put-put of the shrimping luggers.

We completed our swim and had dinner about two o'clock. Then some of us went to the beach in Mr. Farquar's car to watch the milling crowds around the dance halls and beach. The bathing beauty contest was just over. There were newspaper men and two news reel men packing their equipment. The whole island was mad with excitement. The natives, ever quiet and watchful, contrasted greatly with the rip-roaring pleasure seekers and were quite content that Grande Isle was profiting.

Returned to the camp we rested and later went swimming again. The gulf was very calm, with gentle sea swells barely crumbling on the bars. We stayed in an hour then went back to the camp.

At sun down Bob and Don returned to the "Pintail" and I remained with the Farquars. We drove to the far end of the isle and watched the last rays of the sun

burn crimson patches on the gaudy horizon. The water was still and the porpoise played close in shore. As darkness settled we drove to Milliet's landing for cigarettes and gum. There I saw Snodgrass, owner of the "Flying Dutchman", a forty foot auxiliary schooner, and we exchanged addresses, in lieu of an expedition to the Dry Tortugas next summer.

Back at camp for the last time we ate a light supper and played hearts until midnight. I was the champion duck. I inevitably got the queen of spades and a flock of hearts with very fine consistency. Oh, well, nothing to lose.

Returning to the boat I got into my bunk without awakening either Bob or Don. Or rather, it was my space on the cabin top where we again slept under the teester net.

Monday, July 3rd:

The mosquitoes were bad again last night, but were nothing compared with the vicious insects, of a small variety, smaller than gnats, that come thru the net like wind. They get in your bed clothes and hair and give you one hell of a time. There's no escaping them. The only refuge is the sleep that follows the fatiguing hours of squirming and pitching and cursing and slapping.

Dawn was welcome. Somehow our night visitors disappeared with break of day. (Sound of knocking on wood).

Today we again visited the Farquhars (right spelling this time!) but after our dinner, of course! They were all at the table eating fried oysters. David Bell was there. He is down from Jeannerette with his parents, aboard their lugger, the "Vodey". Dave is a very recent addition to the bunch.

The swimming was really good today. The gulf was emerald, calm and clear. We ducked each other and played games of tag. David managed to stick his foot into the mouth of a very large fish, that wasn't above clamping down upon it. His toes were cut slightly. For the sake of excitement we voted the fish a shark. There's more glory to a shark bite than to that of an ordinary fish. It's very common place to be nibbled at by an ordinary fish or a crab. That's no accomplishment. But to be sampled by a shark is to be in a class that is highly restricted.

Fourth of July crowds still enlarging; island still running wild; people still whooping with the proper holiday spirit; everything gala, in a primitive way. Looks like a boom is on. Not much dog but lots of whoopee. That's the aspect of the isle as we head for the camp. We are all hungry and prepare a feast. Chicken! Oysters! Prunes! Pie! It's all ready at sunset so we lay to with glutinous eye.

Big dance tonight. Bob and Don, not interested, go to boat. The rest of us go. Marian, Dave, Dan and Helen participate, but not I. I'd rather watch. Anyway, I didn't have the necessary six bits.

In one corner of the room a crap table was running wide open, with betting ranging all the way from twenty-five cents to two dollars a crack.

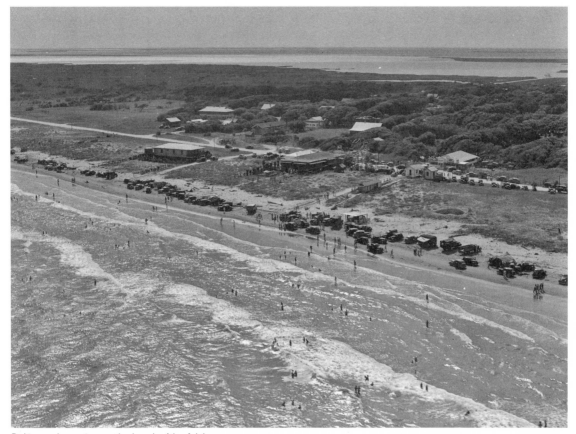
Parking and camping on the beach, 4th of July

At midnight I bid the bunch goodnight and returned to the "Pintail". The crew was battling the mysterious invaders that sail through the net like wind. I crawled in and joined the melee.

Tuesday, July 4th:

The wind last night drove the tide so high that we had to wade half way to the island levee. All spanked out in clean uniforms, we arrived at the Farquhar's camp at 9:30 A.M. This day being the Fourth, they had invited us to dinner. Had it been any other day they would have invited us anyway. But today, being what it is, we had received a special invitation for this special occasion. In preparation for dinner I fried a heap of pork chops and made a skillet full of brown gravy. After a while we all went to the beach for bathing. The surf was unusually high and rough and as far as the eye could see the high waves were breaking. Last night a large fishing boat, that had been anchored outside the first sand bar, broke anchor and was washed

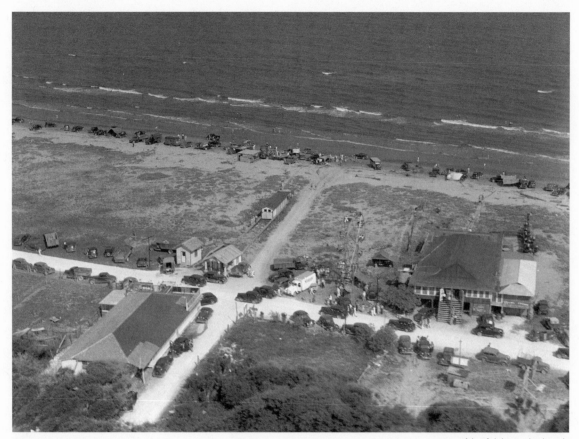

4th of July on the beach

ashore. Heavy rollers had settled her high on the sands where now only fragments of the heavy sea could barely reach her stern.

I tried, by walking and swimming, to reach the first bar but it seemed that every ten feet I would gain I would lose twenty. I almost reached it once. I had struggled against the undertow, dived under several waves to prevent being washed too far back, and was just about to make it when a big wall of water rushed at me and crumbled over. I went to the bottom, rolling over and over and over, and came up in time to be inundated by its brother. By the time they were through with me I was pretty close in shore. Thereafter, the plain roaring surf suited me fine.

After dinner we all sat around the big living room and spun yarns. Later Bob, Don, and I went to the beach to make movies. I had the camera set up in the surf preparatory to shooting a scene when some people gathered around asking irrelevant questions. A big wave stopped the quiz and wrecked one of the tripod legs by washing a spectator into it. I could still use the broken leg however, so continued to

film until intermittent rainstorms stopped me. Back at the camp, we dressed and I played my sax for a while.

As night fell, and during the lingering dusk, our party explored some of the nearby lanes. We terminated at the beach where the moon was just beginning to shine brightly over the disturbed gulf.

Returning to camp once more I played tunes on my sax, before we, the Pintail crew, returned to our boat for the night.

The high wind prevented the coming of the night insects so we dispensed with erecting the net and sprawled immediately on our pallets atop the cabin.

Wednesday, July 5th:

The wind reached a terriffic force last night. Don took refuge below, unable (or unwilling) to grapple with his blankets any longer. Bob never moved unless it was to shift position. My one twisted blanket afforded no adequate protection; the wind blew through. I asked Don to pass me a canvas hammock, which I put to windward of myself. Thereafter I slept warmly.

The inevitable pancakes again this morning, and after cleaning up and donning the uniforms we started inshore. The tide was high, higher than we had ever seen it before. The whole boardwalk and pier was submerged. Boats down for the holiday tied up alongside, unable to leave. Wind and rain squalls frequent. We could hear the surf booming from across the isle.

All the way to the levee, about one quarter mile, we waded knee deep in water along the shell road leading into "town". At Boudreaux's general merchandise store we stopped to redeem Bob's shotgun that had been covering our grocery bill, await-ing arrival of ten dollars from Bob's bank account. The bill was $2.52. Then on to the Farquhar camp.

Helped around the place for a while then set out for the beach to make more movies. Most of the bunch came along. Nasty weather came in from the sea, blow-ing a gale that whipped feathery edges to the high waves which were often pushed far into the dunes, swirling around our feet. Soon one of those cold, driving rains started. I was on the deck of the oyster boat, "Hope" that had been washed ashore night before last and had just sent Bob to the camp for my telephoto attachment. The other[s] scattered along behind him running at breakneck speed for shelter. I, too, started running but for the shelter of the dance hall a short distance away. Others had taken refuge there too, and loafed about talking with the negro dance band members. The conversations bordered around the series of disturbances that occurred here last night during the dance. The fights! All had to relate their own peculiar experiences and in the eagerness of telling, most of the accounts were overlapping each other.

At this moment I caught sight of Bob running out along the beach looking for

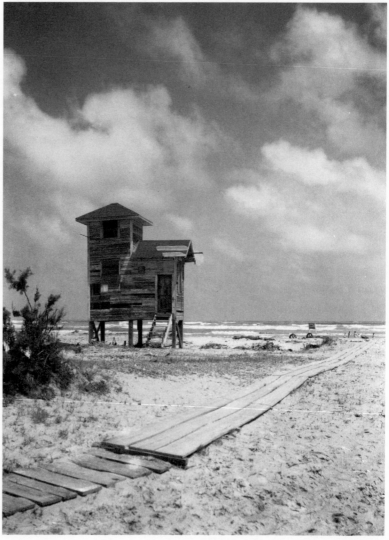

"Coast Guard Tower"

me and whistled loudly at him, but the roar of the surf would make a galloping lo-comotive sound like a whimper. Finally he caught sight of my waving arms and ran to join me, but the rain suddenly stopped. I joined him, instead. I made some tele-photo shots of the breakers then we mounted the coast guard lookout tower which rises thirty feet above the dunes. I didn't "shoot" any from here but scouted the pos-sibilities. We had an excellent view of the island coast. It was about 12:00 and the tide was dropping, making travel possible on the beach for automobiles if the driver were careful. The rough weather had brought the tide so high that all autos were

marooned, but now, with the tide dropping, they were to be seen making nervous departures. If the tide had risen three more feet one could have paddled over the isle in a pirogue.

Among the refugees we saw the Farquhar family feeling their way cautiously along the beach in the Plymouth, waves surging against the wheels. They had mentioned leaving until the bad weather passed, and sure enough, they really did. Bob and I didn't even get to tell them goodbye. We supposed we'd find Don awaiting us at the camp.

He was there alright and informed us the camp was ours until the Farquhar's return. We couldn't kick. A camp all of our own! A delco lighting system! An ice box full of good things to eat, and soft, comfortable beds to sleep in. I'll say we couldn't kick.

So we sat ourselves down to a hearty meal, and then cleaned up the kitchen. Bob and I went to the "Pintail" to get some personal effects and to leave her in good shape for rain and storms. On our return we were forced to take refuge under a tin roof when a sudden deluge of rain drenched the isle. At length it abated somewhat. At Ludwig Lane Bob turned toward the store to get some post cards while I continued through the lanes to the camp. Bob arrived with Dave who had come to visit the Farquhars but he visited us instead, joining us in a spread of coffee and bread and peanut butter.

At 5:00 Dave went with me to mail a letter to John Burns, Star Telegram reporter in Ft. Worth. I had written him a brief account of the trip which was to be published in the paper. I got the Farquhar's mail and a letter for Bob.

Johnny Rebstock, who had been staying at the Farquhar's, was at the store and mentioned getting up a stag party for tonight. We would make some fudge. I said it was a go. Dave and I met Flo on our way back through the lanes and invited her to drop in on us when she returned from the store.

Dave had to return to his boat so I bid him goodbye at our lane. After a while Flo came by. I had been playing on my sax but soon put it up. She invited us to transfer our party to her house tonight and she would make the fudge for us. We said to expect five of us. When she left we lay around and talked and smoked our pipes.

Night fell, and black clouds raced across the full moon. A wild, exotic night! Mystery and romance lurked somewhere. Johnny came in and dressed then he and I left. Bob and Don had backed out of going. We went to Flo's but could find no trace of her. We went to the restaurant by the dance hall where John expected to meet his date. No one awaited Johnny. Walking through the lanes some distance we came upon her house. It slept in the center of a small clearing, serenely sillouhetted against the wild moon and racing clouds. It was ten o'clock. All was quiet but the shrilling wind in the tangled oaks.

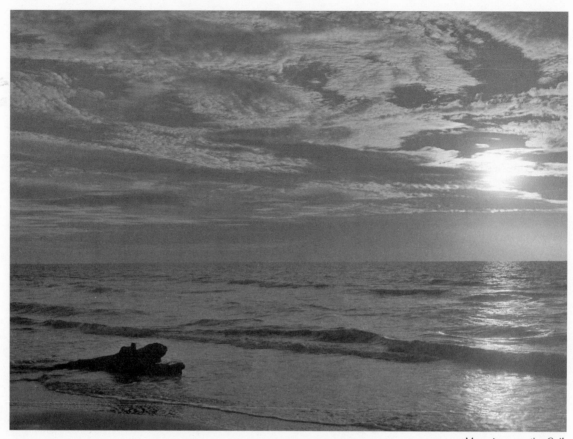

Moonrise over the Gulf

We stopped in at the Oleander Hotel on the way back and watched some women playing bridge. At ten thirty we returned to camp and found Bob and Don having coffee. We drank some too, then we all talked awhile before going to bed. I slept on the single bed on the moonlit, windswept gallery. The drone of the surf lulled me to sleep.

Thursday, July 6th:

Had a very fine sleep last night that was only interrupted once. That was when it rained so suddenly I thought someone had tossed a bucket of water through the screen. I grabbed my bed and tried to carry it through the door, but it was too wide, or the door was too narrow. I don't know which. Anyway, the mattress came off and I tripped over it, dropping the iron cot. Fortunately it folded up and I finally got it through the door. When I at last got everything into the room the rain stopped as suddenly as it had begun.

Johnny's alarm went off at 6:30. He had to go to work at Ludwig's at 7:00. He stopped the sleep meter from making further disturbance, raised his brows in a devil may care manner, turned over with a grunt, and went back to sleep. Next time I awoke it was 7:45. Bob was arousing John from his prolonged slumbers. Johnny again raised his brows, but not in his customary nonchallant manner. Ten minutes later he was dressed and gone.

We had soft boiled eggs for breakfast, then Bob and Don went to the boat to get a few things while I typed on my diary.

Most of today was spent in doing general house work. Don, unusually ambitious at times, bit off a very nice sized chunk, and chewed it, and still wasn't satisfied, I think. The laundry, scrubbing of floors, and the building of numerous shelves, kept him busy most of the day. As for me, I cooked. My worst accomplishment was doughnuts, as I made up the recipe, but they were eatable, nevertheless.

Bob and I went to the beach for bathing. That is our only means of keeping clean. We sit in the surf and rub sand on ourselves then rub down each other's backs.

The waves are still high and continue to roar up and down the beach. The "Hope" has been washed farther upon the dunes and has settled deeper in the sands, the waves continuously battering at her stern.

Saw Flo in bathing. She said I was a fine one for not showing up last night with the rest of the boys. She said she had waited up for us until 10:00. Was that a hot one! We, Johnny and I, had gone over at 9:20.

Bob and I climbed to the top of the coast guard lookout. A heavy storm was passing around the end of the isle and encircling it. Already we felt the driving wind and rain. Rain accompanied us back to camp.

Every time I go out with the camera it starts to rain. Guess we'll be here on the isle for some time to come. It's a good life that I'll not rejoice in giving up.

Went to bed rather early tonight: 9:00. No sign or word of the Farquhars today. Still enjoying the exclusion and luxury of their camp.

Friday, July 7th:

Arose at 7:00. Had creamed eggs on toast for breakfast, then loafed around the house for the rest of the morning and enjoyed the intermittent rain storms. In the afternoon we went crabbing on the beach and only got three medium size crabs. The breakers were too large and I guess the crabs found it rather hard to hang onto the bait. Swam a bit, too, and had lots of fun diving through the high waves.

I cooked an early supper. It consisted of rice and brown gravy and beans, only the beans didn't get done and later in the evening, they burned to a crisp when I forgot to add some water. Night fell, and we were lying on the cots talking. Suddenly the island was deluged in a torrent of rain, the sky seeming to beat the earth,

and then, because we were hard up for excitement, we put on our bathing suits and started for Ludwig's for candy. Bob had received a buck from his mother and wanted to do something to relieve the strain. The rain pounded down with an icy furriness. We crossed the road, scaled a rickety sty and entered the inky tunnel of the lane. The path curved through the stygian forest, led beneath storm tossed oaks. No visibility. We felt our way skeptically along and emerged into the lane leading to Ludwig's. We bought candy there and headed back to camp via the beach road. The moon shone over the gulf. It still stormed here. Stopped at the restaurant and bought more candy and three packages of cookies. At camp we made coffee and had eats. Pretty soon it rained with redoubled fury and a half gale blew. An open window over the cots allowed them to thoroughly acquire an excellent soaking. No sleeping on them tonight. My cot wasn't flooded. Bob and Don slept in the big bed. They have gone to bed and as I'm typing this last line Don is suffering from acute indigestion and making up crazy rhymes. I'm going to bed now. Goodnight.

Saturday, July 8th:

The morning dawned beautifully but I continued to sleep until the sun was fairly high. I looked out when I got up to stretch and yawn, and beheld the fair day; cloudless, soft breezes blowing, balmy air. Bob and Don slept on. I dressed, ate some pancakes and coffee, and washed out my uniform. When Bob and Don got up I made pancakes for them as fast as they could eat them. Later in the morning, house cleaned and every thing, we went to the beach to crab. I carried the movie equipment to film the fun.

While they were baiting the lines I made some more photos of the "Hope" which was by now buried very deep in the quicksand of the beach. The occupants of the boat are living under a big tarp that they erected on the dunes. The shipwreck seems to be a hopeless case, according to the natives.

The crabs were biting exceptionally good and in a little while we had a bucket full of them. About that time I ran out of film and went back to camp to reload. When I returned to the beach Bob and Don had a fire started of driftwood, and water on to boil for the crabs. We went in swimming and when we got out the water was ready. In went the crabs, squirming for a moment before sinking. When they were done we cleaned them and returned to camp.

About 3:30 we had dinner: crab gravy, coffee, and bread, then remained at the table for quite a while to smoke and talk.

Pretty soon I remembered that the boat hadn't been bailed for two days and must, by now, be full of water. Leaving Bob and Don to continue their smoke and chat I went on my way. Sure enough, the boat needed bailing badly, and when I got through heavy beads of sweat stood out all over my body. I was stripped to the waist. I carried a few things back to camp with me where Bob and Don were still

smoking and talking and the dishes were still dirty. After a while we all cleaned up the camp and lay down on the cots to smoke and talk until the daylight was gone. John and Dave walked in about that time on their way to the dance and persuaded me to join them. I put on my freshly washed, but not ironed, uniform.

Five policemen from the mainland were there to prevent any trouble should it threaten. The last dance was too much for the peace of mind of the isle. Drunkenness and rioting, and fights galore. Nothing developed, however, in the way of brawls, so I contented myself with watching the dancing couples. Dave treated to beer and Johnny to candy so I didn't make out so bad after all. I left the hall, or pavilion, at 11:00. I had to walk abreast of the beach the length of a city block before turning down my lane. The full moon was high in the sky and struck up on the billowy gulf a silvery, iridescent path that reached to the dark, purple horizon. The lane was lighted clearly with the milky, mystic atmosphere. Canopies of moss silhouetted darkly against the starry sky. What a night! I went to sleep with the wild strains of dance music from the beach rollicking in my head.

Sunday, July 9th:

After breakfast, while we were laying on the cots smoking, the Farquhars drove in. They caught us red handed; the dishes weren't washed. But that was soon remedied and the camp cleaned up in general.

Later we all went swimming, then returned to prepare dinner. Mrs. Farquhar and I stated that we would cook dinner if the rest would clean up after us; so they consented. The dinner was excellent. It consisted of thick juicy steaks, rice and gravy, tomatoes (that had been saturated in mosquito lotion), butter beans, ice tea, etc. The lotion had been accidentally spilled on the tomatoes while in the back of the Farquhar's car. However, we ate them and are hoping the mosquitoes will find it out and call a halt to activities.

We went down to the boat in the car to get our bunks to put up at the camp tonight.

Dan and I took a long walk after we got back. We have both started moustaches and wanted to give the island's population a show. In other words, we put on the dog for a while.

About sundown we all got in the car to drive around, but first we had to go to Ludwig's for some sugar, etc. We had intended driving down the beach to the other end of the island to see Dave and his folks aboard the "Vodey," but Mr. Ludwig gave Mrs. Farquhar five large trout, freshly caught, which put us of mind to returning to camp and getting supper. Bob and I cleaned the trout while the others got the table ready. We had all the fish we wanted and got up from the table feeling friendly with the world.

I played dance tunes on my sax while Marian, Bob, Mrs. Farquhar, and Don

"Fonville, Self-Portrait"

danced. This lasted about 45 minutes, then Johnny rushed in announcing a free dance at the opening of the restaurant next to the dance hall. For that reason there was no dance at the pavilion tonight. Well, here was a chance to do some dancing myself. Heretofore, all I had done was play for the others to dance. We all piled into the car and arrived at the restaurant a couple of minutes later. Already the small floor was teeming with rhythmic couples swinging in time to an asthmatic accordion manipulated by one of the native young men. I leaned on a post, smoking my pipe, to watch awhile before dancing myself. Nita was there, the handsome Indian girl with the dark, laughing eyes and always a flashing smile. I had watched her at some of the other dances and noticed that she was a good dancer and very popular. So, as Johnny knows everyone on the island, I got him to "fix me up." She was indeed a good dancer but very independent. After every dance I had with her she would waltz off to the side lines without a word, leaving me in the middle of the floor feeling like a fish on land.

Pretty soon our crowd rigged up a tagging system and it worked fine. There were about five couples of us and did we have the fun!

After taking Dave to his boat, we returned to the camp, about 11:00. Bob, Don, and I slept on pallets on the screened-in gallery.

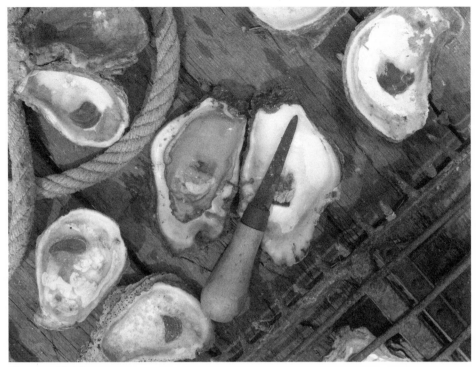

"Oyster and Rake"

Monday, July 10th:

Our party divided today to forage for sea food. Don and Dan went to the beach to crab; the rest of us went to the boat in the car to go get oysters. The dilapidated dock had crumpled in one span so Bob and I did the best we could in transporting the ladies over without ducking too many. Our passenger list consisted of Mrs. Farquhar, Helen, Marian, Flo Lanier (of N.O.), Bob and myself. The oyster beds are about a quarter mile into the lake, not far from a small piece of land. The beds are identified by a cluster of poles sticking from the water. I dropped anchor in about three and a half feet of water. Mrs. Farquhar stayed on board to fish while the rest of us went overboard to dive for oysters. By wading and diving we soon had several bucketfuls of the delectable sea food. The keeper of the beds noticed us getting them and rowed out in a skiff. He is a very kindly old negro man, but warned us against letting the owner know of our raid. We had enough oysters; so I gave him a cigar (one of many we had purchased in Ft. Worth for one cent each); and we went back to the Chighizola Landing (Coast guard dock) where the Pintail is kept.

Getting the ladies back past the gap in the dock was more hazardous an undertaking than getting them to the boat. Mrs. Farquhar was the last one to be passed and some miscalculation occurred. She was doused past the waist.

Don and Dan were still crabbing when we drove past the beach on the way to camp. Bob, Marian and I opened the oysters, and Don and Dan, who had come in a little bit after we did, settled down to picking the meat from their crabs.

We had a great dinner: fried oysters, crab gumbo, and hominy grits. After dinner Mrs. Farquhar, Dan and Helen wandered off, leaving the rest of us to act quite kiddish for a while. Finally, as it grew later, Bob and Don went to the P.O. for lots of expected mail, Marian and I cleaned the kitchen and the dishes, and Flo went on her way to her camp. Before dinner, as we were very splattered with oyster juice from opening them, Marian and I dashed to the beach for a swim. While there it started raining and we walked back in the rain.

Later we all went swimming, but as it was chilly we did not remain in very long.

After night had fallen we all drove down the beach to Milliets Landing to put some mail on the boat. Everything was dark but Dave's boat, so we called him out and entrusted the mailing of the letter to him. He could put them on in the morning. Then we returned to camp, made pancakes for supper and went to bed.

On Tuesday, July 11th:

Tuesday's wash day! Everybody to their tubs and boards. Fonville, you scrub while Helen rinses, while Bob hangs the clothes on the lines, then after a while let Bob scrub, Helen rinse, and Fonville hang the clothes on the line.

In the meantime, there's the kitchen and the dishes to clean. Marian and Bob can do that, then relieve with the washing.

And so on into the day. Rained while we washed and the sun came out in time to dry the clothing.

We were still tired from washing but the afternoon had become so pleasant that Mrs. Farquhar and I went in the car to call on some of the interesting residents of the isle. Dan, ever curious, came with us.

We drove west on the isle almost to the end of the shell road and turned into the trees down an oleander tunnel. Near the bakery, a weather-worn shack to all appearances, we stopped opposite a queer house with flower gardens about. Mrs. Farquhar knew the people. We crawled over a wooden gate and approached the house. An old woman came out to meet us. Her hair was grey-black and gathered in heaps at the back. Her face was lined and a light mustache adorned her lip, but yet her mien was friendly. She was dressed cheaply in a soiled cotton skirt, long co[a]rse black stockings, and tennis shoes encased her large flat feet. Mrs. Farquhar started conversation by admiring the flower gardens, but the woman only smiled and asked in broken English if we spoke french. She smiled at our negative answer and gave her shoulders a shrug, then called a small boy and sent him after her husband who knew a little English. The man was a typical islander and, inviting us into the upper story of his structure, began telling us stories of the island.

His grandparents came from France and some way or other (I experienced great difficulty in following his very imperfect English) they came to settle in the land of Cheneire Caminada on the mainland opposite the western-most end of this island. At that time the Cheneire Caminada was covered with trees, but the settlers, not being acquainted with the versatility of the gulf, cut down all the trees for building and fuel. By 1893 the place was treeless. The tidal wave of that year swept uninterrupted over the land, no trees hindering its progress, drowning and killing about 1500 natives. A large number escaped by boat and other means and came to settle on Grande Isle.

We asked how he liked the island. His answer: "Where else there is to go?"

He was one of the island settlers from Caminada and no sooner had he become well established than the storm of 1915 wrecked his house. It was just inside the tree line from the dunes.

His next house was built farther back on the isle and just three years ago he sold the place and built his present abode which is even more so within the sheltering trees. Now he fears no storm. He feels perfectly and safely anchored. His house is of great pride to him. The numerous heavy timbers and bracings were pointed out to us. The house is not large—two rooms up and two rooms down. The ceilings are low and I had to stoop to move about. Upstairs there are three pieces of antique furniture that belonged to the man's grandfather in France. One is a hand-carved Napoleonic table; there is the old solid teester bed of the colonial period; and a very old straight chair of some period in France. (I am not a connosieur of furniture.)

Downstairs on the ground floor are even more interesting things—antiques, works of art on the old sewing machine that the woman owned, and other things that I'm not ambitious enough to tell about.

From here we went to call on the English colonel who has built a sturdy structure on the dunes. His sister lives with him. They are both old and came originally from London, England. The colonel reminds me of pictures I've seen of Mark Twain. A very picturesque character, typically English, whom one immediately pictures in tropical regalia tromping through steaming jungles. My first mind pictures rang true and soon we had him telling of his experiences in wild parts of Spain and of railroading in South America. He is at present working as engineer of roads for the state. We stayed about an hour and then returned to camp.

Late in the evening as the sun had settled behind a stormy bank of clouds in the marshes to the east, we piled into the Plymouth to visit the log-strewn beaches at the end of the island by the pass. Our crowd consisted of Mrs. Farquhar, Marian, Dan, Don and myself; I driving.

The recent storms had changed the character of the beaches at that end by carving shallow veins into the dunes, cutting down the beach width, and strewing driftwood helter-skelter. We followed down a sand bar that was separated from the

beach by a narrow strip of shallow water, or so we thought it was. Finally the bar terminated in a thundering break of rollers; I was driving pretty fast and already was skimming through thin water that had gradually covered the bar. We all thought that the water separating us from the beach was only three or four inches deep, so instead of trying to back off the bar the way I had come I urged the motor into the separation.

I've already told how the "Hope" was washed upon the sand beach and soon settled to the bulwarks in the quicksand and waves. Also one day we helped get a car out of the surf that had hesitated a few moments there, sinking to the hubs immediately. It took a dozen men to get that car out with the gulf waves breaking against it.

The strip of "shallow" water was a foot and a half deep and killed the engine outright. The beach was steep at this place, but after a straining struggle we managed to roll it up past the waves, then leaving the motor to dry we started combing the beach. Driftwood was piled carelessly here and there and we searched these piles for odd sea curios. Then the sun set and we returned to the car with a few finds; namely, a lucky bean (or sea bean), a coconut, and miscellaneous shells.

The car wouldn't start. It grew darker. Still it wouldn't start, even after tinkering. The mosquitoes grew thick and vicious, and wouldn't allow anyone outside the car. What to do? The camp was four miles away, and besides no towing service on the island. Civilized comforts had just this year found ways to the isle.

Mrs. Farquhar, Marian and Dan set out for Milliets landing to await us there should the car happen to start. Don and I stayed to tinker and battle the blood-thirsty mosquitos. We took turns, one tinkering while the other retreated behind the car windows from the ravages of the tortuous insects. We cussed them with every breath, condemning them to hot places and calling them unconventional names, and calling their kindred like names also.

Time began to pass and nothing happened that hadn't already happened. The only tool we had to work with was a pair of pliers and a jack. The jack was about as useful as the pliers, so I struck out down the dunes for Milliet's to borrow some tools. A little ways down the beach I met Dan. He was returning to inform us that Mrs. Farquhar and Marian had hooked a ride to the camp and would send the coast guard after us. We returned to the car and fortified ourselves from mosquitos. Pretty soon I got out and went down the dunes hoping to meet the coast guard and guide them to the car. I noticed a dim light burning way down the beach. As I came nearer I saw it was a car. It had started down the sand bar, and as it could only go as far as the end of the bar and then no farther, I ran out in front and stopped it. It wasn't the coast guard, but it was Bob with a native in a Chevy truck roadster. I directed them through some clear passage. They followed and came through alright. Bob got in the Plymouth with Dan and Don and the native tied on. Then again I hopped through the dunes, pointing the way back to passage onto the beach.

Dave was at the camp and he and I worked for a long time before we got the motor to running. I took time out for a while to stow away some pancakes, then several of us took the car to take Dave to his boat. His parting words were, "Be here at five in the morning." We were going fishing with him and his parents aboard the Vodey; the Farquhar's , Dan Hall, and us (Don, Bob, and I).

Wednesday, July 12th:

At 3:45 the alarm went off. Dan remained motionless; Bob gave a grunt of disgust, mumbled something about sleeping longer, and turned over; Don shut the clock off; I pried my eyes open and sat up. The moon was shining brightly and it was still night.

A little before 5:00 we all piled in the car and were off for Milliet's landing where Dave and his folks waited. A strong wind was blowing out of the Northwest, bringing ugly black clouds that blended with the dark dawn. As we arrived at the landing, the cloud, shutting off the dawn, closed over the land like a cover over the circus caterpiller. A bright light was burning within the "Vodey". The Bells were eating breakfast. I parked the car under the eaves of the general store and in the morning gloom we made our way over the clam shells, across the dock and aboard boat. Then the bottom dropped out of the sky and the elements raged. The air was black with storm. Now and then a blinding flash rent the gloomy darkness and the crash that followed rocked the boat. As the day grew lighter the storm petered out, but the rain continued monotonously. A blast sounded. A yacht was drawing to dock. It was a Louisiana conservation boat. In the sprinkling rain, I wandered up shore, leaned on a piling, and began curiously to look her over. A man strolled out of the cabin and I inquired of their activities in this section. We were talking when a young man came out and introduced himself and in a few moments introduced his grandfather, who followed. His grandfather turned out to be a scientist, study- ing the birds and their parasites and as soon as I acquainted him with my mission on the island he was all interest and invited us in (Marian and Bob had followed). He was immediately interested in my work and I in his, so we had quite a talk. He wanted my address and went aft for paper and pencil. He handed me his N. O. address and handed Marian the pencil and paper. I thought he was getting her address and she seemed puzzled, too. But when he asked innocently, "He's your husband, isn't he?" (referring to me) we nearly passed out. I'm still wondering why he mistook Marian for my wife and asked her to put down "our" address.

From the conversation it developed that he would like to get lined up for an expedition next summer aboard the "Pintail", he making arrangements for the finances. The object of the expedition would be to make collections, studies, and educational movies of natural life along the coast. The movies would be shown dur- ing the remainder of the seasons at universities and schools.

His name and address: Mr. Frank M. Carroll, 815 N. Rampart, New Orleans, Louisiana.

Pretty soon the rain stopped and we went back to the Vodey and left out. We dropped anchor over the oyster beds of our recent raids and while the others fished I dived for oysters and soon had a bucketful. I ate about a dozen of them and opened some for Mrs. Bell and Marian. Hot sauce flavors them excellently. The only luck at fishing consisted of catching some Barataria trout, (hardheads to the natives and catfish to you and me). They are not considered edible by the natives but once Bob and Don caught a mess of them and we had fried fish with no casualties. They were good, too.

Well, as the fish weren't biting here we pulled anchor and moved across the bay and dropped anchor in a small bayou. The fishing continued and again I went overboard to collect oysters. The same run of fishing luck here, so giving it up we pulled anchor and returned to the dock. Had a little trouble starting the car but soon managed to do so, and returned to the camp.

We hadn't been to the boat for two days now so when we reached camp from Dave's boat at Milliet's Landing, Bob and I went on down to the Chigazola Landing in the car. It stopped raining when we got there but nevertheless I raised the hood and placed a canvas over the plugs and distributor.

Before we got to the boat I noticed she was sitting unusually low in the water. The dock is still tumbled down in one place but we removed our shoes and made it safely enough. I jumped on deck, shoved back the hatch, and gave a groan. The floor was covered with bilge water, four inches deep. There was nothing to do but bail out, so I set at that task while Bob dug into the compartments for our sodden possessions. Everything was wet, blanket, clothing, all. Soon the water was at a more reasonable level, so I let Bob take the pump while I tore out the starter button. A cable was eaten apart during the submersion.

When the boat was bailed, we bundled all the wet clothes into the suit case, the damp ones into the laundry, and shouldered the rest of the blankets. We could dry everything out at the camp. I followed Bob along the shaky dock to the place where it had caved in. Bob was to walk down the inclined plank into the water to his knees and I was to pass him the load, piece by piece, which he in turn would toss to the deck of a lugger. He started down the plank with the suit case ashoulder, stepped on a slick spot, made a wild pass at the lugger's bow line, and sat in the bay. The suitcase remained high and dry on his shoulder, but I had to remove it in order that he might get up without slipping farther. This time he stood sturdily erect at his post. I passed him the suitcase, he tossed it aboard the lugger, and it bounced off. There it was floating. Bob scrambled after it and saved it from a watery grave. I was standing on an eight-inch plank with the rest of the load, and laughing so hard I came very near to going overboard myself. Luck would have the bowline of the

lugger within reach. Finally the cargo was portaged past the gap and we drove back to camp, ate dinner, and hung the wet cargo on the lines to dry.

We had a late dinner and about five o'clock all piled in the car to go to the post office to get the mail. Saw Johnny coming up the lane looking worried but thought nothing of it. Bob and Mrs. Farquhar were in the P. O. getting the mail when Johnny walked in and informed the postmistress that her child had just drowned. The father was behind Johnny and grabbed his wife with a desperate gesture. He was in bathing suit and had come with Johnny from the beach. We had noticed a crowd on the beach on our way to the P. O. but connected nothing serious with it as they were gathered by the "Hope."

The postmistress went almost crazy as they put her in a car and rushed to the beach. We followed and joined the throng. Capt. Hagglove was working calmly over the prostrated form, two doctors were in attendance, the crowd stood around talking in excited whispers. The mother must have left the scene on arrival for I never saw her there. The father remained constantly with a drawn and haggard face. For three hours artificial respiration was rendered then as the sun projected his last dying ray into a crimson sky, the doctor gave up. The limp form was wrapped in a blanket and carried away. The crowd left the beach. In the dusk the waves continued to lap at the sands incessantly.

The child was a Ludwig, a native of the island. Last year when Mrs. Farquhar stayed at the island she stayed at the Ludwig Hotel. She was continually taking Richard (the drowned child) and his brother, Ray, in swimming. They had lived at the hotel, too.

Mrs. Farquhar, being a good friend of the unfortunate people, offered her services and they were accepted. I went along as chauffeur. We changed clothes and had tea at the camp first, then drove to the store. Mrs. Ludwig, daughter-in-law to the old man Ludwig, the child's mother, was at her duties in the post office, assorting and stamping the mail. Mrs. Farquhar went in to comfort her. The mother was very upset but bearing up fairly well. Every now and then she broke down in hysterics and cried and moaned.

I ran several errands and finally ended up at the house of misfortune. The house is near the store and built about five feet from the ground. The wide front steps lead to a screened-in porch that runs the length of the house front. I entered and stood on the porch. Mrs. Farquhar was inside with Mrs. Ludwig. Several natives were gathered on the porch looking in upon the body as it lay in its bed. Inside a group of the native women sat around with long faces and fanned themselves. Once the mother came beside the bed and moaned and took on over the child.

Miss Minnich and her niece, Vivian, came out on the porch, spotted me, and started conversation. I had talked with them earlier at the store about the drowning, etc. That was when Mrs. Farquhar was in the Post Office talking to Mrs. Lud-

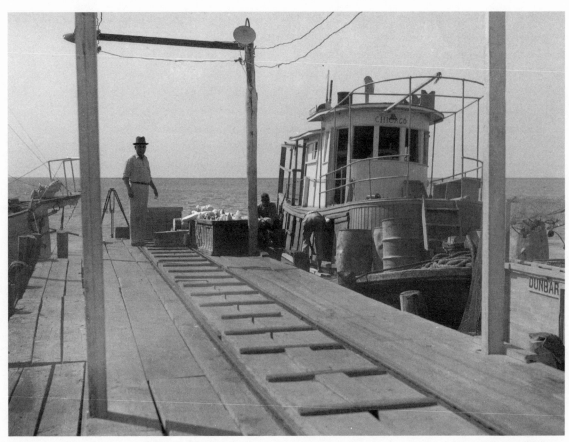

Mailboat *Chicago*

wig. Old man Ludwig, in his characteristic shirt (cross between a shirt and a night gown) and Dr. Englebach sat at a lamp-lit table discussing the drowning and filling out a blank form of some sort. Nolty, the father, stood calmly by supplying information. Durkee, an eccentric little Frenchman that I had met one day in the lanes, walked in and up to Nolty to offer his services as carpenter to make the coffin. Nolty accepted the offer and Durkee said he would get the coffin ready. The body was going to "the city" on the U. S. Mail Boat, Chicago, tonight. It would return by early morning for the mail. Durkee waddled over to us for an exchange of greetings before departing on his mission. He was a couple of sheets to the wind and in telling us of his love for everybody he stated that all people—black, yellow, red or white—were as brothers and sisters to him. We assured him that he was exceptionally broadminded as he left us.

In talking, Miss Minnich (who experienced the '93 hurricane) used the expression: sweated brickbats. I call that some sweating. Bet she had a hell of a headache

afterward. I told her that I wanted to include her in our motion pictures. She seemed flattered and inquired eagerly if her cow Bessie could be in the picture also. It wasn't exactly her cow, as it belonged to her niece, who had twenty of them. In telling me, her niece said, "They are all for me." Translated, that expression means, "They belong to me". Bessie has an unusually large bag in the morning and would I make the pictures before milking because the bag would look so good in the pictures. Bessie has a two gallon per day output. It would be a shame to photograph her with an empty bag. I promised I would as she turned and walked into the house. Vivian and I remained, talking. She was telling me about her trip to New Orleans. She had gone there to have her appendix removed, but at the hospital it was learned that her appendix was giving her no trouble. I said, "Well, what was it, then?" and she answered, "Well, it wasn't my appendix."

As the clock struck 11, Mrs. Farquhar emerged from the death room to inform me that we would take the child and his parents to Milliets Landing, and Jonny, who was also on the porch, and I went inside and removed the body to the car. We carried it in our arms upon its little mattress, then sat in the back seat with the body stretched across our laps. The parents, with their remaining child, got in front. Mrs. Farquhar drove, slowly. At the landing, two of the Chicago's crew assisted with the body. It was placed in the hold and the engine started immediately. The sad parents climbed on board with their luggage and bid us farewell. I drove back, letting Jonney out at Ludwig's and returned to camp. There we found Bob, Don, and Mary [i.e., Marian] on the bed terminating a session in which they had solved the problems of necking—I mean, as to whether necking is proper or not. Their conclusion was negative. Oh, well.—We all turned in immediately.

Thursday, July 13th:

Bob and I were to shoot the scenes of the coast guard drill this morning. The alarm went off on schedule at six-thirty, and as the drill was called for eight, we were there on the beach at that time. No Coast Guard men in sight; so we went to the station where they told us there would be no drill today, as they were still trying to get the Hope off the beach. We returned by the Oleander Hotel and dropped in to look over some of George Izvolski's drawings. We saw George and talked to him for awhile before leaving. Back at camp we lay around for a while and then had breakfast at ten o'clock. After a while Bob and I started for the boat to bail it out and stopped by the barber shop to get a hair cut. I was beginning to get shaggy and a bit leary of the dog catcher.

The boat was full of water again, so this time we bailed her out thoroughly and located several bad leaks while the rest remained a secret of the boat's. One leak in particular gave us a fright. The more we worked to stop it, the worse it leaked, so in desperation, amid a volley of curses, I passed under the boat with a rope to hoist the

"We shave when and where we can"

boat over on its side. This would put the leak out of water where I could work on it. The tide was low and the keel of the boat rested on the oozy mud bottom. I dug my way beneath and emerged on the other side out of breath and covered with mud.

While repairing the hull Bob discovered the boat had been rifled. Four cans of food, a pile of potatoes, a package of pancake flour, our little box of pepper, the "silverware" and butcher knife, and a sack of shotgun and .22 ammunition. The pirate was honorable enough to remove and leave a package of 30.40 shells for which we had no use whatever. Oh yes, he didn't forget our toilet and laundry soap. What did he want with the toilet soap? We're still puzzled.

Found a quarter in the bilge while bailing out. Donated it to the company. By the way, my haircut set me back 35 cents.

On the way back to camp we dropped alongside a native going our way with a bucket of mullet. He carried his casting net over his shoulder. His headgear of straw patched with calico, surmounted his bronzed and handsome features. He was talkative. He told of his rum-running activities before the repeal. He ran a forty-five foot boat to British Honduras and back twice a year. Local liquor put him out of business. It is too easy to get and not hoggishly priced.

At camp we found the bunch leaving for Milliet's to visit the Bells. We remained to eat. Work on the boat has whetted our appetites so we laid to heartily and ate so fast that when we finished we wondered if we had eaten our capacity after all. Bob cleared away the dishes while I did some writing.

The bunch came back after dark and ate their supper. Bob and I weren't hungry. We had already gorged.

Dave and a friend came by to make the final arrangements for the fishing trip tomorrow. They did not stay long. Later in the evening Captain Hagglove of the Coast Guard here and his wife came in at Mrs. Farquhar's request. They live upstairs. Mrs. Hagglove laid her young son on the bed and sat down beside the captain. I showed them my photos then started asking the captain questions about adventures he had encountered since in the services of the government. The captain is not a large man, but stockily built and good looking. He is boyish in a way as he is reddish tanned and sort of, well, he looks like he might blush easily. He was a terror to the rum runners of the great lakes and is known throughout the country as the "Flying Swede". He rarely missed his man.

His adventures are many. Before "joining up" he was a whale hunter. Now he is quietly located here and his most exciting task at present is helping get the "Hope" off of the beach. Time passed swiftly. Mrs. Hagglove yawned and left with the baby. Hagglove continued his entrancing tales. When he slowed down we popped eager questions to hear more adventures. Don had fallen asleep, Marian dozed on his shoulder, Mrs. Farquhar was sleeping on the porch, Dan was sleepy but listening intently, Helen was asleep on one of our pallets, but Bob and I were all ears and wide awake.

The captain looked at his watch and bid us goodnight at 12:00. Everybody turned in then with the knowledge that the alarm would go off at 4:00 to awaken us for an early fishing trip.

Friday, July 14th:

At four o'clock the alarm went off. Dave and his friend drove into the yard at the same time and came in. We made coffee and ate breakfast and were all off (except Dan, who remained to sleep), for the bridge that connects the island to the mainland. The bridge is 7/8ths of a mile long and affords good fishing over the bay.

I took along the movie camera and only made one shot. That was the sunrise. It rose in a veil of leaden clouds and only shone for a little while, it being very cloudy overhead. A strong wind was blowing from the west so we fished mostly on the east side of the bridge.

Don caught a small sting ray right away. But the general run of luck was bad. Helen landed a nice-sized trout. I fished near the center of the bridge and caught three hefty sea cat. They gave me a good struggle. The last fish I hooked threatened to pull me overboard but cut the wire leader instead. Several channel mullet were caught by Dave. We also had another trout.

At 9:13 (according to Dan) we arrived back at the camp and cleaned our prey. Dave and his friend returned to the Vodey to clean up and came back later to assist in the preparation of dinner.

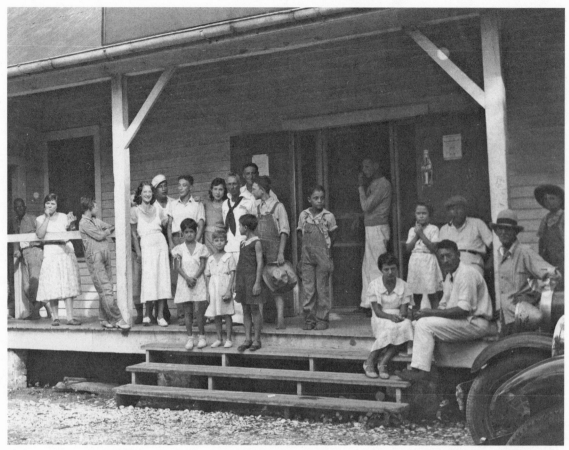

Ludwig's Store and Post Office

The fish feast was enjoyed by all. Then Dave and Clayton (his friend from Lockport) left in Clayton's car. They dropped Bob and I at the head of the Chigazola Lane, as we were on our way to attend to the boat.

She still leaked, the bilge water was almost to the floor, so while Bob manned the bilge pump I repaired the starter cable. To try it out, I started the motor. It started perfectly and to see how she was running we took her out for a spin. When we got back I stripped and lowered myself into the deep ooze beside the boat (the tide was exceptionally low) and started in with the repair work. She had a mysterious leak we couldn't locate. By the elimination method, and after a couple of hours of chilled labor, I finally located the vicinity of the trouble and slowed the leak considerably.

We took inventory of our gas supply and transferred 13 gallons from the drum to the main tank. We have only 29 gallons left. That will afford a cruise range of 116 miles. We'll have to take on some more gas before arriving back at Morgan City, but

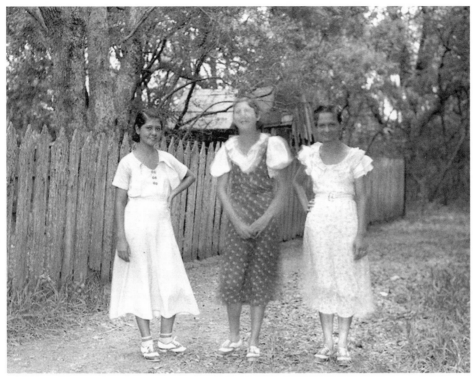

Marian Brashear (New Orleans), Flo Lanier (New Orleans), and Vivian Minnich (Grand Isle)

not so very much more. No pirates have touched us for gas up to date. (Sound of knocking on wood).

Bob went on to the camp while I turned down Ludwig Lane to get the mail. The mail had just arrived and a large number of the island residents were gathered on the porch waiting for the window to open. I waited a long while, talking to Johnny, Marian Brashear (New Orleans), Flo Lanier (New Orleans), and Vivian Minnich, an island girl. Johnny works at the store; the others were there for the same purpose as I. Pretty soon we all got tired of waiting and suggested to Johnny that he go in and get our mail. He did so and I started for the camp. Bob was the only one of our crew to get mail. He had two packages and a letter. The packages contained two pairs of socks and a new pair of uniform pants from the factory. Bob's mother had ordered them for him when she learned that a pair of his had been stolen or blown overboard. We never learned their fate, they just simply disappeared while hanging out to dry. The letter was from his mother bearing news from home.

I was dog-tired from working on the Pintail, so I remained at the camp while the rest of the bunch went for a swim in the gulf. I had some coffee and cake and wrote a while on the typewriter. The bunch returned from the beach at sunset.

Tonight, I went to the dance at the Sea Breeze Pavillion. Incidentally, the music is furnished by the crew of the Chicago which comes to the isle with the mail three times a week. They are absolutely of no account but do manage to make a lot of noise and wet notes. Absolutely sour. Nevertheless I paid my admission, which was 35 cents for the whole evening. The proprietor of the pavillion remembers everyone that pays admission, so does not pin any identification on the dancers. They come and go at will. If any one walks in and dances without paying, he is politely requested to do so after the first dance. The band plays a selection, then the dance ends. They play the same piece again and again the dance ends. Then they repeat, and are through with that particular song for a while.

The mosquitoes gave us quite a time as the pavillion was open and unscreened. They came by the thousands. The native old women chaperones were waving frayed palmetto leaves about their ankles and heads; the dancers would miss a step now and then to bat one of the vampires.

Johnny and Marian B. and Vivian and I went for a walk on the beach for a few minutes to cool off. It was pitch dark there, the waves were murmuring on the shore. When we returned to the hall Miss Minnich came hurrying toward us, saying she had been hunting for Vivian. We told her where we had been and she said to me: "Please be good to me and don't take my niece on the beach any more. You see, her daddy is very particular about her, and Vivian is not a wild girl like those other girls". And she added, "Thank God for that."

Later, while I was dancing with Vivian she asked in her own peculiar way, "How old you is? Nineteen or twenty-one?" I smiled and told her the latter was right, then asked her, "How old you is?". She said sixteen, then added that she would be sixteen in three months. Vivian is a native of the island and loves to dance, as do the rest of the girls on the island. But there is just one thing—I had to limp back to camp.

It was about 11:30 when I returned and everybody had just gone to bed so I followed suit. We boys remained awake for a while, talking and laughing. I was telling them about the dance. I had danced a good deal with Rita, the tall, dark, and handsome Indian girl so I told about her, too. The bunch has been kidding me about her because I like to dance with her.

The bunch dropped by the pavillion for a little while tonight to watch the dancers and I had several dances with Marian Farquhar. She is quite light in my arms and a pleasure to dance with.

On Saturday, July 15th:

Don woke us this morning by serving us coffee in bed. We had a late breakfast then Bob and I sallied forth with the movie equipment to shoot some scenes. Here are the scenes in order:

(1) Setting of Spanish Dagger with Bob walking thru.

(2) Bob walking through tall weeds.

(3) Bloom of the Spanish Dagger.

(4) George Izvolsky, the artist who stays at the island every summer to make sketches and paintings, holding several of his sketches.

(5), (6), and (7) Close-ups of the sketches.

(8) Portrait of Colonel Stevens.

(9) Colonel Stevens at the corner of his home on the dunes.

(10) His house.

(11) A picturesque tree, back of the dunes.

(12) The umbrel tree tops.

(13) A hedge of Spanish Dagger.

We purchased a bar of candy each before returning to camp. Marian was the only one there, the rest being at the beach.

After lunch all of us except Bob drove to the end of the island opposite Fort Livingston. While others busied themselves prowling around, I made a sketch of the Fort. It turned out fairly well; it could have been worse. We returned along the beach near sunset, and passed by the Hope. The Coast Guards have got it jacked up and will soon have it high and dry and ready for repairs.

Mr. Farquhar returned after supper from his work at Leeville, where he is engineering construction of a bridge across Bayou Lafourche.

Two scenes I forgot to mention: A bronzed and picturesque native, big straw hat, shirt open and out, and towsack slung ashoulder. We approached him and asked if we might photograph him as we were making pictures of the island people. He pointed to his watch pocket with a gesture and said, "I got no money." We finally convinced him that we did not expect any munerical compensation and photographed him. He was terribly camera-shy and unnatural.

The other scene was just back of the dunes in the trees.

Tonight found the bunch accumulated in the camp with nothing in particular to do. The dance band at the pavillion had already set up its wild rhythm, and there the population of the island had migrated as was the Saturday night custom. The rhythm got under my skin so I put on a clean shirt (my present one was caked so with whateveryoucallit that I had to bend it off) and announced that the pavillion was my destination. I tried to get the bunch to come along, but all of them, except Marian and her mother, were indisposed. We went there in the car, regardless of the brief distance.

Of course, I couldn't participate in the dancing because I didn't have the necessary seventy five cents. Instead, I contented myself with watching the affair. Marian

danced a lot with various boys and Mrs. Farquhar talked with Mrs. Lanier who was there with her daughter, Flo. Johnny was there, too, dancing mostly with one of the Rigaud girls. They danced beautifully together; I spent most of the time watching just them.

John Cherebonier, a boy I had met in Gretna, was there dancing. I introduced him to Marian and Flo. Rita, the Indian girl, was there. Also, Vivian and her aunt, Miss Minnick. Vivian didn't seem to be dancing.

Lots of the older ladies of the isle sat around the dance batting mosquitoes with their frayed palmetto leaves prepared for the purpose.

When the mosquitos got unbearable, we returned to camp and went to bed.

Sunday, July 16th:

Dan was up before any of us this morning and served the customary round of pre-breakfast coffee. The coffee was not very hot but I couldn't kick; it was good and thick. I say "thick" but I do not mean thick. I have heard so much about the Louisiana coffee that is as thick as sirup but I've never seen any of it, nor have I ever seen anybody that has seen any such thing. It's just exceptionally strong and of unusual flavor, that's all.

After a late breakfast Bob and I went to the boat. Two days had passed since we had bailed her out, so we were not surprised to find her quite full of water. Spent several hours looking for leaks and found some more. Discovered also that our same pirate, or his brother, had made us for several gallons of gas and a roll of adhesive tape. (May his after life be plenty hot!)

Returned to camp at 2:00 and found dinner just ready. Experienced no difficulty in eating.

The dance band was playing a jitney dance at the pavillion so Marian, Mrs. Farquhar, Dan and Helen, and I drove there in the car, the others being indisposed. The dance ended shortly after our arrival so we went to Adam's place and used his radio. I drove back to camp to try to persuade the others to join us and succeeded only in getting Bob. Later in the evening Bob and I took a walk and bought some tobacco.

As night fell we all returned to Adam's and danced some more. Several times when I wasn't dancing I strolled over to the Sea Breeze pavillion and danced some there, trying to persuade some of the girls to come over to Adam's. We needed more girls at Adam's because we had an excess of boys.

Drove to Milliet's to take Dave to his boat, then returned to camp and went to bed.

Monday July 17th:

A heavy rain storm drove us off the sleeping porch in the gray of dawn, and having no place to go back to sleep, went in the kitchen and made coffee. Finally Bob

curled up in a corner in the kitchen and dropped off to sleep, Dan dropped across a pile of blankets, Don stretched out on a cot, and I wrote until broad daylight.

Later in the day the weather cleared. Marian, Don and Mrs. Farquhar went crabbing on the beach and Bob and I remained to write. Later I went to the beach to join them, but they were just getting out so I enjoyed a swim alone. I watched the coast guardsmen working to get the Hope off the beach, then Mrs. Farquhar came by for me in the car and we returned to the camp. She had been talking to Mr. Danziger and learned that he would be interested in having me accompany an excursion to New Orleans. He was taking all the island children between the ages of six and fourteen to see the show at Loews State Theatre where the pictures taken during the Fourth of July here are now showing. The excursion would leave at 5:00 in the morning, carrying 75 children on board the Silver Moon.

After a while Bob and I got in the car and found Danziger at Ludwig's store talking to Mr. Ludwig and Nolty. I explained my call and soon we had the arrangements made. I would go along with all expenses paid, and Bob, Dan, and Don were to accompany me. He had already invited Mrs. Farquhar and the girls but she declined.

Back at the camp I washed out my uniform then ate a dinner of crab gumbo and crabs.

In due time went to the post office. Bob got a letter from home but Don and I got nothing. Was expecting a still camera. Somewhat disappointed. Dan and I were in the car, met Dave and drove him to his boat. Being pretty sure that Don wouldn't accompany us tomorrow, I persuaded Dave to take his place.

Just before sunset we all got in the car and drove to the mainland where Mrs. Farquhar called on a friend of hers. There we watched the sun set over the flaming marshlands, then returned to the camp.

Tuesday, July 18th:

Last night we boys had a great time, cracking jokes and not going to sleep, so Helen, peeved because we were having a hilarious time of it, opened the door and threw a pail of garbage on us. It contained tomatoes with histories, sweet peppers with pasts, and other vegetables that were edible but not palatable. I had suspected the attack and pulled a blanket over my head; Bob rolled off his pallet and under Dan's bed; Dan cowered at the foot of the bed with a sheet held against the onslaught; and Don, taking no stock in her forewarning threat, stopped most of the refuse with his back. I came out of my blanket, about to die laughing, as Don shouldered some of his burden onto me. Well, the stuff stunk, and it wasn't quite so funny. Bob sloughed around and finally managed to lie on a huge tomato that had passed its prime. Dan came out untarnished and laughing so hard he could hardly get his breath.

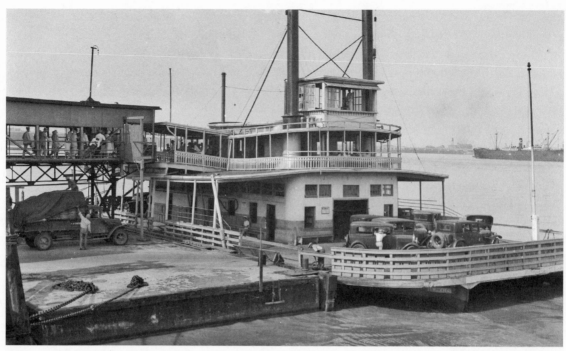

Ferryboat in New Orleans

Pretty soon we got to sleep. At 4:00 A.M. the alarm wrung the slumber from us and we arose to make the trip to New Orleans on the "Silver Moon." Don wasn't going, but he drove us to the landing. We were all aboard and got under way at 5:15.

The sun was rising in majestic splendor over Fort Livingston as we turned northward into Barataria Bay. The water was calm and interrupted only by the schools of frolicking porpoise.

Our pilot, a native old timer, stood supreme at the helm singing snatches of French songs to the group of children gathered around him. His face, a dark bronze gotten from long years of scanning the gulf waters; his hands, toughened and cal-loused from long years of handling ropes and poles; his dress, common dress of the natives, blue duck jacket and pants and instead of the usual battered straw hat, he wore a mussed up campaign hat. The eager children of Grand Isle sang and laughed with him.

As settlements began to appear the children became more talkative and excited. To most of them this was their first experience off of Grand Isle and it was very interesting to watch the expressions on their faces as they were watching a century of progress take place before their eyes.

Every boat we passed they gathered at the rail and cheered long and loud.

At twelve o'clock we arrived at the Harvey Canal locks that give entrance to the

Lowe's Theater, New Orleans

broad Mississippi River. The locks were jammed and the men working on them didn't seem to be in such a sweat to get them open. Well, there we were, tied up with a bunch of children that were scheduled to be at Loew's State Theatre in a little while. Nothing to do but catch the ferry, so Mr. Danziger bought the tickets and thirty six of us crossed over. I made movies of the children getting on the ferry. On the other side we all went in a bus to the theatre.

The name of the show was Gold diggers of 1933. At sometime during the program the pictures made of the bathing review at Grand Isle were projected.

When the picture ended, but not the show, I went with Mr. Danziger to the Eastman Kodak Store where he bought the roll of film to take the place of the one in the camera. Just replenished my film supply, that's all. Mr. Danziger had to leave but I remained to project the two rolls I had shot in New Orleans when we were there. They couldn't have been better, so I returned to the show somewhat at ease to stay out the rest of the program. Comedy was a Zasu Pitts and Thelma Todd production.

Left the theatre on the bus at 4:45 P.M. Before leaving met a Mr. Harrison, President of a movie corporation, who wants to keep in touch with me. He may be a good bet; don't know, but I'll see.

Crossed the river and left on the Silver Moon at 5:30 for Grand Isle. As night fell,

the air grew chilly and all the children collected in the lower cabin and sprawled around. I went on the stern and had a long talk with Dr. Theo. Englebach who has been on the island for thirty five years. He told many interesting things about the natives and the history of the place. I am going to visit him later at his house and learn more about Grand Island.

Late tonight, just out of Dupree Cut, I relieved the pilot and was at the helm for some time, steering the Silver Moon down Barataria Bay. Dave relieved me before we neared the Ft. Livingston light and I got a little nap before landing at Milliet's Landing. Our arrival, or return, to Grand Isle, was clocked at 1:10 am. We got to bed at the camp about an hour later.

Wednesday, July 19th:

This morning I finished the reel of film in the camera for Mr. Danziger.

Went swimming this afternoon. Also, got the mail and bailed out the "Pintail". Incidentally, no mail or packages for me. Been expecting my last supply of film and a 120 still camera.

Met two cute suntanned girls named Patsy and Gladys, respectively. Dave and his sis dropped in tonight. Mr. Farquhar came in from Leeville for the night.

Bob and I been kidding the socks off Don and Mary about their serious puppy love for each other. From what I can see it gets under their skins, too. Oh, well, they shouldn't have done it, especially around me as I love to razz mooneyed calves (that's what they resemble). Otherwise, nothing particular.

Oh, yes, I was about to forget something. Just before noon we all (the bunch) drove down to Milliet's Landing to make movies of a big Sea Bass that had been landed at South West Pass by some people from New Orleans. The bass had already been disposed of so I ran over to the Flying Dutchman to give the skipper and crew a slight visit. They suggested we all go for a sail so I called the bunch and they all climbed on board. Don and I rowed down the bayou to the beacon in the tender and I set up my camera on shore to make a movie of the "Flying Dutchman" as she sailed out.

When we returned aboard we sailed out into the bay, fooled around a bit trying to get movies of the elusive porpoises that were playing in schools near the pass, then sailed slowly around the fort in order that I might get some shots of the ruins. After that we returned to the Landing in Bayou Rigaud.

Thursday, July 20th:

Dan was early dressed and off to the hotel to locate prospective buyers of Grand Isle lots. About 8:30 he returned with news that Mr. Danziger was staging a fishing party into the gulf on board the yatch [yacht], "Silver Moon", and had extended special invitation to the crew of the "Pintail". The object of the fishing trip was sharks. Would we go? You guess.

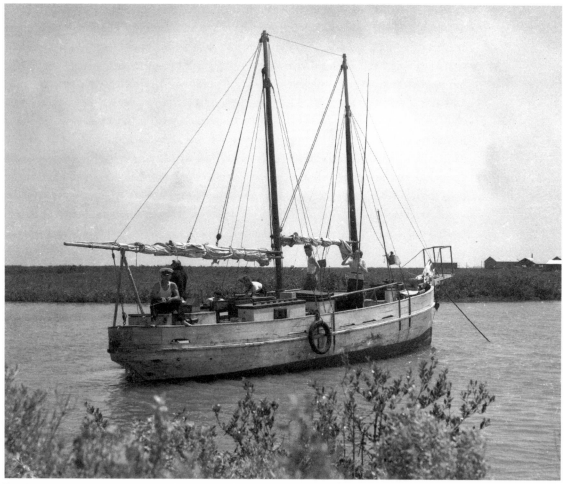

The *Flying Dutchman*

At Danziger's place at 9:00. Finding that the party wasn't leaving for about 45 minutes, Bob and I hurried to the Chighizola Landing to bail the "Pintail" and get my sharking hook, then returned at a dog trot through scattered showers of rain. Most of the crowd, composed of Oleander Hotel guests, gathered in Ludwig Lane and loaded into several sedans. The captain of the coast guard, Capt. Hagglove, was there with his optimistic shark line of heavy sash cord; so was the picturesque Englishman, Colonel Stevens. Bob, Don, Dan, and I went to the landing in a truck piloted by Clarence Frazier, known widely as the "Shark Man". He is a Houma Indian and a very friendly fellow.

At the landing, Mr. Danziger, skeptical of the numerous squalls that darkened the horizons, decided to anchor in the pass and fish 'til the weather cleared a bit. Capt. Hagglove piloted us to the west side of the pass. There we anchored and

everybody got out his lines and set to fishing for redfish, shark, or tarpon. Outside of a couple of "hardheads" and two small shovel nose shark no one caught a thing. Anyway, the boat had a sickening roll in the ocean so we anchored on the other side of the pass and a little way into the gulf. The swells were more sickening here but nobody realized it at the time. Someone caught a baby shark about ten inches and, not counting two or three hardhead, that was all. Most of the guests on board were panicky and pink around the gills. Others were prone on the seats with their heads buried out of sight in pillows or hats. No one had lost their pride yet, so Mrs. Miller, Danziger's sister, urged him to put to port which he did. At the landing about half of the passenger list departed. The rest of us returned to fishing but this time went several miles out into the gulf to the blue green water. Luck was better here. Dan was the first to land a shark. It was about two feet in length. The captain landed one about three feet long, and another fisherman, with rod and reel, bagged two four footers. The sport was exciting but I had no real opportunities to make movies. It seemed that everyone was conspiring to get in my way. It was fun, however, to watch them caught as the water was very clear and we could see the wolves of the sea cruising at the end of their leashes. Once on deck with the help of the gaff the shark man took charge. First he severed the spine just back of the dorsal fin, then cut out the hook. The shark were very vicious and snapped and flopped a lot. A severed spine put a crimp in the flopping. Shark blood was smeared everywhere. A few more people were getting woozy when we pulled anchor and returned to Milliet's landing. The Shark Man let us out at our lane after driving through a down pour of heavy rain and beating it up the road. We had to run for it as the deluge was about to inundate us again, and arrived breathless on the porch as the rain pounded and drove into the earth. The Farquhar's weren't there so Bob crawled through a window and let us in the door. Some time later the rest of the "family" returned. Darkness settled with us still doing nothing in particular. We ate supper which consisted of pancakes, then loafed around for an hour or so before going to bed.

Friday, July 21st:

Before dawn the elements cut loose and drove us inside with blankets stringing out behind. Mrs. Farquhar suggested that we turn on the light to arrange our pallets so I wrapped a blanket around myself and, hoping that the others had done the same, I switched on the light. Marian was awake and between her and Mrs. Far-quhar we had a devil of a time trying to make up the pallets and keep enshrouded in a blanket at the same time. The ordeal was finally accomplished, however, and we all went back to sleep.

When we got up it was rather late and still raining. Don, ever ready to be of service (where ladies are concerned), served everybody their coffee in bed. Which was nice of him, I'd say offhand.

Charles Snodgrass, skipper of the *Flying Dutchman*

I cooked the corn fritters. We had them for breakfast, then drove to Milliet's landing to catch crabs. The surf on the beach being too rough, Bob stayed at the camp to write. It still continued to rain.

After setting the crab lines the bunch took refuge on deck of the "Silver Moon" while I went over to visit the crew of the "Flying Dutchman". Charles Snodgrass, the skipper, and one of his crew were in a stilted shack on shore from their boat, so I climbed the steps and joined them. We scouted the prospects of an expedition to Central America next summer on the "Flying Dutchman". Another thing I wanted to see him about was the use of his boat for the filming of some pirate scenes at the fort. Mr. Danziger and Colonel Stevens have already promised to help recruit native talent for the re-enaction of some Lafitte episodes. The "Flying Dutchman" is a splendid boat to play the part of a pirate ship. The skipper quite agreed and promised his cooperation.

We all had coffee with Dave and his dad on the "Vodey" when they came in from the fort, then later returned to camp with almost half a bushel of crabs. After preparations for dinner were started we all went to the beach for bathing. A heavy sea rolled and we had much fun hitting the high waves as they came over the bar.

There were lots of needle shrimp in the water and caused quite a bit of discomfort when lodged inside the suit in generous numbers.

Bob and I went to the boat to bail her out and found that our old friend the pirate had again been to the boat and made us for the rest of our oil supply which amounted to about three gallons. We were plenty mad and vocally expressed our feelings and regard for him. When that ritual was completed we finished with the boat and drove to Milliet's to pick up Dave and Mr. Bell who were to have dinner with us. After dinner I played my sax awhile for Dave and Marian to dance, then every body but me sat down to games of cards. I busied myself with the typewriter.

Later Bob and I drove Dave and his dad to their boat.

Saturday, July 22nd:

After breakfast, which we had late as usual, Bob and I got in the car to go get the boat ready for a trip to Leeville. That's where Mr. Farquhar is engineering a bridge across Bayou Lafourche. It has been raining to such an extent lately as to put the roads to Grand Isle out of commission; therefore the only remaining communications to the mainland available are boats.

Mr. Farquhar usually comes to the island for the week ends but this time he would be obliged to remain at his camp as far as automobiles are concerned. So Mrs. Farquhar decided upon going for him in the "Pintail".

We stopped at Ludwig's for two quarts of lube then went on down to the Chighizola Landing. She needed bailing as usual then I tried to start the motor. After a little difficulty the motor did start but died quite suddenly a few minutes later. To add to the troubles a part of the carburetor broke. It seemed we would never get the motor started again so Bob left in the car to notify the rest of the engine trouble. And he had a flat on the way. Jammed an oyster shell in the tire.

I continued to sweat and cuss over the engine and finally improvised a piece of carburetor. Bob returned pretty soon and Don with him. Once more I tugged at the crank (starter cable eaten in two again) and the motor started so Bob and Don returned to camp after the others. It was already afternoon when they arrived, then Bob, Don, and Dan returned the car to camp and walked back to the landing. In the meantime I had a devil of a time getting the motor started again so I left it running this time.

We left the dock, bound for Leeville at 3:00 and a few minutes later ran aground trying a short cut into the bay. Running full speed we slid out of the shallow water, turned around and took the longer but more navigable course across the bay. This route was new to me but I used chart and compass and made it O.K. After about an hour in the bay we turned up a bayou and immediately put to port up the S.E. Louisiana Canal that leads straight to Leeville on Bayou Lafourche. An hour and a half put us at our destination.

All the way one of the spark plugs gave plenty of trouble causing us to run on three cylinders most of the time. Mr. Farquhar gave me one out of his ford and soon we started back for Grand Isle. It was six o'clock. The motor ran perfectly now. But later when we were about to enter the bay country again the motor got temperamental once more. Darkness was fast gathering and a high wind was chopping up the surface of the bay. Many low lying islands were scattered about and in the dusk appeared only as dark patches on the horizon. We were taking the short cut back. Mr. Farquhar had been this way before.

Not far progressed into the island dotted bay, the motor failed. Fouled gas line, but after lots of inconvenience and a little loss of time it was again running. The waves were piling high now and spraying over the decks as we plunged ahead on our uncertain course in the last strained light of evening. The stars came out bright and dark wind clouds raced across the sky. I lit the running lights after some difficulty with the wind and placed them. Mr. Farquhar, Bob, and I remained on deck to pilot the boat through the darkness. Mr. Farquhar checked on some familiar lights on land; every now and then I went below to check our course and position with the chart and compass; Bob steered. Our course was E.S.E. Soon we were able to recognize the lights at Milliet's Landing and the lights at the Grand Isle end of the Caminada Bridge. Still we were confused as to our exact location. If we happened to be off course there was danger in running aground in shallow water. And that's exactly what happened. Low tide had caught us to make things worse. The motor got fidgety and would only run a few moments at a time. Ahead we could make out a dark stretch of land and presumed it to be Grand Isle. Nor could we tell how far away it was.

Stranded, dry docked so to speak, in Barataria Bay. 10:00 and eight of us on board; boat leaking like a sieve from listing in the ebbtide. Strong winds from South; a wild night to be grounded and yet in the water! Something must be done.

We three boys stripped to our undies and went over board to tow the boat into deeper water if possible. We strained to the utmost, the boat moved slowly, painfully. Bob was singing the Volga Boatman as we tugged at the bowline, but that didn't seem to help much. The water did not get any deeper. Our motion in the water was lighted brightly by the phosphorous and it appeared that we were wading in green fire. Even the slightest motion set the water to glowing. At last we gave up and put out the anchor to hold the bow into the wind.

Nothing to do now but wait for dawn. But Bob and I elected to find out if we were really off the shore of Grand Isle and set out toward the dark stretch, wading. The running lights were left on for our guidance back to the boat. We waded side by side and due to the glowing phosphorous caused by our plodding we could see each other plainly and looking down we could see the dark outline of our feet surging through the green fire. Now and then a crab scuttled to one side, lighting its

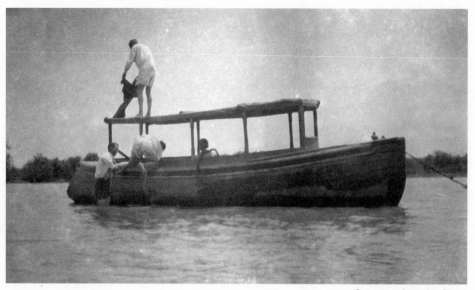

Swimming from the *Pintail*

way plainly with this strange fire. Fish made paths of light past our feet, sometimes striking us and streaking away at an angle. When the shrimp chose to flip themselves from the surface a large patch of water would be set aglow with the greenish light. Watching this weird phenomenon was of unending interest, but soon we tired of wading and sank into the water to our necks to continue our progress by half crawling and half swimming. I looked at Bob. He was sillouetted in his fiery bath and trailing shortly behind was a comet like wake. As for myself, I seemed to be swimming in green fire, the water seemingly foaming with the eerie light, and all about, the water continued to be streaked with fire, the paths of darting denizens of the bay. Once in a while I contacted a crab but it scuttled hurriedly away, not unseen. Looking ahead the dark patch rose to meet us. We struggled through the remaining mud and water and reached shore cold and shivering. I looked back to locate the boat but could see no lights.

After ascertaining that we were on Grand Isle (could hear the ocean surf across the isle and see the dark outline of the trees) we hollered out to the boat for lights to be displayed. In a few moments we detected their flicker and started wading again. After what seemed an eternity the lights grew brighter and we could discern the dark hulk of the "Pintail" a short distance ahead. Again on board, we realized the unfeasability of getting ashore so resignedly made preparations to spend the night.

Mrs. and Mr. Farquhar, Marian, and Helen remained below in the cabin while Bob, Don, Dan, and I arranged ourselves on top and covered up with the sail. The night was chilly and the sail kept off the strong winds.

Sunday, July 23rd:

Tonight Dave and I went to Danziger's for the projector. I wanted to try it out before showing to a crowd tomorrow night. Danziger had gone to the "city," so Mary let me take it.

While Dave drove to the "Vodey" to get his dad, I ran off a reel of film and discovered that the shutter was out of adjustment. But that was soon remedied and when Dave returned we had a show. The captain and his wife dropped in for the second reel. When I put up the machine we all sat around telling yarns until late, then I drove Dave and his dad to their boat. Instead of returning immediately to the camp I drove on up the Oleander Road to Adam's dance pavilion and watched the gaiety for a while.

Back at camp I discovered everybody getting ready for bed, so I did likewise.

Monday, July 24th:

Mr. Farquhar had to meet a boat somewhere up the road this morning so while Bob and Don repaired the spare tire I drove to the "Pintail" and removed the plug he had lent me from his ford. Mrs. Farquhar, Dan, Helen, and Marian went in the car to bring it back. Not that the youngsters were needed, but that the action comes under Mrs. Farquhar's jurisdiction and sagacity as chaperon. "Crip" was to meet Mr. Farquhar where a canal intersects the road and take him the rest of the way to Leeville by water.

Bob, Don, and I ate breakfast, then cleaned up the camp. In due time Mrs. Farquhar, the girls, and Dan returned. After they had breakfast we all prepared to do the laundry and were already at the tubs when Dave walked in with the announcement, "Let's all go get some sharks." We dropped everything, so to speak, and in hardly no time, were at Bayou Rigaud boarding the "Vodey".

This morning the gulf had been a bit rough but now was heaving gentle land swells. The Vodey dipped gracefully onward. About three miles out we dropped anchor, baited the heavy shark lines, and fell waiting for the excitement to begin. An hour passed and nothing happened. Not even a "hardhead" came aboard.

Anyway, the fish weren't biting here so we pulled anchor and moved out three more miles. This time the boat was allowed to drift at will. Still no sharks. Or anything else for that matter.

Mr. Bell went below and fixed us up a nice lunch which was in entire accord under the circumstances. For myself, I was about to pass out, I was so hungry. Marian thought she was hungry but when she looked at her plate of food she let Bob and me split it. Don's enormous appetite was up a stump, too. Mrs. Farquhar and Helen believed they didn't care for a thing. But Bob and I compensated for their indispositions.

Anyway, we caught no sharks and returned to Grand Isle about three o'clock.

Dave came to the camp with us as he had to go after his mail. He and Marian went on after the mail and Bob and I followed, on our way to the "Pintail" to do some bailing. At the post office Bob had a package of cookies from home awaiting him and I had awaiting me the very much expected still camera and films. The films are the four reels that I had already taken on Grande Isle and Grand Terre. That meant a movie show for tonight.

We had the show at the Hotel after much deliberation. It started at 8:30 with quite a crowd in attendance. All the hotel guests and a lot of special guests. The Colonel was one of them. When he appeared on the screen a roaring cheer arose from the audience.

The show was six 100 feet reels long and lasted about 40 minutes. When it was over, I received many congratulations on the success of the pictures, then we all went home and went to bed.

Tuesday, July 25th:

We all went beach combing this morning to pick up the little curiosities that are washed ashore after or during bad weather at sea. The most sought after articles of drift are the lucky beans. About as much in diameter as a quarter and thick as a thimble. They are dull amber with a black band running three quarters of the circumference. When rubbed in the sand for a while they are left with a beautiful velvet lustre. The next sought after object is the sea bean. It is larger than the lucky bean, but not as decorative. They are more numerous. Hunting all morning Bob and I found four lucky beans and nine sea beans. Will use them in our show exhibit.

During the latter part of the hunt I detached myself from the others and made five snapshots. Earlier, I made several movie scenes on the beach. I also photographed a sand crab after much difficulty.

Strangest of sea creatures washed ashore are little fish that bear faint resemblance to chestnuts. About the size of a golf ball when bloated, they are white bellied, gray backed, and marked with dark spots. The head, set slightly above the middle, looks not unlike that of a frog. We found three of this species and took them back to camp in a pan of sea water.

Two were dead; the other appeared as dead for some time, but was finally discovered in a deflated form swimming below the surface. It had assumed a size about one third of its former size. It continually nosed about the side of the pan, waving its two flimsy fins and its two tail fins. Just in front of the side fins are small holes about an eighth of an inch in perpendicular length and half moon shaped. The fins seemed to be circulating water through these gills. When disturbed, the creature would inflate itself and float to the surface. The inflation took place beneath the surface so I suppose the process works like that of a submarine. To

rise, the creature merely allows his air to expand by enlarging his "tanks". To sink, it compresses its air supply, then the movement of the flimsy appendages keeps it below the surface.

It was rather late when we returned and I had intentions of making close-ups of the sea creature, but dull weather and rain did not allow the necessary light for making adequate exposure of the subject, so hoping that the thing would remain alive until tomorrow, I postponed the procedure. It continued to rain all afternoon, sporadically, but by night fall the deluges ceased and only the wind blew.

Had another showing of the movies tonight here at the camp. Johnny came with three girls from the hotel; Patsy and her folks were here; Mrs. Jardet and her sister, summer residents of the isle, attended; also, the captain and his wife from upstairs. When the show was over the captain and his wife remained and we made pull candy, during which he told us more of his adventuresome life as a rum chaser. He has had a very exciting life. Was promoted to captaincy in the coast guard when only twenty years old. Is now twenty nine years of age. Went to sea from Sweden aboard a sea going schooner when at the tender age of fourteen. Has shipped on whalers and had excitement aplenty.

Party broke up pretty late when everybody started yawning.

Wednesday, July 26th:

I made the coffee this morning. It was strong and good as usual but everybody had to "Come and get it". When all the personnel of the camp had arisen and were wide awake, they piled into the car and were off for a swim in the surf. I remained to do some writing.

When they returned, we had breakfast then I took the car to Nolty's to do some repair work on it. Nothing seemed to work out right, so I returned, resolved to do the work at camp with my own spare tools. I set to work and accomplished absolutely nothing. The job was beyond my inadequate tool supply. The clutch and brake are stuck together, the brakes are on the blink, and the car needs greasing.

Rained unusually hard today. Having one exposure left in the camera I made a photo of the downpour, then rigged up a dark room and developed the roll of film. Photos O.K. with one exception. It was over exposed.

Had a late dinner during which Dave and his dad dropped in. Dave, Marian, and I later went to the P.O. No mail for the "Pintail" crew. On returning to camp Bob and I made our way to the "Pintail" to do our duty by the bilge water. Unusually deep this time; four inches over the floor. And in twenty four hours, too. Had the movie and still with us and I made several shots of the sinking sun. We got back as the sun disappeared over the horizon in a bank of rain clouds.

Dave stayed at the camp until late; his dad went to the Vodey early. They are checking out early in the morning to do some fishing around Last Island. Had a late

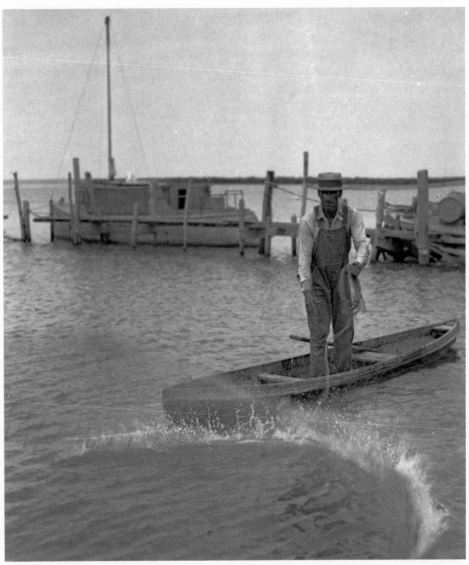

"Net Caster"

supper of batter cakes, then told ghost stories and tried some hypnotism. Incidentally, the latter not so hot.

Thursday, July 27th:
 The day broke in clouds and rain which lasted all day long. Don took the car to Nolty's this morning to be greased. After our late breakfast I went to Nolty's to do the work on the clutch. About 12:00 I had the clutch and the brake fixed. It was raining oceans as I drove back to camp.

I cleaned up then printed some photos. The results are the best to be expected.

Had a late dinner after which Bob and I made our daily pilgrimage to the "Pintail". As usual, water over the floor. Brought back to camp with us our bottle of pickled creatures. Added several species of crabs to the collection. Forgot to mention that we all went bathing in the surf about an hour after dinner. Nothing particular tonight.

Friday, July 28th:

Late breakfast as per usual after which Bob and I set out to accomplish something with the camera equipment. First, we went to the beach where the coast guardsmen were having a drill. A dummy ship's mast is erected on the dunes a little way back from the shore. The guardsmen wheel their apparatus into position about one hundred yards down the sands. There are the cart with the coils of rope, a wooden spiked board for coiling the lead line and a small brass cannon for firing the weight that carries the life line over the ship's "mast".

This interesting maneuver did not last very long so we were soon located at the Chighizola landing. I took several Kodak pictures and shot up about 25 feet of movie film. The movie scenes were of a native casting a net from a pirogue, and of a native driving his horse cart in the water.

We finally wound up at camp about noon and had dinner a little later. Made some more shots in the afternoon and when night fell, I developed three rolls of film. I dried the negatives by immersing them in alcohol and hanging them in front of the electric fans. I'm quite pleased with the success of the pictures.

Saturday, July 29th:

During the night a rattle of tin scared Mrs. Farquhar and she aroused me to investigate. Together we crept into the kitchen and snapped on the light. Just as I peered out of the window something rushed through the grass followed by a clink of iron. Mrs. Farquhar gasped. I stepped out of each of the doors but saw or heard nothing. Mrs. Farquhar went on back to bed and I remained beside the door with the light out, staring intently into the darkness. I had not long to wait for the rattle of tin again occurred and I saw something white move not eight feet in front of me. I'm glad it was a white cat instead of a black one. I stepped out and chased it off. It was trying to get some crab bait out of the bucket and what made things more inconvenient for the night marauder was the fact that strings were attached to the baits and had become entangled with the handle of the bucket.

Dan got up earlier than the rest this morning and served up piping hot coffee in bed. It surely was good. Seems to help one to collect his faculties immediately on arising.

Mrs. Farquhar was all set for going fishing off the bridge this morning. Bob and I intended to stay behind to work on the boat and get some photos made, but just

Seafood processing plants on Bayou Lafourche

as the fishing party was about to pull out for the bridge Nolty Ludwig arrived and asked for me.

One of his guests at the hotel, Mr. E. Constantine, Jr., whom Bob and I rendered a courtesy the other day, desired a way to Golden Meadow for himself and five others. Would I take them there in the "Pintail"? They wanted to leave by ten or eleven A.M. It was eight thirty now.

The proposition required quick thinking. The "Pintail" was not in cruising condition. She was leaking badly, needed new gaskets on the carburetor and the ignition system was on the blink. Also the plugs were here at camp soaking in kerosene and one of them was bad.

We needed the money badly, and it was up to Bob and me to raise it, so I told Nolty that we would drive the folks to Golden Meadow and would be ready by ten o'clock.

And what I mean, we showed up at the hotel at ten o'clock, ready to leave. Of course, we'd been to the "Pintail" working our heads off and had bought one new

Golden Meadow

plug. We had coffee with Nolty in the dining room, then with the passengers and their luggage went in Nolty's truck to the landing. It was 11:00 A.M. when we were off and with the motor missing and spitting something terrible. It kind of got on my nerves and once we got off the course through the bay and dragged mud bottom for several miles. That was in the S.E. part of the bay and in an hour we were going up the canal to Bayou Lafourche. Had to pay canal toll of forty five cents one way. Paid for the return trip at the same time. About three we arrived in Golden Meadow, discharged our passengers, and pocketed the ten dollar fare. All in all, the trip did not cost us over three dollars at the most. The distance from Grand Isle to Golden Meadow is 25 miles. We got some groceries for Mrs. Farquhar before turning back and also something to stuff under our belts. And also a mug of beer apiece, by the way!

Never in all my life have I seen such a concentration of luggers lining the banks of any stream as line the banks of this Bayou Lafourche. All are coated with new paint and look beautifully trim and sea worthy. The shrimping season opens on the

tenth of August, then they will all go forth and trawl day by day, taking their shrimp to the platforms for drying at night.

I think it was about four o'clock when we started back. The motor ran like a purring cat and the fresh head winds were exhilarating. While crossing the bay the sun set in all its glory and we had to find the rest of our way in the dark. The spotlight finally guided us to the Chighizola Landing and after making fast to the wharf, made our way to the camp.

Supper was about to be served so we fell to with all our hearts.

The Silver Moon was due in tonight and as Mr. Danziger was aboard and would want to see the movies, I set up the apparatus at the hotel. After some time it was learned that the Silver Moon was hung on a sand bar off Middle Bank light so I gave the show anyway to an impromptu audience that had gathered. George Izvolski was one of the crowd and greatly admired many of my scenic shots.

Being very tired, I had no trouble in going to sleep when I reached camp.

Sunday, July 30th:

Was second only to Dan this morning in arising and immediately took a bath in the tub which I had placed on top of the outside ice box. I needed a bath badly. I had to unbend the collar off my neck last night.

Very hot today so did nothing much but hang around camp. At two o'clock I showed the films to Mr. Danziger. He was very much pleased with them and is interested in getting me to make him up a film of Grand Isle from the scenes I have obtained. He told me to get in touch with him at the New Orleans Bank Bldg., if I thought I could rig him up such a film. He wants the film for sales purposes.

After our late dinner, Bob and I went to the "Pintail" to find about six inches of water over the floor. What a leak! We'd better hurry up and end this cruise or else we'll be playing "submarine". Water had risen to such a level as to fill the crankcase and force all the oil out into the hull. At sunset we bathed in water from a rain barrel and returned to camp feeling fresh but tired, if you get what I mean. The rest of the bunch had gone fishing off the bridge so we had to pick our way through the back door as the place was all locked up. Bob fell to smoking his pipe while I busied myself with the typewriter.

Monday, July 31st:

Last night the minute insects that come through screens like so many gentle breezes, only they are not so gentle, selected us for landing fields and had an air meet. It takes a magnifying glass to locate the Lillipuction vampires, and not having any handy, it wasn't any trouble either to locate them by finding the place where one might happen to drill. Anyone happening to be watching us in bed, which they shouldn't be, might think we were wrestling (or Wrestling, if you Prefer) with the

Fort Livingston ruins on Grand Terre island, off east end of Grand Isle

blankets. No sooner will one of the insects get through biting you in an inaccessible part of your anatomy, than another will select drilling location at a point distant. That requires rolling over and using the other hand and muttering a phrase peculiar to sailors. The pillow I slept on was a loose feather affair with no slip. The feathers insisted on worming their way out decorating my crown. No wonder tho, for in contesting the night aerialists I was continually butting and burying my head into its softness. This morning when I got up I let out a war whoop. I was looking in a mirror. There I was, head dress and all, an Indian chief.

Anyway, we all ate breakfast, then Marian, Don, Helen and Dan went with Mrs. Farquhar to take Mr. F. to the bridge. Bob and I set out with the movie camera. In the first lane in the wooded section I "shot" several scenes. Namely, two natives with weed cutting apparatus, the baker with an arm load of bread, and a picturesque chicken house.

Farther on we met Dr. Englebach. He posed for a photo then told us what he knew of Ft. Livingston, which isn't much. Information on that particular ruin is very hard to get. The bricks used in the construction were brought around the coast from Mobile, Ala. in schooners. That was in the eighteen forties. The Ft. was in command of General Beauregard.

Then we went on down to the Pintail to bail 'er out. Water was over the floor as usual and being as this was a very hot day we were in a terrible sweat when we

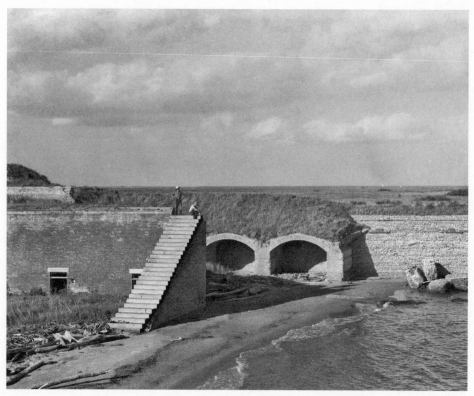

Exploring the ruins of Fort Livingston

finished. To cool off we started the engine and took a short spin into the bay. Back at the dock Bob captured a large fiddler crab and we started for the camp to photograph it. Stopped at Boudreaux's for a soda pop, and finally wound up at camp at 11:30 in another sweat.

The crab objected to being photographed and would not remain in one place so I bored two small holes in a little board and running a piece of black thread through one and down the other, forming a loop, I managed to pass the thread over the crab's body and pull the loop tight. Thereafter he posed very well. Then we put him in our pickle jar.

The rest of the bunch had gone to the beach so we put on our swim suits and followed. Not having any shoes on and wading through baking sand we fairly scorched our feet going up the lane but when we started out across the dunes our feet started smoking. We just couldn't seem to run to the water fast enough and when we reached it our feet sizzled. Never again without shoes.

The gulf was as calm as possible and fairly clear in the surf. When we returned to camp I lay down on the cot on the porch and smoked my pipe. Pretty soon I fell

Fort Livingston ruins

asleep and was awakened later with the call of "Come to dinner" ringing in my ears. I needed no second invitation and at present am hoping I didn't disgrace myself at the table.

Played my sax for a while, for Bob and Marian and Don to dance. That's the way I get out of doing the dishes. Pleasant pastime, that sax tooting.

Received no mail on the boat but Bob got enough to make up for what I didn't get. Four letters from home!! Everything's well. In one of the letters was the society section of the press. Tot's photo with a horse was among the collection of photos on the page. Reading through others of the columns I found mentioned many of the girls I know. Mighty good to get hold of a newspaper, especially one from home. Makes one want to get back.

Don and Dan went to Chighizola Landing to get some bait for a proposed fishing trip off the bridge this evening and found a tough specimen of the crab family. I think someone told me that the creature is referred to as a rock crab. They gave it to Bob and me for our collection. I'd hate for the thing to get aholta my finger. Very murderous looking claws. Bet they could cut nails.

"The Doctor," Dr. Theo Englebach

At six o'clock Bob and I bailed out the "Pintail" and returned to camp in a sweat. The rest had gone fishing, so I fell to writing and Bob to loafing.

When the others returned with a few fish they had hooked from the bridge we had a fish supper. Tasted mighty good, too, as it was some time since we'd eaten.

Tuesday, August 1st:

Some black coffee I had before going to bed last night plus a herd of horses that were always whinnying plus a few mosquitoes and sand flies gave me a slight case of insomnia. But I finally got to sleep and woke up this morning with the puppy whining at the screen. I let her in and she licked all the boy's faces, waking them up.

The captain came down stairs just as we got up from the breakfast table and announced that the Coast Guard was having capsizing drills and we might make movies if we wished. The drill was to be at the Chighizola Landing. Bob and I hurriedly finished dressing and shouldering the equipment, made our way there.

After the drill we rode back to camp with the captain then with the rest of the bunch, went to the beach for crabbing and bathing. Ate some of the crabs on the beach and brought the rest back to camp.

Late in the afternoon Bob and I went to call on Dr. Theo Engelbach. We found

him busy writing but he invited us to have a seat on the porch and that he would join us in a few minutes. As he talked to us after he had temporarily abandoned his writing, he would stop now and then to look after the wants of whatever patients chose to drop around. The first patient had a boil under his left arm, and the next had a sore foot from some reason the patient denied existed.

First, we wanted to know about buried treasure. Some time ago, he related some treasure was found in this vicinity, but it was not on Grand Isle. A fellow that was engaged in the oyster business and lived on a small island in the bay found the treasure near his house. Of course, he kept it quiet for a long time but it finally leaked out. The treasure was a box of Spanish money. Not long ago a man was browsing about on Grand Terre Island and found a few old Spanish coins. Not having the time or implements to investigate at that time he went off and kept the secret closely. After many days had passed he acquired digging tools and returned to Grand Terre with the intention of digging the place up and locating a treasure. But when he arrived there he found instead of the treasure that he had forgotten where he had found the coins, so he had to give up his treasure hunt. Never, repeated the doctor, has treasure been found on Grand Isle. Not long ago, he continued, a native of the isle hinted to him that he knew where treasure was buried. But whether the native ever found any the doctor knows not.

Then we asked about pirates, for which the island was famed. This island was a rendezvous for Lafitte's privateers, but he had other places too. He had a location on Grand Terre. Right over there, and the doctor pointed to a small house in a smother of oleander nearby, is the oldest house on the island. That is where the pirates divided the spoils among themselves. One of the earliest Chighizolas built the place. The method of dividing the spoils is such a one that proves that the pirates were very distrustful of each other. They all sat around the pile of spoils while Lafitte dished out the articles one at a time, continuing around the circle until there was no more left to divide. It wasn't until they saw that everything had been dished out that they were satisfied. After the pirates were gone from the isle their method of division still lingered until not so many years ago. It lingered in the shrimping crews and the doctor himself has even watched the crude division of the profits. He has watched it time and again in Ludwig's store. The shrimping crew gathers around the counter in the store and the captain, with a roll of one dollar bills in his hand, deals the bills out to his men like one dealing cards, and when the men see the roll disappear they are satisfied. Of course, preceding the division, the leader places on the counter a wad of bills announcing it is the expenses and that the rest is to be divided.

The Doctor related an incident in pirate history that occurred a little ways out into the gulf to a pirate chieftain that operated from Cheniere Caminada. His name was Gambio. One of his men, a young fellow, had some spoils coming to him and

with the rest of the crew present he asked Gambio for settlement. Gambio's weakness was a fiery temper so he answered, "I'll settle with you, I'll settle with you all!" His crew didn't like that remark so they rigged up a little plan to rid themselves of him. It was decided that the fellow on the lookout would not announce a ship's presence until they were right upon it. They knew Gambio would be very irritated at this as he was very easily roused up. Then, they reasoned, he would climb the mast and do violence to the lookout man, so they stationed the young fellow at the foot of the mast behind something, with a machete in hand. So when a ship was sighted it was not announced. When they were quite upon the vessel the lookout shouted down that some prey was on hand. This negligence got under Gambio's skin and he started up the mast with drawn dirk. At that moment the young fellow jumped from his hiding place and sliced off the old man's head. With that they tossed his remains overboard and proceeded to man the prey on their own.

Then the doctor got out some of the earliest maps of the island. They were in French and dated as far back as 1782.

It was getting late, and as we had to get to the Pintail, we took our leave. He walked as far as the front gate with us and there bid us, "Aufweidesence."

Mr. Farquhar had come in and let us take the ford to the landing. Water was almost to the floor. We'd bailed her out dry this morning.

Tonight we all took a ride along the beach. The moon shone on the ruffled water of the gulf lighting it like quicksilver. It was a beautiful night, a night for love. I was sitting in the back seat with Dan holding Helen on my port and Don holding Marian to starboard. So there I was. To break the monotony, Bob and I got out and ran down a sand crab for our collection. Of course, we didn't neglect a little razzing now and then. The lover sets looked so forlorn. This was Don's last night on the island, and with Marian, and he needed special attention. He got it, from me! If wishes came true I suppose I would have died.

Wednesday, August 3rd:

Today we got up early and began to prepare to cruise on the Pintail again. About 7:30 we had all our stuff in a pile on the porch. Bob and I drove to the landing to bail out the boat before loading her up. A high wind was blowing in from the gulf and the tide was high, much higher than usual. The shell road leading out across the marshy rear part of the island to the landing was completely submerged. Sometimes the water surged over the running boards. The bilge water in the boat was just to the floor and it didn't take us long to bail her out.

After breakfast we loaded all the stuff in the car and Dan went with us to the Pintail to help load her and to drive the car back. Don was to drive the rest up to Leeville, where we would all have dinner together, then join us on the Pintail.

I made a couple of movie shots of Bob loading up then we pulled out, heading

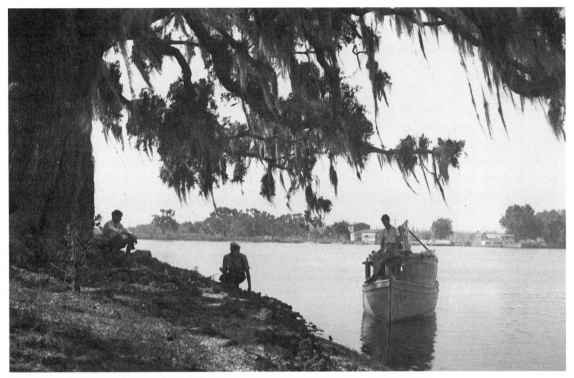

The *Pintail* anchored near shore on Bayou Lafourche

into Barataria Bay on the short cut. High tide would enable us to get through. The bay was pretty rough, but the wind was with us and we made good time. In the canal we put up the sail and with the motor, too, made excellent time and soon arrived at Leeville. The bunch hadn't arrived from Grand Isle yet and when we told Mr. Farquhar their plans he was certain they were stuck in the quicksand of the beach which served as the only road from the bridge to the inhabited part of the island. Decided that the only thing to do was to get in his ford and run to Grand Isle to find out why they had not yet arrived. We sat at the table to get a bite to eat before starting. While we were engaged in this pleasant past time the Grand Islanders arrived intact. Everybody ate then we three took off on the Pintail after many adieus.

At Golden Meadow we took on gas and grub and continued on up Bayou Lafourche, running, now and then, through showers of rain. All the way up evidences of the opening of the shrimping season were to be seen. All the ways were occupied with luggers being overhauled, and the banks of the bayou were lined with the newly painted boats, ready to go shrimping on the morrow in the gulf.

In going up the historic Bayou Lafourche we were able to witness the blend of

the trembling prairie into the forested swamplands. But the banks were so thickly populated that this change occurred some distance beyond the banks. And, too, the ground got higher and more solid. At Larose we reached Lockport. Darkness and mosquitoes caught almost to Lockport. Ahead we watched the sun set in a blazing sky while our wake was rippled with the silver moon. Bob and I rigged up the mosquito bar on top and a little while later, just as visibility was passing, we landed at the sugar wharf and tied up for the night. Inside the net we ate our supper. It was of coffee cake, peaches, and boiled ham that Mrs. Farquhar had donated. Water was the drink.

Thursday, August 4th:

Knowing that the boat would be leaking pretty bad as a result of an all day's travel I slept lightly that I might bail her during the night. It was about 12:00 that I pushed back the hatch, and reaching down to the pump, bailed for about 15 minutes. At one o'clock Bob went onto the back deck and finished bailing. Bailing from the top by reaching through the hatchway let in too many mosquitoes.

A little while after sun up I set the movie camera up on the high bank and "shot" Bob as he crawled through the hatch from the mosquito bar on top.

We weren't far from Lockport and were soon there. Bob went ashore to mail two letters for me and to get some eating utensils. At Grand Isle, the fellow (meaning Pirate) that raided the boat hadn't neglected to carry off all our silverware. The kind and considerate soul left us a fork, however. The hour was too early so Bob didn't get any hardware.

I made coffee and we finished up the coffee cakes and ham. That was our breakfast. We must have spent an hour at Lockport, then we turned out of Bayou Lafourche, forced our way through a blanket of water hyacinth while a pontoon bridge was floating open, passed through and were on our way down another populated waterway. At Houma, we passed through another floating bridge and entered Bayou Black. A heavy wind sprang up and rain started so we closed up the curtains and windows. Then the flexible pump connection tore loose and we had to anchor while I fixed it with a piece of steam hose.

Soon as we were started again the weather cleared, leaving the fresh breezes to blow through the warm sunshine. Castles of cumulus were piled everywhere in the blue sky. What a day!

We had gotten so much sunshine on our backs yesterday that shade was preferable today. This morning I rigged up the sail as an awning and all day long we enjoyed the most luxurious travel.

Two miles out of Houma we came to a fork in the waterway and asked a Negro in a pirogue which was the way to Morgan City. He pointed to the left. For about eight miles the way led through a variation of swamp and marsh that wasn't at all familiar. Then we arrived at a pontoon bridge and asked the attendant if this was

the way to Morgan City. He nodded so we passed through and continued, but for only a very short distance. A bank of hyacinth had piled against the bridge and when we drove through them a bale of them collected on the propeller. That slowed the boat down to such a degree that the hyacinth would have to be removed. This is accomplished by diving over board and tearing them off by hand or knife. Usually the hand suffices.

The swamps vanished to a bluish blot on the horizon as we kept straight ahead on this canal through the marsh. On either side was nothing but tall waving grasses and sometimes solid fields of cattails. The country was strange to us. We didn't remember coming this way. The way we'd come had been thickly populated. And we hadn't seen a house for hours. After some time we passed through a small lake with a row of piling to mark the channel and just beyond were two boats tied in the entrance of a hyacinth chocked bayou. We asked the fisherman if this was the way to Morgan City and he nodded in the affirmative.

We found we were headed out into a long narrow lake with the channel marked plainly with tall sticks. The lake was wooded on the shore and of a very swampy nature. By checking on compass and chart we discovered we were in Lake Wallace and on the new intracoastal route that had only been opened about two weeks ago. With minds at ease we soon turned from the Lake and entered Bayou Cocodrie and latter were in very familiar territory. Morgan City was not far away now.

At 4:40 we pulled into Morgan City at the Gulf Gas Dock.

After shower and shave, we bought some bread, ham, and pickles and had a picnic in the park. Bought candy to complete the meal, then went to Breaux's to inspect our "T" Model. Mr. [Breaux] was there and glad to find that our trip had met with success. To celebrate our return he outs with three bottles of delicious wine and with the help of his two sons and daughter we promptly killed them.

When we go back to the boat, we are feeling at peace with the world. By the way, the ford appeared as usual only somebody had lifted the two spares.

Tonight we rigged up the mosquito net on the dock and slept on pallets within its confines.

Note: Left Golden Meadow with eighteen gallons of gas in the main tank and without adding any, arrived at Morgan City with five gallons left.

Friday, August 5th:
Slept none too good on the cypress planking last night. Got up early and bailed out the boat. Found ants in the sugar and proceeded to eradicate them. Then I wrote awhile. When Bob and Don got up I went to town to get something to fix for breakfast. I bought bacon, eggs, bread, and renewed our "silver ware" supply. After breakfast, while we were cleaning up, a man fishing crabs off the dock caught the largest crab that had ever been seen by a number of men on the dock at the time. Figuring that the crab would look good on exhibition back home I gave the fellow a

nickel for it, then set to wondering how on earth it could be preserved. Letting the matter rest for the time being, Bob and I struck out for town to make some friendly connections.

Mr. Burquist had hung a sign on his door to the effect, "Be back in a few minutes." At the Post Office we talked to Mr. Palmer who seemed very glad to see us, then after a while we returned to the express office where Mr. Burquist is agent. He was very glad to see us, too, and was beginning to wonder if we were ever coming back. We talked a long time about photography and made arrangements to print up all my negatives.

Next we called on Mr. Mead to see what was what about the oyster industry on the coast and what could be done about photographing it. Mr. Mead seemed to think it would be a waste of time going down there as every thing was at a standstill and it would be hard to get apparatus in motion. Still, if we wished, he would send us down on the mail boat "Flying Cloud" to obtain the necessary shots. The other plan I had pondered on if the photographing of the oyster business wasn't feasible, was to go into the interior of the swamp back of Morgan City and photograph its jungle and the primitive existence of the Cajuns in there. It would make a very interesting addition to the film. So on Mr. Mead's advice, we decided on the swamp filming. Next year Mr. Mead hopes to have the momentum up on the oyster business to such an extent that we could secure the most modern of oyster farming on our films.

Taking our leave of Mr. Mead, we returned to the boat for all our exposed films then went to the post office and mailed them, some home and some to the processing station in Kansas City.

Back at the boat I started making up batter for pancakes while Bob and Don went for ice. In the meantime our box of groceries that we'd ordered from the store arrived. When they returned we enjoyed many large pancakes.

After dinner Bob and I took some tools and set out to get our ford in running order. The first thing we discovered was that the battery was dead so I used Ira Breaux's bike to go get the boat battery. Late in the afternoon after locating many short circuits, bad plugs, coils, etc., we had the thing running and drove it down to the dock. It was still missing so I took it out for a run but didn't have much luck tuning her up. I was all messy and greasy and took a shower bath on returning, then Bob and I took my developing outfit and struck out for Mr. Burquist's house. He had gone to band practice so we left the apparatus and returned to the boat and went to bed on the cypress planks again.

Saturday, August 6th:
We had bacon and eggs this morning. I don't know when I've enjoyed bacon and eggs so much. After breakfast I tinkered with the ford engine and rewired

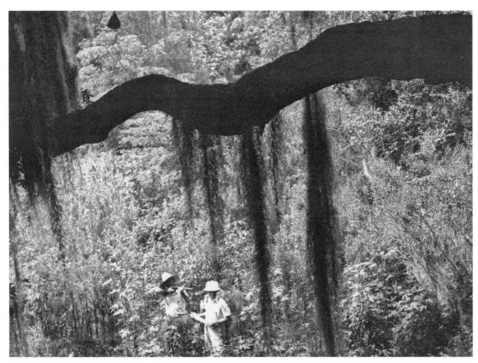

Morgan City swamps

the timer, then took her for a short run out on the highway back of town. Back at the dock I took a swim and followed up with a refreshing shower. After a dinner of canned lima beans and ice cold lemonade, Bob and I went in the ford to town to see Mr. Burquist about printing the pictures. We met him on the street near his office and agreed on tonight to develop the prints. We also mailed the roll of movie film I'd finished up this morning on loading of dried moss from a barge to a truck. Then having nothing else to do we drove out the highway to Bayou Ramos, about four miles back of town. We drove back to Greenwood, one mile, where I introduced Bob to Mr. John Greenwood and his son, Claud, friends of mine of two year's standing. They told us of a way we might walk back into the Ramos swamps if we cared to see the wild jungle scenery so we went back to Bayou Ramos and took to an almost obliterated path along its east bank. The way was jungly enough, our progress being slow and frequently impeded by canopies of moss, palmetto clumps, and entangling spider nets. The webs are of a very beautiful spider. The spider itself is very large; sometimes as much as three and a half inches spread out, and are russet gold, red and black in color. They weave a very intricate web of about a two foot spread, and golden in color. The threads are unusually strong and can be heard tearing when brushed aside with a stick.

Fonville with camera

The ground was swampy and in one place, in trying to walk along a fallen tree, my foot slipped and got soused. I caught three large gumbo grass hoppers that were black as coal, and wrapping them up in a hanky, put them in my pocket for the collection. We came finally to a bayou emanating from the Ramos and cutting our path. So being unable to cross the scummy stream without wading or swimming, we turned back along the way we had come, and were soon ambulating in the ford. We crossed the Ramos bridge that father had built two years ago using me as one of his carpenters, and explored an old dilapidated house nearby under a smother of oak and moss. Satisfied, we drove over to the mansion on Avoca island and continued our explorations and after a while, returned to the Gulf dock. Don, a bunch of Morgan City boys were in swimming. I shaved then busied myself with the typewriter a while.

Bob bargained with a negro man, who happened to be passing in a skiff, for a mess of fish for our supper. The fellow returned later with the fish. Seven medium size catfish for a dime! Not bad at all.

After supper we sat around and talked awhile then all went swimming. At seven o'clock Bob and I left in the ford for Mr. Burquist's house to develop photographs. Most of my Grand Isle negatives proved to be very dense but we managed to get some very satisfactory prints from them. Left the prints at his house to dry and returned to the dock after purchasing a hunk of candy each. The bright silver moon was riding high in the cloudless night and seemed to fill the air with a ghostly phosphorescence. Scattered islands of the water hyacinth were on their way down with the tide, passing in dark silhouette. The night was calm and the water glassy and in the lurid light the first giant span of the Atchafalaya Bridge that towered above the sleeping town of Berwick stood out stark against the sky and was duplicated on the water's surface. We just couldn't turn in so early on such an incomparable night. So we struck out for town, walking. Bought a dozen bananas and ended up in the park sitting in swings, eating them. Tried all the playground apparatus before starting for the boat. Had most fun on the giant slides.

On way to the boat we were passing under the land span of the giant automobile bridge and Bob suggested mounting to the top and giving the country the once over, which we did. Stayed about five minutes and finally got to the dock. Still the night remained silvery, so we sat atop the Pintail trying to think up something else to do and having no luck, decided to go for a swim a la nude, which we did. Did not stay in long. Took a shower before crawling under the mosquito bar for the night.

Sunday, August 6th:
I got up rather early this morning and busied myself with the typewriter for some time. Then I started the coffee and Don got up to set out the crab lines. Pretty soon Bob got up and we all had coffee then started catching crabs which were to be

our breakfast. It was 11:00 when we sat down to a breakfast of crab gravy, bread and some more of the inevitable drip coffee which we have become accustomed to.

Pretty soon it started one of those torrential downpours of rain which are frequent in this country so there was nothing to do but sit around on the dock and watch the cloudburst pound on the river. Bob went in the boat and started writing, then I got in the letter writing mood and followed suit, writing to Tot. When the rain let down, Don and I went to town in search of bread and wieners. The wieners, I bought at the Hub Beer Garden after much harangue with the proprietor, and the bread, well, after visiting every restaurant and drug store in town, I ran upon a loaf at the Costello Hotel for a dime. Back at the boat I prepared our Sunday dinner, sauerkraut and wiener and lemonade. When the dishes were washed we talked and smoked for a while and during the rest of the afternoon went in swimming at intervals. A gang of wharf urchins insisted on hanging around most of the day. They swam most of the time but in their spare moments contented themselves with snooping about the boat and prying into some of our stuff on the dock.

Just before dark, I trimmed down a two by four that I had picked up at the bridge the other day in order that we might enjoy the luxury of the canvas bunks once more. Anything but the hard cypress dock. Then we put up the bunks and spread the blankets. Bob went on to bed and Don and I struck out for town to find some excitement. We stopped at the stand at the ferry landing, bought eight bananas and a piece of cake, and proceeded to eat while engaging in erstwhile conversation with the proprietor.

It seemed he had been a school teacher for years, had dabbled in oil, and was only running the stand to fight the depression. He inquired about our filming activities and when I started relating the fine times we were having filming the country he pricked up his ears with intense interest. Nothing would suit him better, he said, than to join on such an enterprise, as he knew all the principals in the state and would have no trouble in booking the La. schools. As we left he said he would drop around to the boat to talk with us tomorrow.

In passing a drug store Andy Boudreaux joined us in our jaunt about town. At the station a train had just pulled in and many people were boarding for an excursion to New Orleans. Quite a large crowd was on hand to watch the train pull out.

In the park we dropped onto a bench and fell to talking. That was before we knew Andy's last name. He was telling about the time the weather got rough in the Atchafalaya when he was out in his pirogue, and being unable to handle the craft, was blown up the river and landed at "Boudreaux's". Then we mentioned how every body and his dog in this country was by name of Boudreaux to which he answered that happened to be his name. We all had a good laugh then and started talking about Gretna where he had gone to school. We knew several girls there but he did not remember them. The only girl he remembered was Lena Boudreaux! There it

was again. Take all the Boudreaux's out of Louisiana and where would you be. Yes, where would you be? You guess.

Some girls were walking down the side of the park, arm in arm, and I noticed the tallest of them was more attractive. I asked Andy if he knew her and he answered, "Yes, her name is Mamie Boudreaux". With that we bid Andy goodnight and left, dropped by a drugstore to get Bob a piece of candy, and returned to the boat. We each took a shower before turning in.

Monday, August 7th:

While breakfast was in progress, Louis Whatsisname, newly appointed local correspondent for the Times Picayune, came down to the boat for a write up about our expedition.

After breakfast Don and Bob took the pan off the ford and proceeded, through dirt and grease, to tighten a few loose bearings and I, after spraining and bruising a couple of fingers with an enlarged wrench, managed to extract the spark plugs and overhaul them. When all tuning was completed Bob and I took the lizzie for a short run to see if she ran any better. A slight knock was still to be heard from the engine room and the plugs took turns in firing. Oh, well, she moved, and if she can just move another 600 miles we'll be satisfied.

Returning to the dock we took showers and cleaned up in general and went to the post office for mail. I received the film from the Camera Shop. Bob got a letter from Janey Lou, and Don (won't he waltz on clouds!) got a message from Grande Isle. You don't have to guess the sender. While opening the film from the Camera Shop, I discovered a letter pasted on the back side of the package. It contained a short note from the Camera Shop and enclosed two news clippings. One was a short item from the afternoon paper stating that two Ft. Worth boys accompanied by a Marshall boy were spending the summer cruising the La. coast. The other was the whole front page of the second section of the morning paper. And in a prominent place was a two column cut of the photo I had sent in and a very nice write up. Thanks to John Burns and the Camera Shop.

For dinner today, we enjoyed a mess of cat fish that we had bought this morning for a dime. After the dishes were cleaned, Andy Boudreaux and I went into town where I purchased a few groceries in lieu of moving out to the Ramos this afternoon. We dropped by his house to pick up his pirogue which he had kindly offered to lend to the company for convenience in shooting some scenes in the swamps, and returned to the dock. At two thirty we were under way in the face of an oncoming combination of driving wind and slashing rain. Heading up the Bayou Boeuf the deluge thickened to the point that visibility was limited. The engine missed a couple of times and putting Bob at the helm I went below to look her over. When I came on deck again I saw we were headed down Bayou Chaver and

taking the wheel, swung around and returned to Bayou Boeuf. The rain had been so foggy that Bob, being unfamiliar with the course anyway, and not being able to see the Avoca Bridge ahead, had turned off the course without knowing.

Pretty far up Bayou Boeuf the rain ceased altogether then we turned, and, passing beneath the highway and railroad bridges, rammed into the hyacinth pack of Bayou Ramos. The typical jungle water way and penetrator of somber swampland. The hyacinth jam slowed the Pintail almost to a dead stop but Don and I, with oar and gaff pole or pike, hacked a crude path through the mass. Bob remained at the helm. Once in the open water of the bayou I went overboard to clear the prop and water intake, then taking to the pirogue I paddled ahead to scout the possibilities of photographing the Pintail. Then Bob and Don brought the boat on up to where I was. I climbed aboard and loaded the movie camera after which I started the motor and we continued up the narrowing waterway.

Pretty soon the banks closed in on us and we were passing through a veritable tunnel of lush vegetation. Then we arrived at the head of the Ramos where it enters the broad waters of Lake Paloudre. There, just back of the cypress lined lake shore, lies the small settlement of two Cajun families. I had made their acquaintance two years ago when Father was building the Ramos bridge and had visited them many times since. On last year's expedition I had included this place in filming "Cruise of the Pintail."

So here I was again, to film some more of this primitive place. We were talking with one of the boys when his dad, Mr. "Rushard" Richard oared in from the lake to greet us. He was going back out again to run his trot line so I accompanied him. Some distance from shore we arrived at a stick with a palmetto fan attached. The line began here. As he went along the line he related to me the many things that had happened since last I was here. For one thing his wife had died. Then during a storm on the lake his motor boat was almost beat to pieces and he came very near sinking before reaching shore. I was sitting between the oars and he on the prow, baiting the empty hooks with clams. They get the clams from the lake bottom. Once in a while the line was felt to be jerking. That meant fish. The first one was a rather large catfish. Garfish had put rakish cuts along the body. Sometimes the gars take the fish altogether. He emitted a curse for their clan and continued. Several more large fish were caught before arriving at the line's end, then I rowed the craft back to the settlement. The way of propelling these skiffs is peculiar to this neck of the woods. I had learned the way, after a fashion, during an alligator hunt two years ago with the same fellow. It is accomplished by standing behind the elevated oar handles and swaying back and forth with a funny twist of the handles and a downward push.

At sunset, while Bob and Don were rigging up the hammocks, I paddled in the pirogue to the edge of the lake. The water was glassy and the air still. Gaunt cypress

"Papa's Pride"

stood in dark silhouette against the glowing sky. As the sun shot his last rays into the darkening blue I returned into the Ramos.

Tuesday, August 8th:

During the wee hours our slumbers aboard the Pintail were interrupted by a splashing commotion in the water. Thinking it was caused by the big 'gator the boys had been telling about, I sat up, tense and listening. The natives rushed from their huts and collected on the bayou side, talking excitedly and pointing to a dark object which floated or swam away with the current. One of the fellows had a gun which I could hear click as he shoved a shell in the chamber. Another whispered excitedly to shoot but the gun bearer refrained stating that he must first know the nature of his target. In the meantime, I was peering intently outside, watching the stolid group mill about in the shafts of moonlight that penetrated the jungle's canopy, and expecting any moment to hear the roar of the gun and a shout that an alligator had been bagged. Much to my disappointment the discovery was made that their motor boat had sunk and after all there was no use for a shot gun. The object that floated

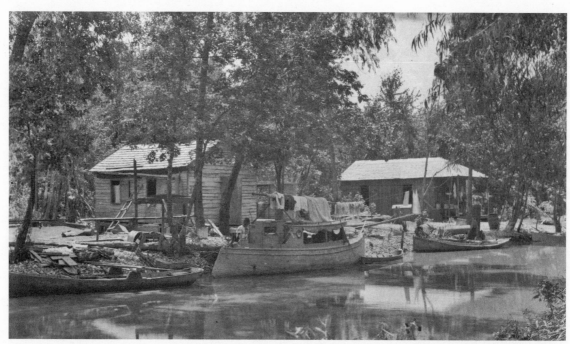

Lake Palourde settlement, north of Morgan City. The village was accessible only by boat.

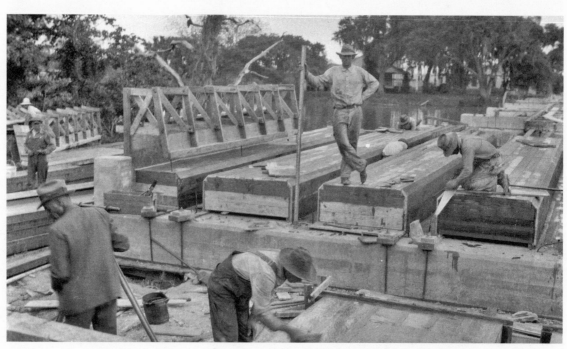

Bayou Ramos bridge. This is the bridge built by Fonville's father, Lawrence Winans.

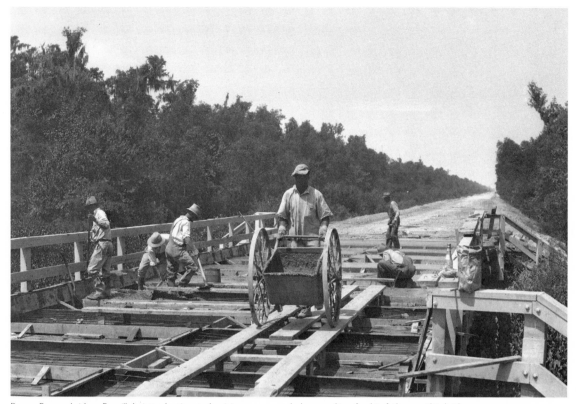
Bayou Ramos bridge. Fonville's introduction to Louisiana was as a helper working for his father on this bridge.

away with the current was something that had been aboard the boat. So they set to with ropes and other apparatus, while I grunted and went back to sleep, and got the boat from the inky water and put her high and dry ashore.

The natives were up early and about the place with their different chores. We slept rather late as the light wouldn't be good for photography until about 9:00. When we did get up the natives, that is, several of them, were gathered around a large pile of clams that they had gathered from the lake bottom, and were engaged in opening them. They use the clams for fish bait.

For breakfast I prepared some large pancakes which we washed down with thick drip coffee. After that pleasant process was completed, Bob and I planned the scenario for the day's shooting. Then about 9:00, we staged the first scene. A native boy manipulated a pirogue and Bob and Don, watching the delicate maneuvers enviously from the bank, decide to try their skill. They go and end up by overturning in midstream. For the next scene we got two native boys to gather moss from the cypress trees in the lake in the customary manner of pulling down the tresses and filling the tied boat below. Then they paddled ashore and hung the moss on lines

Two boys in pirogue

to dry. Next Bob and I boarded the skiff and the two boys, the pirogue, and we all set out down the narrow bayou to where was some typical jungle scenery. There we filmed the boys as they paddled among the hyacinth and flowing curtains of moss. Once they see an alligator (supposedly) and point excitedly.

Then after filming the opening of more clams we were ready to take out. I paddled ahead in the pirogue and locating the camera in the pirogue I had pulled over some reeds on shore, I whistled for the Pintail to cruise on down into sight. This was to secure some shots of the boat under way through tropical grandeur. I had to wait for some time but finally the Pintail hove in sight around a bend and I started cranking the camera. They had the native boys aboard with the boy's skiff in tow. I made a few shots from the skiff before the boys left us then farther down the stream we dropped anchor and went ashore in the pirogue to a beautiful setting of moss and palmetto. While filming here a squall of rain came up and we beat a hasty retreat to the boat. Arriving at the turn of the bayou that gives straightaway to the RR bridge and Bayou Boeuf, we found that our way was blocked by a tight jam of water hyacinth that had been wedged against the bridge by the reversed current or the out flow of the tide. Nothing to do but labor our way through so I put the motor at full speed and our momentum carried us well into the green mass. The hyacinth reached to the cabin so we were half buried in the vegetation. I operated the motor while Bob and Don hacked away at the mass with oar and pike, but frequently I

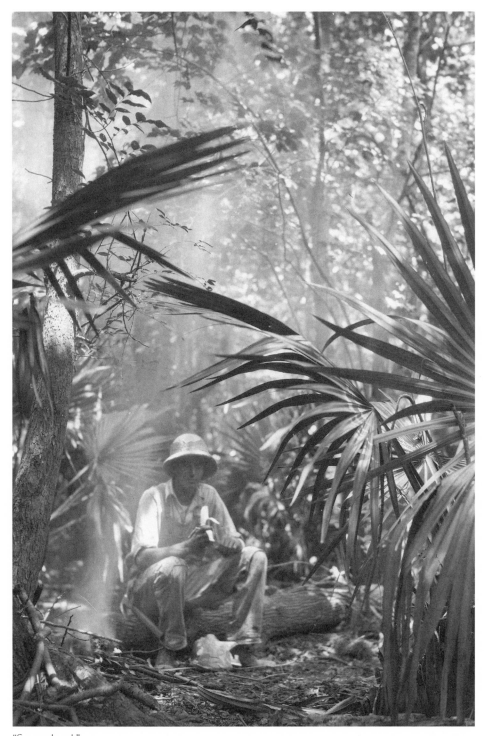

"Swamp Lunch"

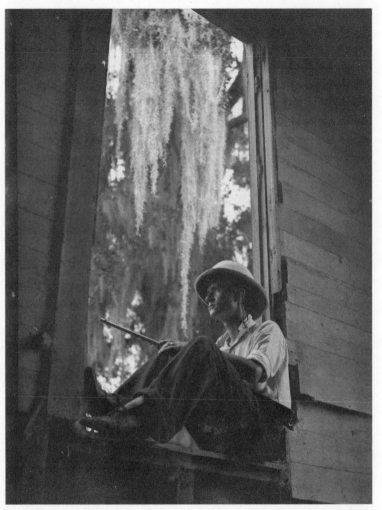

Old house, Avoca Island

had to stop it and go overboard to remove the bale of hyacinth from the propeller. When almost to the bridge, I, with camera equipment, loaded into the pirogue, and stretching out on the bow of the frail craft, proceeded to part my way through to the bridge. From a point of vantage beneath the bridge, I filmed the labors of the Pintail in getting through the hyacinth jam. Some work, getting a boat through that blockade.

We steered to the opposite bank of the Boeuf and tied up at Avoca Island where we immediately ate lunch. Then we went ashore to take a few stills. It was necessary to wade through the entangled swamp to get to the higher ground beyond where the weed grown and crumbling old houses are located. Just back of one of the houses we made several "stills" among a confusion of moss and palmetto then

Wagon on Avoca Island

returned through the swamp to the boat. Returning to the dock past Morgan City I passed slowly next to the ferry landing and Bob showed up at the dock empty handed so we went on over to Mr. Breaux's to make final arrangements concerning the Pintail to be left in his care. He was in his bath. Mrs. Breaux suggested that the mail hadn't yet been assorted so in rising hope we set out for the post office. I spotted Louie so while Bob continued to the P. O. I went to get the negative I had lent him. He showed me the write up he had sent in to the Times Picayune about us. There wasn't much to the article but it stated the object of our expedition. When Bob returned with the expected mail we bought a Picayune in order to have the clipping, then returned to Breaux's house. He had finished his bath and on learning that we were leaving on the morrow he produced two bottles of his very potent wine to wish us a good trip back. After settling the winter fate of the Pintail, and doing excellently by the wine, we bid Mr. Breaux and his family goodbye and set out in a dizzy lumber down the street. Boy, that juice packed a wallop! Pardon me, the wine must have packed a wallop, for instead of our walking to the dock, Mr. Breaux drove us there in his car.

As the sun set in a fiery mass of clouds over the sluggish Atchafalaya, the Pintail left the dock and steered to mid river, then turning off course crossed the glittering

"Avoca Island Homestead"

path of the sinking orb. Just for a moment she seemed to hesitate in a sharp silhouette then passed on across the silvery surface beyond. I was cranking away at the camera on the dock. Then when I stopped she made several more streaks across the sun before returning to the dock. Bob and Don had manned her so in order that they might have their last sight of the boat cruising in sunset waters. I put the boat through her paces for their especial benefit. The Pintail is really beautiful and good to look at when cruising in silhouette at sundown.

Having no grub on board tonight we got expansive and wound our way to the ferry stand. There we splurged on hamburgers and milk, the whole of which set us back 55 cents. I showed the proprietor, who had shown great interest in the project, the photographs I happened to have aboard the Pintail. Bob and Don wandered off somewhere in town. Later they returned and we went to the boat to go to bed. But it was rather hot and uncomfortable in the bunks and as Bob and I were talkative (much to Don's disgust) and not at all sleepy, we went pirogueing out onto the broad Atchafalaya. I paddled the craft some distance against the strong tide, then Bob paddled her farther. I was lying in the bow staring up at the brilliant sky and moon when a large garfish struck the pirogue tipping it for a second at a terrifying

angle to ship a little water. That was some scare though we had heard of no authentic report on the viciousness of the murderous looking fish. The Cajun on Bayou Ramos had related to us several incidents when a gar had inflicted ghastly wounds but we paid the tales no attention otherwise than curious.

Now we were giving the tales serious thought and allowed the current to return us to the boat where we went on the dock and took a shower instead of the proposed swim we had contemplated. Then to bed. Some unnecessary fidgeting broke down the bunks so we spent the rest of the night in very impromptu perches.

Tomorrow we would be on our way in the ford, leaving the Pintail to wait out the winter for our next summer's return. The cruise is ended, motion pictures secured and our time up. It has been a most wonderful adventure.

Wednesday, August 9th:

Up early and shaved. Unload our equipment onto dock and putting boat battery in ford, Don and I return pirogue to Andy Boudreaux. On letting Don out at the dock to help with the arranging of our junk, I drive to town for groceries. We have bacon and eggs for breakfast then I fix the carburetor. It has been leaking badly. We leave all our junk on the dock under the watchful eye of a friend, Don and some more friends man the Pintail for the short trip up Bayou Boeuf to her winter quarters at the N&B Mill, and Bob and I take out in the ford to meet them there and bring them and the battery back to town. We installed the battery in the ford. We take our last look at the Pintail, then leave for the dock to load up the ford and at 12:00 we are at the landing waiting for the ferry. It cost 35 cents to cross, then we are on a stretch of pavement headed for home. The motor is running fine and we run for miles through scattered showers of rain.

Our first tire trouble looms up in the form of the right front tire slinging off the tread. Tying the tread to the tire did no good and after several flats, we stuffed the casing full of boots and continued. End up by coming into Lecompte, La. during the night on a rim and camping on the outskirts.

Thursday, August 10th:

Last night we watched the moon rise in the east. It rose beneath a bower of moss curtained limbs of oak in all its silvery glory and the few clouds that lingered near were set aglow with the phosphorous. Then we fell asleep to be awakened in the morning by the rising of the sun in the same setting. The clouds were now of a purplish color, ridged with gold. We got up and ate our meager breakfast. It was a loaf of bread split three ways and washed down with water. Incidentally, our supper of the night before had been similar. Breakfast over, Don remained with the ford while Bob and I strolled into town to dicker for a casing. No luck, so we decided to pick up a rim at a filling station for a dime and a little farther down the road we bought

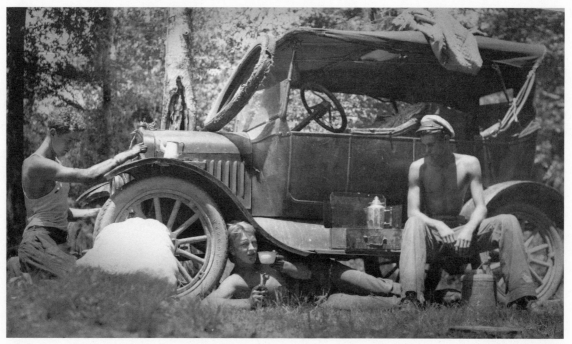

"I made coffee"

a tire from a darky woman. Then we drove to a filling station to put on our newly acquired accessories. The tire was found to be rimcut but we applied boots and used it just the same. Passed through Alexandria alright, but not far the other side our tire troubles recommenced in the form of a blowout. Thereafter all we did was fix blowouts every few miles and cuss a little for the especial benefit of the guy who swiped our spares in Morgan City. We were running low on oil by this time and as our finances were exceedingly low, we couldn't afford to purchase any. Result was that at every filling station or garage we drove in and asked for old oil. They had usually just given it away, burned it, or poured it out. Our bearings were beginning to protest loudly, so we bought a quart of oil for 15 cents which lowered us to the financial standing of 32 cents. That didn't seem to pacify the bearings so at a shady spot beside a creek we hove to. Bob and Don proceeded with the bearings while I made coffee. We still had our stove and about a quarter lb. of coffee. No sugar and no cream, but it was coffee anyway. The job of tightening the bearings took some time but when it was completed we all went for a bath in the branch. Boy! it was cold. I took a photo of us three there with the aid of my self-timer, then we dressed and left. Not far down the road we again fixed another blowout.

Late in the afternoon we were located opposite a cotton field with another blowout (how I would have welcomed, for variety, an honest to goodness puncture with

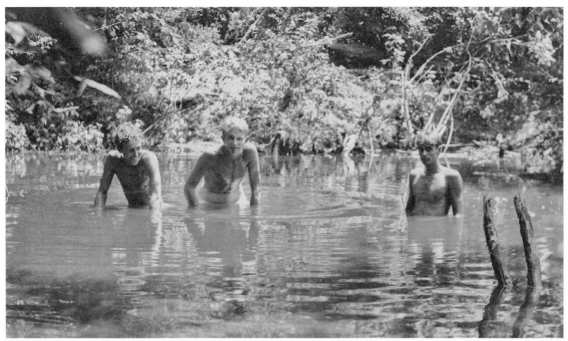
Bath in the branch

a nail). There was a rip in the tube five inches long and an inch wide and the casing was suffering from a terrible rupture.

Really up a stump now, but Bob and Don got some rope and laced the foot long rim cut while I cold patched the tube with most of our patching.

Some negroes were plowing in the field and Don, his stomach growling like the starter on a car, hollered to them and asked where he might swipe a watermelon. They did not know of any place off hand so he hollered back, "Is cotton good to eat?" and "How do you cook grass in these parts?" and "Could we borrow your horse for a minute?" etc. The Negroes thought he was joking and paid him no mind. The grass we plucked had a juicy nut flavor but somehow we felt kinda horsey eating it and when people would pass, we would get busy over our tire repairs.

The next town was about a mile down the road and before we got there we had two more flats and rode into town on the rim. We parked the car in the care of Don and strolled about in search of "T" model spares but found none. It was just about dark and still nothing under our belts. A chicken was beginning to roost by the road side but there was a house opposite. Our plan was to start the ford and under cover of its din catch the beautiful thing, but Bob happened to remember that a friend of his was put in the jug for just such an act. We all tightened our

belts a notch or two, and went noisily on our way on the rim. And so far into the night we found ourselves still plodding along on the rim with Shreveport about 45 miles away. Then the other front tire blew out. Being pretty disgusted with flats we continued anyway. About twelve o'clock we drove into Shreveport. Three hours to drive forty five miles! We looked at the gas and seeing that we had enough to make Marshall, bought a dozen bananas and ate them on the spot. We put water in the radiator and poured in some more of the used oil we had finally managed to collect and threading through the sleeping streets of the quiet city making all the din possible, we reached the highway on the home stretch to Marshall, Tx. Don lived in Marshall and it surely would seem like home even to Bob and me. At three o'clock we rattled up Don's driveway and a few minutes later were fast asleep in a real bed, with sheets, pillows, and everything.

Friday, August 11th:

Little too tired to get a real night's rest so didn't sleep very late. One of Don's friends, Fred Stuebben, came by this morning in his car and showed us the town, bought cokes and cigarettes. During the course of the outing we made plans for a party tomorrow night.

After dinner I wrote John Burns a letter and then we got in Don's car and drove to Fred's farm on the outskirts of town. We spent some time wandering through the trees, funning with each other and kidding Don about his Grand Isle sweety.

On return to the house I spent a lot of time with writing during which plans for a picnic for tonight popped up.

Being in a lather on account of the weather being hot I slopped around in the tub awhile before dressing for the proposed picnic, then the girls who were taking us came by. There was Fred, Don, Bob, and myself and the four girls in the one car. The affair was held at a small lake and a good time was had by all. The girls let us out at the house at 11:00 but not being ready to hit the hay, we went to town and indulged in cokes and cigs at Fred's expense then returned to the house and sat in Fred's car talking. Pretty soon we all got sleepy. Fred went home and we went to bed.

Saturday, August 12th:

Bob and I didn't get up until 10:00, then we had breakfast and washed out our clothes in lieu of tonight's spree. I caught up on this diary before noon then ate dinner and loafed around the rest of the afternoon. As the daylight was dimming an electrical storm came quite suddenly with an accompaniment of high wind. Bob and I rescued our equipment from the ford and placed it securely within the confines of the house. Then the storm broke in all its fury, blowing and raining with the customary fireworks.

After supper, I ironed my uniform and got ready for the party that was staged for tonight. It was to be held at a small cabin in the pine woods but due to the rain, location was switched to Don's house.

To further dampen my aspects my "blind" date phoned to announce that the rain would prevent her coming. But Duke, a friend of Don's, made a hasty call and managed for another girl, her name being Charlotte Lindsey.

The party was a great success, about six couples being in attendance. I was wholly satisfied with my partner. She was of medium height, wavy hair of dark color, very pretty, and a good dancer. The affair broke up about 11:30 just as a deluge of rain slithered down from the sky. Don and I, in taking our dates home, stopped to watch a negro shanty burn. The fire department was out and was stringing hoses about in the muddy streets. We caught a glimpse of Charlotte's dad who is the fire chief of Marshall.

Later Bob, Don, Fred, and I sat out in Fred's car and talked. Smoked, then after a while Fred went home and we went to bed.

Sunday, August 13th:

Nothing much happening this morning. Enjoyed the luxury of knowing there was nothing to do and smoked my pipe in contemplation of our past adventures and the coming preparations prior to presentation of the picture in the schools. After dinner Fred dropped in while I was playing on my sax. We strolled through the streets of town finally winding up where some of the fellows were playing ball. Don played with them but watching the game was not much fun and soon got tiresome so Fred, Bob, and I strolled about some more and finally separated, Fred returning to the game and Bob and I going to the house to smoke and read and talk.

While browsing through the pages of a magazine a ford coupe drove up in front. The girl not driving waved up at me, but I had to bat my eyes twice before recognizing her. She happened to be Melba Vauter of Ft. Worth whom I had gone to high school with. Just happened to be passing and recognized me. Talked for quite a while then she left.

After supper we did up the dishes than I sat on the front porch and read until the gathering dusk obliterated the print. Fred came by and we went strolling through the streets of town again. After some time at this arduous occupation we returned to Don's house to sit out in front and talk. Talk shifted through various channels and finally ended up by Fred leaving and our going to bed.

Monday, August 14th:

Searched the whole town over for rims, tires and tubes for our anemic T model but to no avail. The front wheels remained without tires as we pulled out of Mar-

shall at 10:25 bound for Ft. Worth and home. Shan't elaborate on the tiresome and slow trip but once we got off on the wrong road, and travelling around in circles, so to speak, for about thirty miles that got us no nearer home, we wound up on the highway again with badly battered rims. Pretty soon one of the rims unwrapped off the wheel and after a gyrating flight through the surrounding atmosphere rolled down the hill into a lake. We halted and put on another rim and ate hamburgers and milk for lunch at Mineola. Arrived in Dallas after dark and immediately helped enlarge a traffic jam. The rims clung to a carline and after a few vicious tugs at the wheel, spun out across a line of traffic and almost prostrated two cops and several drivers. I mopped my brow and drove crazily onward.

Not far along into the business outskirts, the lights got to blinking and finally went out. We pulled to a stop near a well lighted alley and after mumbling a little bit, got out and tinkered with the illuminators. Got one to burn brightly and one half way so, then got back in the ford, drove a block and pulled up to the curb again. Nothing at all only both of the lights had burned out.

Now give a look. Here we were, within a cannon throw of home; no tires on the front wheels; no brakes; lights out, burned to a crisp; no tail light; two tires draped across the hood that belonged on the front rims but weren't there because they were sorta motheaten, you know, transparent all the way around. Just souvenirs, that's all. A couple of five gallon cans hanging off the top and the back seat cushion tucked behind the spare tire rack all hung with flowing spanish moss that was to be used on exhibition in the schools was the outward aspect of the contraption. Bob and I took on disgusted airs and thought naughty things. How much money had we left? Exactly six cents. We had a worn out storage battery that had attracted an offer of twenty cents in Berwick, La. Maybe we could trade it for a globe. So we groped along the dark streets and located a filling station. The attendant didn't want any old worn out batteries and told us so, so we didn't trade him as we had thought we would.

Sitting in the car all night in the Dallas streets wasn't such a hot idea. In the first place, I always get a crick in my neck nodding when I try to sleep sitting up. In the next place, I'm always bumping my chin on the steering wheel and that ain't so hot either. Then, too, Bob would sorta stretch out unknowingly and use me for a pillow and that's another thing that wouldn't work.

Being disgusted with the general run of affairs we started the ford and stole along noisily through crowded and lighted thorofares. Finally, we found ourselves in a maelstrom of traffic being jostled and pushed in an uncomfortable manner, so to speak, along the darkened highway. The only means of our seeing our way along was the oncoming traffic from the rear. Finally that source got irregular and we saw ditches and poles and everything else looming up in front. We were just in the outskirts of Dallas and a couple of cars almost kissed on account of they didn't

count on us traveling along without lights. That scared us so we camped on somebody's front yard stretching out on the blankets. Immediately we fell asleep. Then lightning began renting the heavens and the wind tossed the tree tops to a frenzy. It drizzled a little and woke us up. Thinking nothing of it we turned over and resumed our slumbers. Then the baptism commenced. I ran to the car and got two strips of canvas which I thought would be sufficient canopy. But it wasn't and in no time at all the rivulets were travelling through our blankets, regardless of us. That wouldn't do, so we got in the car and cussed about the top leaking until we could see in the first gloom of dawn.

Bob cranked up and we struck out for home once more, wobbling along uncertainly on the two front rims. It was six thirty when we pulled into the portechere and greeted Mrs. Frederick who had come running to the porch on hearing the strange boiler factory-like noises approaching.

A hot bath and breakfast normalized us once more. We had donned dry clothes, too, and were feeling quite civilized as we stretched out on the front room furniture and sipped at a cigarette.

Pretty soon Bob drove me home in their Chrysler, which was some luxury.

The end. See you later.

Diary of

FONVILLE WINANS

Started on

Wed. Aug. 31, 1932

Wed Aug 31 1932

A soft blue day arrived
this morning tufted with
grey and white clouds
with a suggestion of
pink.

I dressed, ate breakfast
and repaired to my room
to continue on the book I
laid down last night —
"Old Louisiana" by Lyle Saxon.

It is very interesting
for me to read for I spent
6 months of last year in
the Atchafalaya country
and have just recently
returned from a month's
visit there in my cruiser

Pages from the fall 1932 diary

INTERLUDE

Fonville, Bob, and Don went and rescued their beloved Pintail, *fixed her up, and took her all over creation making movies and taking pictures: Then they returned to edit and realize their profits. This part didn't work exactly as planned, but the film was a huge hit in schools. The authorities, in fact, had to shut them down because schoolchildren were spending their parents' hard-earned lunch money on the movie.*

As I say, Fonville returned home to Fort Worth, Texas, in the late summer of 1932. His return was filled with ambiguities. He and his pals had done what they set out to do—make a movie, a sort of documentary film of an almost unknown, quasi-dangerous wilderness, Louisiana. They focused on the coastland with its waving sea of grasses and its winding bayous, its fishing and trapping villages—remarkable stuff for three fellows just beyond adolescence. But it had been not only creative and exhilarating; it had been very tough at times. Fonville was broke and in debt. He owed $130. The only jobs, if you could get one, were for hard labor at $5 to $9 a week. Paying off a $130 debt was daunting. And Fonville by this time was much less a candidate for errand boy, big brother, or college frat. The sun, the hardships, the dark people, the grown-up things they all had to do to survive had now marked him and his friends as tested veterans of a far-away campaign. His duty now was not to treat a wound or patch a leaking stuffing box; the blood and the swamps were behind them. His mama wanted him to mow the lawn with a rickety old push mower. It had to be a comedown, though his diaries do not let on.

From his diaries we see that he has shown the film to family and friends. Reading carefully, we learn that he was essentially loafing about town with his pals. He read books. He kept a journal. He dated and played his saxophone for dance bands. He tried cigars and wine but settled instead on milkshakes. The Pintail *had been not only an adventure but a penance, a quest. Hunger had been commonplace aboard the* Pintail, *and now a milkshake was an inexpensive luxury.*

In 1931 he had spent a semester at Texas Christian University. Now he placed the

Wed. Sept. 14, 1932

Woke up early in order to cut the grass but the mower wouldn't percolate. Being thrown to my own resources I resorted to my camera, taking several unusual shots of myself working on the lawn (which I wasn't), also one of myself tooting the sax. I completed the roll by snapping one of Ed in the wheel chair. The bath room soon took on the dark dignity of a dark room while I developed the films.

Raymon came over and had dinner with us, working on the map after—wards.

He painted on the Gulf while I adorned an alligator of my art in green paint. The map is gradually being completed and at the present rate of progress it is estimated that it will be completed by Xmas after next. Lets hope so

More pages from the fall 1932 diary

cruise of the Pintail *above all that. Dusty old zoology or rubbery old biology was out of the question. Without the discipline required and very likely without the money needed to return, Fonville probably saw college as a waste of time for a real explorer, a man of action, a trailblazer. People watched the film and had dinner parties to celebrate Fonville's triumph, then retired to the parlor or to the porch to listen to the radio and sing along . . . "I'll see you in my dreams."*

Fonville may now have begun to substitute late nights and lollygagging for a slow-down in lifestyle. Other diaries of this period are crowded with the details of triviality. Was he preparing himself as most of us must for a true exit? Should he return to the Pintail and Louisiana? He mowed the lawn, he clipped the hedges, and he drummed up rather exotic milkshakes. He negotiated unsatisfactory arrangements to show his film. He argued with his adoring sisters. He set up darkrooms at home and in his old high school. He took pictures and practiced his music. He stole a "good nighter" kiss or

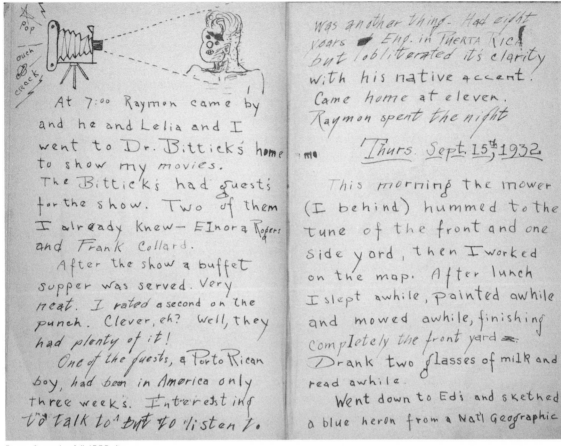

Pop
ouch
crack

At 7:00 Raymon came by and he and Lelia and I went to Dr. Bittick's home to show my movies. The Bittick's had guests for the show. Two of them I already knew— Elnora Rogers and Frank Collard.

After the show a buffet supper was served. Very neat. I rated a second on the punch. Clever, eh? Well, they had plenty of it!

One of the guests, a Porto Rican boy, had been in America only three weeks. Interesting to talk to but to listen to

was another thing. Had eight years of Eng. in Puerta Rica but obliterated it's clarity with his native accent. Came home at eleven. Raymon spent the night

Thurs. Sept. 15th 1932

This morning the mower (I behind) hummed to the tune of the front and one side yard, then I worked on the map. After lunch I slept awhile, painted awhile and mowed awhile, finishing completely the front yard. Drank two glasses of milk and read awhile.

Went down to Ed's and sketched a blue heron from a Nat'l Geographic

Pages from the fall 1932 diary

two from Fort Worth ladies not ready for any real hanky-panky or a slightly less than promising suitor.

On the night of September 19, 1932, he anxiously followed the broadcast news of a great storm bearing down on Morgan City, Louisiana, where the Pintail lay moored waiting for her mates to quit the shore.

He stayed busy but broke. He drafted with great effort a huge map of the "Cruise of the Pintail" and hung it in the old Central High School auditorium. He rented equipment, public address systems, and black-out paper. His debts grew. He wrote and rewrote speeches and announcements. The arrangement with the high school principal and the school board was compromised. The school board insisted on 50 percent of the door for his showings and Fonville was to foot the expenses. He took photographs, yearbook pictures, shots of football players—anything to make a buck. He mowed the grass and clipped the hedges.

In October 1932 he writes a rare and telling bitterness: "Believe me, I'll welcome my day of financial independence. I'll scram."

On February 9, 1933, Fonville sold his 35mm projector on payments for $15 and began planning his next move. He was convinced of only one thing: return to Louisiana and crawl back aboard his lovely *Pintail*. So that summer, Fonville, now the vagabond, thumbed back to his old haunts.

At this point, sadly, we have a cruel lapse in our story of Fonville's adventures. There is no record of the summer of 1933. Fonville alludes to it in a journal of 1932: ". . . my cruiser, the *Pintail* is at Morgan City patiently awaiting my proposed expedition to the Florida Keys next summer." He also refers to the previous summer's adventures in his journal of 1934: "Mr. Breaux drove me . . . to look over the '*Pintail*', which I had left in his charge since the cruise of last summer." Finally, the map that Fonville made of the "Cruise of the *Pintail*" shows a journey west from Morgan City to Beaumont, Texas, via the Intracoastal Waterway and the Gulf of Mexico. There is no diary of that trip westward or of other trips that were apparently taken in the summer of 1933. It is likely that Fonville, perhaps traveling alone (with his cameras), wound his way beyond Last Island and into the Gulf, up the rivers of East Texas, and perhaps to Fort Worth. People interviewing Fonville many years later tell of Fonville's accounts of trips westward and even up to Fort Worth. But the diaries are silent on this point.

The 1934 journal suggests that Fonville also spent time at Grand Isle in the summer of 1933. But at times in the following pages Fonville seems to conflate the summers of 1932 and 1933 in his references to the *Pintail* film and to his acquaintances on the isle. This mystery may never be entirely sorted out. In any case, at the end of the summer of 1933 he apparently returned the *Pintail* to her mooring near Morgan City (Avoca Island), where she began her final decline. On July 12, 1934, he visited the *Pintail* one more time and found her in ruins: "We turned, and left her alone in the dark."

It is hard not to speculate on the real motivation behind Fonville's return to Louisiana in 1934. He had made many new and sincere friendships—friendships that endured for decades. He had been welcomed in most Louisiana settlements with awe and respect. He was terribly handsome, and film making was the cutting edge of glamour. I expect Louisiana had been much like a Peace Corps moment wherein a young and gifted person risks and gives a good deal in a foreign country—a country without much literacy, with primitive ways and an exotic climate, a place where the natives are genuinely impressed with the tall and colorful stranger with skills and ideas: "He's from Texas, he must know what he's talking about!" It can buttress the ego. It can have advantages, and it can bolster your odds. And perhaps it was even more than that. For some of us, geography is everything. A new or different locale can penetrate like an arrow. It is suddenly where you belong. For Fonville, Louisiana was such a place, and it was about to become home.

The story does take an upswing at this point. After discovering his *Pintail* in ruins,

Fonville went on to New Orleans and renewed acquaintance with the well-connected businessman Mr. Alford Danzinger. Mr. Danzinger and his associates had the idea of enlarging on their promotions of Grand Isle as a vacation and tourist destination. Fonville miraculously was offered Mr. Danzinger's private camp in exchange for services rendered: take photographs, entertain visitors, and keep the place neat and tidy. Now Fonville was set up on his treasure island. He took off for Grand Isle and settled in for another summer of joy and the things he had come to love—picture taking and socializing.

Fonville now took an abundance of classic photographs of people and places that are etched in the shared memories of so many of the people of Louisiana. Mr. Danzinger sent other roomers for Fonville to show the ropes. They learned to dance, to cook, to work, and to appreciate the great drama of an unfolding inevitability. People live and love and pass into oblivion. Their traditions fade. The events that shaped their lives go unnoticed. But there was a camera there, and from it we know more than words can ever tell.

summer 1934

Things were getting dull around home. I had a job on the Press as photographer, a bit of photo business of my own built up on the side, and occasional dance orchestra work at night. Still things were dull. I kept dreaming about the swamps and marshes, of delightful days spent on Grand Isle, of pleasant and adventurous cruises thru the broken Louisiana coastland. The more I dreamt the more restless I got, until one day I began packing my locker and a week later I told the folks goodbye. I knew where I was going—New Orleans; that was all. What I would do there I had no inkling. I didn't exactly know why I was going. I just went. All I had was thirty seven dollars. I figured I might get a job and live, romantically, in the Vieux Carre. It was just a fancy. Anyway, I was all wrong.

I left with the sincere avowal to keep a diary; to put in it everything that happened everyday. I made a weak start, and soon abandoned the effort. Later, as things continued to be interesting, I returned to the task of keeping a diary, an elaborate one. But at present, here is the first attempt, word for word:

Sunday, July 9th:

Left Fort Worth on the Greyhound Bus at 11:15 P.M., bound for New Orleans to seek fortune.

Monday, July 10th:

Left out of Houston this A.M. at 7:00 and arrived in Lake Charles, La. about noon for a stop-over with the Farquhars. (Family I met on Grand Isle last summer.)

Tuesday, July 11th:

Drove Marian, Helen, and Mrs. Farquhar to Beaumont where they did some shopping. We all took in a picture show before returning.

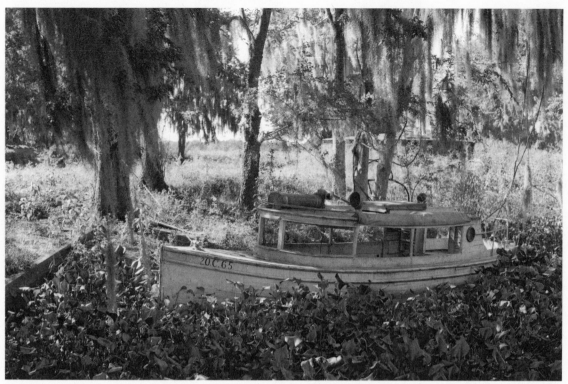

Final resting place for the *Pintail* after the 1934 hurricane that hit Morgan City

Wednesday, July 12th:

Continued on my way by bus at 12:00, and arrived in Morgan City at 5:00 P.M.
Called on Mr. Breaux (Father and I had roomed there while doing some construc-
tion work near Morgan City in 1931) and was invited to spend the night there.
Also called on Mr. Bergquist (a fellow photographer), Mr. Palmer (postmaster),
and Mr. Alfred Mead, a man of some means and instrumental in promoting the
oyster and shrimp industries of the coast. I showed him my collection of pictorial
photographs, some of which were of the coast country, and presented one of them
to him. In turn, he bought two others at $3.00 a piece.

Just before dark Mr. Breaux drove me to Avoca Island in his car to look over the
"Pintail", which I had left in his charge since the cruise of last summer. But now she
was pitiful to look upon. Careened halfway up the steep bank, her stern buried in
a mud flat, she seemed to implore of me, "Are our fine days over, the days we spent
thrilling to the tide of the sea, the days of threading the sombre swamps or bayou
slashed marsh, or the nights of wild splendor when I rocked you to sleep or bore
you bravely thru treacherous reefs? And it has all come to this?" I felt a catch in my
throat as I looked sadly upon her, not without a sense of guilt. She had fared badly

Pintail graveyard

in a recent hurricane that had swept the gulf coast. I had read the papers—Morgan City was the center of the tempest. We turned, and left her alone in the dark.

Thursday, July 13th:

Left at twelve o'clock for New Orleans and arrived there at a quarter of four. Checked my locker and photo kit and took a cab to the Y.M.C.A. Room rent being $1.00, I signed for one night only. Took a swim in the Y pool then called on my great uncle, Authur Yancy, with whom I'm barely acquainted. Did not remain long but caught a series of street cars and busses to call on Mr. Frank Carroll who lives some distance out the Old Gentilly Road. He is a naturalist whom I met on Grand Isle last summer, and with whom I had been corresponding. I joined him in his study and we talked at length for several hours. At 9:30 P.M. I caught a bus back to town.

Took a long walk thru the French quarter before turning in for the night.

Friday, July 14th:

Up rather early this A.M. Got breakfast around the corner for 15¢ then strolled around the streets until about 8:30. Called on Mr. Harrison, president of the Harcol

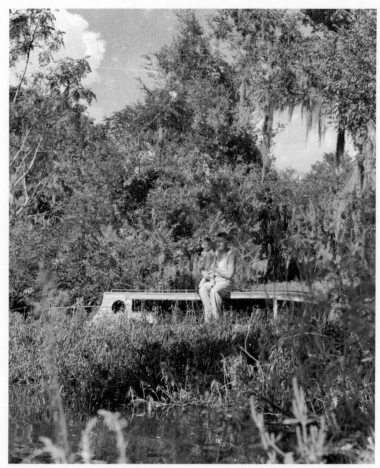

Another view of the *Pintail* graveyard

Motion Pictures, Inc., with whom I had shallow acquaintance, and discussed at length my working for him. When I left, he told me to see him tomorrow.

Next, I called at the New Orleans Bank Building to see Mr. Danziger but he was not in. He owns most of Grand Isle and I had recently sold him a copy, or duplicate, of the film I had made there last summer. Grand Isle is being promoted as a summer resort and he is interested in having photos for advertising. I returned to the Y and slept awhile. Later I shaved.

Went to the post office, very optimistically, but received nothing. From there I again called at Mr. Danziger's office, this time having the luck to catch him in. But he was very busy and I was only able to slip in a few words—about my locating at Grand Isle to make photographs. We agreed upon 2:00 to talk things over.

Again I resorted to the French quarter to pass away the time and was overtaken

by a drenching rain. Sought refuge beneath an awning but as the wind whipped the spray upon me anyway, I ran to a nearby barber shop where I remained until the deluge abated. The sun shone brightly and steam rose from the glistening pavements. Back at the Y.M.C.A. I took a nap.

At 2:00 P.M. I made the appointment at Danziger's office. Met Mrs. Grace Manners there. She does publicity for Grand Isle and is secretary of the Grand Isle Chamber of Commerce. Had quite a talk with her and together we formulated plans whereby I might make a living on Grand Isle with photography. Talked over the plans with Danziger and settled upon my leaving with him for Grand Isle tomorrow at 2:30 P.M.

Went to the bus station, checked out my remaining baggage, and caught a cab for the "Y". About 5:30 I took a swim and put on some fresh clothes. Phoned Doucet Chereboniere for a date. I met her last summer while cruising below New Orleans. She lives in Gretna. She had nothing planned for tonight so took me up on my proposition to call on her tonight.

Having plenty of time, I walked to the Jackson Street ferry, stopping to eat on the way, and boarded the ferry just as the sun was setting. The Mississippi was a writhing dragon of fire, and turbulent, and majestic.

I had to walk a mile from the Gretna landing to get to Doucet's house but I did it in short order. She met me at the door, prettier than ever in a fresh, white dress. Her most cordial smile greeted me and I felt at once at home. Spent the evening talking of first one thing then another. We sat on opposite ends of the antique divan with plenty of space intervening. I supposed this was an "old custom". Other antiques of splendor furnished the room but were hidden from view by dust covers, made to fit their form. I imagined that her grandmother might have "dated" in just such a fashion and in this same room, possibly nothing changed. She probably used this same divan, she and her beau occupying each extremity, such as we were doing. However, I was thoroly enjoying myself, and especially so when her mother brought in on a tray two slender stemmed glasses of transparent grape wine, bits of ice tinkling within. We lifted them to our lips and sipped.

What fine liqueur! I shall never forget. Its warmth and tingle put me in my finest spirit. I thoroly enjoyed conversing with her mother. Later, her brother, too, joined us. At 11:30 I bid them all goodnight, expressing my gratitude for such a pleasant evening, and was on my way. . . .

∽

There the diary ended. I should have kept it up, for interesting events continued to happen. But I didn't. I suppose it was too much trouble. It had been a swell idea at first, but it's like brushing the teeth—no immediate results. The routine gets

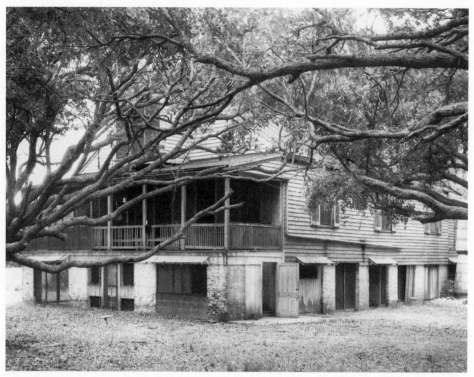

"The Place" (Danziger's camp)

wearisome, grows in unimportance, and is soon abandoned. I didn't have the tooth ache so I wasn't brushing my teeth. Later, I contracted a literary tooth ache, or a sense of responsibility to myself, and again took up the practice. But not so soon as I should have. Briefly, here's what occurred in the interim:

I left with Mr. Danziger the next day. We arrived at Grand Isle in the night and drove three miles along the wave washed beach to reach his camp. His sister, who was staying there at the time for her health, set food on the table for us. After that we went to bed.

In the days that followed, I renewed my last summer's acquaintances on the isle, built a small photo darkroom, and settled down to an island life, that is, of just taking things easy. Of course, I resorted to photography to keep the sea wolf from the door. Every day I went swimming in the restless gulf, acquiring the bronzed skin of the native, and sometimes I spent hours in tramping about the historic and picturesque places. Every week-end Mr. Danziger brought guests down from the city and the Place (as I have chosen to call his camp) would be converted into a veritable clubhouse for the time being. One week-end there came to the isle a young man—

Duyane (Buck) Norman—who was destined to spend the rest of the summer with me at the Place. He was a student of L.S.U. and had done some advertising there for Mr. Danziger. He later got me interested in that school, but that's getting ahead of the story. Anyway, he remained to stay with me on the isle.

Shortly after my arrival on the isle, Mrs. Manners brought her son down to stay with me, that is, for me to take care of. A very brilliant lad was Johnny Manners and only eleven years old, too. He had two bad habits, outside of his many commendable features. One was knowing too much about anything you could mention and the other was telling you about them. He could recite Kipling, too, with a doggedness that made you admire your self control.

Robert Nix, a tall and rangy artist, temperamental, and who made it clearly understood that he wouldn't do a dish, came to the Place a week after Buck did. He came to do some paintings of the isle for Mr. Danziger. Buck had gotten him to come. He and Buck had graduated high school together. We were all just one big family—Buck, Nix, Johnny, and I. Sometimes things ran in harmony; sometimes they didn't. I'll never forget the day that Buck, Johnny, and I scrubbed the entire camp and changed all the linens on all of the fourteen beds. Nix slept all the while. One night, when we were all on the front porch reading, Johnny made a pitcher of ice cold lemonade and, on bringing it out to us, set the pitcher down on a letter that Nix had just written. That made Nix furious and he made a pass at Johnny, striking the lemonade instead. It went all over the floor and all of us were laughing but Nix.

As much as Buck and I would try to keep the guest rooms clean, Nix would invariably sleep in one of them, or switch to another, as suited his mood. We were at our wit's end and reverted several times, outside of implorations, to base pranks. One night, as he slept soundly in one of these rooms, we placed two slop jars near his head, closed all the windows and doors, and went quietly to bed. He was mad the next morning and we snickered. Another time we put burs in his bed. Enough of this, here is the diary:

Sunday, Aug. 12th, 1934.

Up at the crack o' dawn, I put on the coffee water, which is one of the first things you learn to do on arising, i.e., in this neck of the U. S.

Yesterday afternoon Norman, John, and I drove to Milliet's in the Colonel's car. The Colonel accompanied. A plane buzzed overhead and struck out up the island hovering just over the beach. We gave it only a moment's notice; speculated on where it would land. Then John, Norman, and I borrowed a scow and pulled up the bayou to the anchorage of the "Eldes", a neat two-masted schooner owned by E. V. Richards. Richards is head of the Saenger theater chain. Buck (Norman) has been maneauvering for a photo contract. Photos of the schooner. He knew the captain.

Once more ashore we learned that the plane that had buzzed overhead had

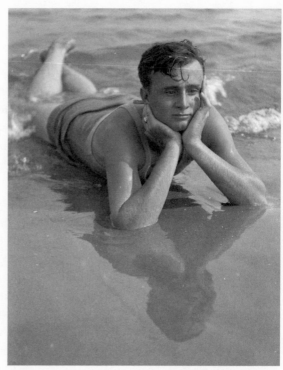

Duyane (Buck) Norman

brought none other than Mr. Danziger, our host, to the isle. The Colonel let us have his car so we ginned on up to the Place. We found two cops, two other strangers, and Mr. Danziger on the front porch. The cops had met the plane and driven them to the Place. We were introduced around. The two "strangers" were owner and pilot of the plane.

That's why I was astir so early putting on coffee water. The guests would inevitably want their morning coffee. Well, they slept fairly late. So did Mr. Danziger. But when they did arise, Buck and I had waiting for them a steaming breakfast of oat meal, bacon and eggs, coffee and oranges.

About 9:00 Mrs. Grace Manners arrived on the isle and hove thru the front door. She is John's mother and does publicity work for Mr. Danziger on Grand Isle. She had plenty lined up for me to photograph before she should depart for the city at 12:00. While breakfast was suffering a general onslaught, Sarah Blum, attractive Houma girl, framed herself in the front door. She had with her a couple of friends, a young man and girl. Two weeks ago when Sarah was on the isle I had made a photographic study of her on the beach. Now she wanted to see the result. I had it enlarged and mounted and looking swell. So she promptly bought [it] as I had guessed she might.

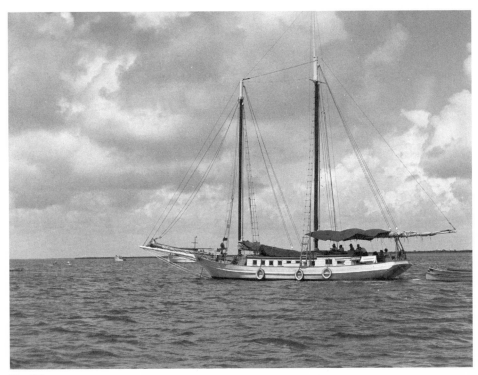

The *Eldes*

About this time Mrs. Manners was getting fidgety so I got the anemic Locomobile started, and with John and the camera as extra equipment, she and I struck for Milliet's to ferret out the big shots who come here on their swanky yachts. They find the fishing and drinking in Utopian style down here. And they are news, too, and the press must prosper. So here we were to photograph and interview them as supplementary advertising for Grand Isle. Soon Mrs. Manners, in grand diplomatic style, had us aboard one of the long cruisers. Men laughing and talking and one of them shoved me a stout cocktail. Others followed and I soon found myself in a mood to accomplish anything with a camera. I photographed them thoroly. Then nothing would do but that we all get into a speedboat and prance out into Barataria Bay, spray and sunshine whipping us, and take a snapshot of Hugh Wilkinson's cruiser, the "Moon Flower". Then we returned for more cocktails and poppycock.

Mrs. Manners parted our company at Milliet's; she had to make connections for a ride in to New Orleans. So John and I returned to the Place. Buck met me at the door looking very desperate. No meat for the table. We had guests. I must get some oysters and be in no small hurry about it. I mumbled a couple of expletives and returned to the exhausted Locomobile. Nix helped me get the machinery in her started and I loped on down to Milliet's again. Oysters seemed to be at a premium

but I mentioned Mr. Danziger's and the oysters were forthcoming—one dollar a sack! My heart wrung itself this time; the cash supply was almost nil.

From bad to worse, the Locomobile refused to start. Not a fizzle, even. A negro and I labored with pushing the museum piece and retired quite exhausted and with myself talking under my breath. I got in the front seat and panted a while. The darky vanished. I hailed a car and, with its shoving, was soon roaring up the beach.

A sack of oysters contains approximately 100 of the bi-valves, unshucked. So the job of shucking our oysters occupied the next half hour. Then a swim in the surf to wash off before returning to complete preparations for dinner.

How's this for the menu?: Fried oysters, raw oysters, cold shrimp, potato salad on a bed of lettuce, beans (country style), snap beans, pickled beets, sliced bologny, bread and butter, and the inevitable drip coffee.

Just before dinner (which was rather late, as it was) Johnny Rebstock drove up with two girls and persuaded Buck to join them. Buck has been friendly of late with one of the girls. He managed to construct a sandwich, though, before leaving.

Mr. Danziger went to the Grand Isle Inn later in the Locomobile, which Nix and I had started by pushing. Then, being attired in bathing suits anyway because it was raining persistently and because it had been necessary to start the car in the rain, we trotted over to the beach for a dousing in the brine. The pelting rain made the surf very speckled and roily. We swam and waded up shore to where our two guests were endeavoring to yank out trout. They were biting lustily but our friends, being true sportsmen, didn't know how to fish. [W]hen a trout struck (as they were doing every minute) they would give the pole a terrific jerk and the bewildered fish would flip back into its element. Not being a kibitzer, I left Nix with them and returned to the Place and browsed thru the paper.

As dark drew on and the rain continued to pelt the isle, Nix accompanied me into the dark room where I spent an hour developing films. Results were excellent.

Monday, Aug. 13th:

This crack o' dawn business again! Coffee for Mr. Danziger and the guests as they were pulling freight for the city in a few minutes. It was still raining when we bid them goodbye and good luck and fell to dozing on the front porch. We heard the plane warming up, then in a few minutes saw it lift above the tree tops and disappear into the gloomy rain. Next stop: New Orleans. Luck to 'em; no landings between here and there.

Breakfast over, Buck and I set out on foot with the camera. The rain had evidently abated. But while I was setting up the camera for photographing the island's oldest cistern, a black, foreboding cloud swept down on us from the north. A hasty retreat brought us to Miss Minnich's house. Vivian was there and while the rain slither[ed] down in flashing sheets we leaned back in chairs on the front porch

"Rainy Day"

and discussed the history of the Isle. While thus engaged I noticed what a pretty pattern was formed on the screen from the whipped rain spray, so in a moment of inspiration I made a photograph thru the screen with the focus on the drops of rain thereon.

When the rain petered out we visited the new grave yard where I took more photos, then did the same by the old one back of the island, or in the rear near Bayou Rigaud. These ruins are either tottering or about to totter into the tall marsh grass where they are. Some of the tombs are broken open and by poking one's head into the aperture the gangly skeletons are to be seen, rotting boards collapsed about. The mosquitos were as interested in us as we were in the graves so we departed without waste of time. Returned to camp via the Danziger Road, which is the only road that stretches the length of the Isle.

John and Nix had just returned from crabbing and had engulfed some beans.

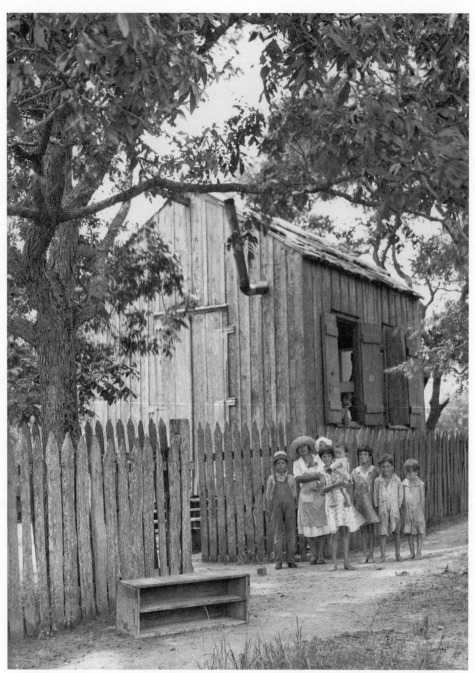

Family (unidentified) in front of Island home

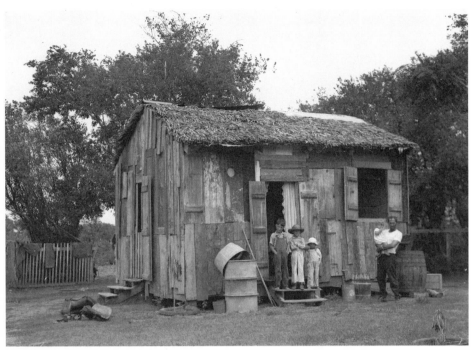

"Chighizola's Shack"

Buck and I, being also hungry, did away with a very luxurious spread of beans also, then reclined for an hour or so. At dusk we repaired to the surf for a swim.

Into the night I wrote letters and so on to bed.

Tuesday, Aug. 14th:

Rather late in arising this morning. Found John and Nix up and preparing to go crabbing. They had just finished a meager breakfast. I hove to and soon had steaming oatmeal and sunny eggs flashing on the table before Buck and myself, with hot tea.

With the dishes tucked away in the cupboard, we barged out of the Place on a photo expedition, and before we reached the gate a dreary cloud rolled over from nowhere, hurtling some advance representatives thru the trembling trees. We turned in our tracks and re-entered the Place.

Later, donned in swim suits, we threaded our way thru the pelting slither toward the beach. There were a few natives lolling in the surf. We swam out to the third bar and pondered and discussed our common problems.

Mid-afternoon was illumined by the sun's incessant butting thru the bulky clouds. I fell to photography, photographing Ludwig's store, the Chighizola House, a picturesque typical dwelling, and Santiny Lane, a veritable tunnel of oleander.

Grand Isle lane

In returning, we caught a ride to the post office. There was the usual number and gathering of natives thronged on the porch. I mailed six letters; got only one in return. It was from one of my best girl friends at home, Maxine Keathley.

Buck and I went for another swim before dark and returned under a concerted attack of a swarm of relentless mosquitos. Run we did, but the abrasive clam shell lane sorely hampered our progress and we could be seen prancing gingerly down the ruts as though eggs were scattered along the way.

We cussed the insects thoroly, making sure not to neglect any one of them and making doubly sure not to omit any of our most effective phrases.

Coffee and sandwiches constituted our night time meal. Then we lounged around, played the Victrola, and what not.

(This morning, while the rain still slithered from the sombre sky, I developed the films that I had exposed yesterday. Except for one film, the results were excellent.)

Colonel Stevens' place

Wednesday, Aug. 15th:

Wham! That's what woke me up. Buck had socked me right in the middle of
the back. We got breakfast started, dressed for a swim, while John went to the store
for bread. The surf was really swell. We swam out to the third bar and frollicked in
the breakers. In due time we returned to the Place and finished with breakfast. In
the half hour recess that followed I got a photographic urge and set out with the
camera. First the surf, then Colonel Steven's place on the dunes. Several pictorials
followed before I returned to the Place but not before I had managed to sideswipe
a dead Spanish Dagger and imbed the point of it in my leg. Not minding the pain
for the moment, I captured a huge yellow-jacket and locust bug that had engaged in
combat. But back at the Place I remembered my mishap. My leg pained nicely now;
the point was buried within. I sterilized my razor, located the gauze and iodine,
and set about the ticklish job of digging it out. I made two incisions but the point
did not budge. It was larger than I thought. Even my sharp etching tool was used
to no avail. Buck then volunteered to perform the operation so I set my teeth and
turned over on the chaise-longue. Sweat saturated my shirt as Buck probed for the
elusive dagger end; but in a moment, after a sickening shoot of pain, he leaned back
triumphantly and exhibited a nasty piece of Spanish Dagger, three eights of an inch

long. It had been driven deep before breaking off. I forced a laugh in spite of the sick feeling I had.

Sandwiches constituted our lunch. After that I sent Buck for Rita Naquin. When she arrived, looking handsomer than ever with a bit of yellow ribbon wound thru her hair, I got her to pose up in one of the weather twisted oaks for a photo. I had the tripod perched on one of the limbs for the shot. Then I developed the plates and was pleased with the results.

About dusk I went for the mail and a few groceries. When I returned Nix was on the front porch talking to two strangers. On being introduced one of them handed me a note from Mr. Danziger. It stated that these two men were Paramount news men and were down to "shoot" the tarpon rodeo. They would spend the night here and we were to be at their service as guidesmen, etc. They had supper at the Ole-ander while we did away with our meager spread, then Buck and I went with them to Milliet's to arrange for a boat for tomorrow. This would be necessary in order to get any tarpon shots. After lots of waiting around for Milliet to return from some-where, with an interview with Joe Marrero thrown in, we finally got wind of a boat, the "Sea Bird", that would be available if the skipper was contacted immediately. That I did, after much groping thru inky lanes and arousing several inhabitants of the Isle from their slumbers. They used lots of French in their directions and I seemed to be getting nowhere fast. But I finally found him— Carabin, the name. The contract was sealed by our yelping at each other thru the thick night. We would meet him in the morning at 8:00 at Milliet's. Twelve dollars was his price. Who can say that the ilk of Lafitte have disappeared from this isle?

Thursday, Aug. 16th:

A cigarette smoked before turning in last night gave me a 100% case of insom-nia. I couldn't sleep a wink. There must have been a dozen or so mosquitos on the porch and I spent most of the night laying for them. I watched the dawn permeate our hedge of wind beaten oaks with no regret. I could get up now.

Buck and I got breakfast ready and prepared a lunch for the day. At 8:00 we pulled up at Milliet's and I located Carabin on the wharf. We put ice, cokes, and shrimp (bait for intended fishing) aboard and got under way for the tarpon grounds which were the vicinity of Grand Pass and beyond into the gulf. It was only a short distance away, being off the east end of Grand Isle. Buchanan, the camera man, set up his outfit on the bow of the cavorting craft and made several "long shots" of the yachts and cruis-ers as they tugged at their anchors in the bay. We've been out about an hour when we make up a gin rickey with pineapple, orange, and lemon juice. I felt mine.

I made several "stills" of the anchored crafts, then later in the morning we dropped anchor near the tumbling ruins of Fort Livingston on Grand Terre Island. We signaled to Mr. Waits, the light house keeper, to come out and row us ashore.

Boats during tarpon rodeo

Only Carabin remained on the boat to watch out for tarpon catches. While I showed Mr. Buchanan and Mr. Wilkes around the fort, Buck and Bill, Mr. Wilkes' son, fished off a promontory that jutted into the gulf amidst crumbled masonry. Later we joined them in their sport, catching trout, sheephead, cat, mullet, and an occasional repulsive looking oyster fish.

A siren sounded above the crashing of waves on the ruins and we all looked up to see the committee boat cruising in the pass with a tarpon dangling from one of her davits. Buchanan, Wilkes, and I retreated to the "Sea Bird" and cruised over to investigate. We hove to alongside the schooner "Eldes" and were invited aboard. The committee boat was nearby, crowded with miscellaneous yachtsmen. The tarpon, we learned, had been captured by Peter Jung down at the other end of the island. Being the first catch of the rodeo, it would net Peter Jung a beautiful silver cup. Prizes are also given for the heaviest tarpon, the longest, and the most number of captures. I met all the men on board, including Mr. E. V. Richards, but failed to meet three very attractive young ladies who went below shortly on our arrival aboard. Mr. Richards explained a lot to us about the various tackles used and later had beer served around. Then we smoked, shortly returning to our boat and going ashore to the fort once more.

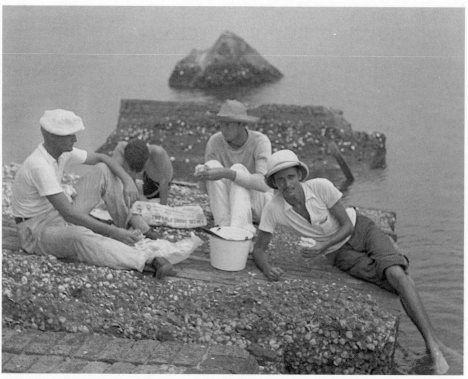

Fishing off Fort Livingston

We brought sandwiches and cokes to the fishing lads as we had partook of ours on board. Quite a few fish had been added to their string since our departure, and our rejoining them added a few more to the collection. Then we all returned to the patient "Sea Bird". Our anchorage was good point of vantage to scan the tarpon rodeo so there we remained. Buck, Bill, and I, to pass away the time, fished over the side in the shallow water. Bill hooked the first one. It was a small cat and in order to avoid the possible danger of Gillis getting finned I undertook dislodging the fish from the line. Taking the line about two feet from the hook I described an arc thru the air with the intention of dashing the creature against the side of the boat, but quite accidentally miscalculated my distance and swung the fish full into my foot, a side fin penetrating my tennis shoe. I suffered a sharp pain as I saw the fish quiver for an instant there then snap off, one fin missing. I jerked my shoe off. The fin had driven thru the end of my big toe and penetrated the next. I gingerly freed the second toe and, catching hold of the barbed end, easily and cautiously pulled it out. But the sharp pain remained and grew in intensity. I held tightly to the injured member somewhat desperately. Seemingly, the day clouded all around. I felt giddy. I rolled over on the deck in a fierce sweat and fought off impending oblivion. Some-

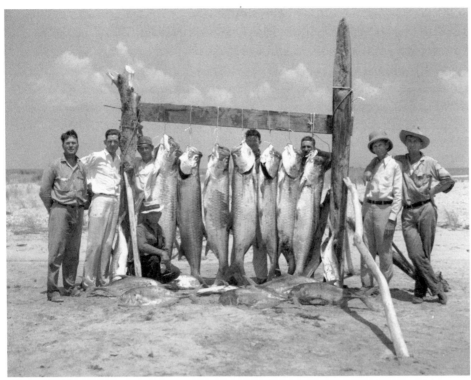
"Tarpon Catch"

one was bending over my foot applying a wad of wet tobacco. It was Carabin. Soon my brain cleared and I sat up and wiped off the cold, streaming sweat. Normality returned and the fishing continued.

Near sundown we cruised past the "Eldes" on our return to Milliet's. I "shot" a still of the scene. There she swung at anchor, resplendent in all of the Barataria Bay sunset glory.

As twilight flared we were again at the Place and our guests had departed for the city.

Friday, Aug. 17th:
Caught napping this morning. Quite unexpectedly, Mr. Danziger walked in and found the Place very untidy. Mrs. Manners and Doctor Tripoli were with him. However, we hurriedly set things aright and got our breakfast out of the way. By then Mr. Danziger and his party were ready to shove off for the end of the island opposite the tarpon rodeo. I went along to take photographs. Ruth St. Cyr (society writer for the Picayune) was along also.

Hugh Wilkinson picked up our party in his auxiliary sail boat and motored us

The *Eldes* at sunset

out to the committee boat where we went aboard. Quite a crowd there; mostly tarpon fishermen. Among those I met was Mel Washburn, Item reporter and photographer. During our stay aboard beer and smokes were passed around. From there we boated over to the "Eldes", anchored nearby. This time I met the three comely debutantes on board and photographed one of them. So what!

When Wilkinson returned us all to the point (end of island) we drove to the Grand Isle Inn and partook of beer and dinner. Once more at the Place I retired to the dark room and developed my films. Beautiful negatives of the "Eldes" came dripping from the hypo.

As twilight waned I went swimming. I watched the last blazing clouds flicker and go out and returned to the Place in phosperescent moon glow.

Buck and I spruced up, borrowed the Colonel's car, and called on some girls who are down for the week. We all rode down the beach to Grand Isle Inn. Put in some gas then retreated to the Place to dance and talk. About ten thirty we took the girls to their camp. On returning, went immediately to bed.

Caught napping

Saturday, Aug. 18th:

Mr. Danziger and the Doc stayed at the Grand Isle Inn last night. Accordingly, Buck and I slept soundly and long this morning. However, we were up by 10:00 for a swim. About noon we cleaned up and caught a ride to the Inn. Loafed on the gallery a while then went to Milliet's to wonder how we might get out to the tarpon fleet to get some photos. Buck borrowed a skiff, however, and we made the "Eldes" our first point of call. The intention was to make more photos of the comely debutantes on board. But on arriving there, and to our distinct disappointment, we learned that they had gone fishing up the bay. So we rowed back to the landing. To our surprise, there were the three girls struggling to hold taut a 104 lb. string of trout for a snapshot. It was too much for them so two men of their party supported the fish string while the girls posed triumphantly alongside. I hurriedly made a photo of the same.

Colonel Stevens had instructed us to get his car at the landing and take it to Mr. Danziger for his use over the week-end so we bought some ice (the ice man had given us the go by this morning) and drove on to camp.

Wrote several letters and went to the post office, while Buck went to call on the priest about a golden wedding story. Buck got a letter from his 12 year old sweety at

Houma. She's a girl he took a fancy to a couple of weeks ago. She was down for the week-end. She was the sister of Sarah Blum, the girl I photographed on the beach. Anyway, Buck thought her to be about sixteen and, as she was very attractive, he corresponded with her when she returned home. Just recently, we learned from a friend of hers that she was only twelve. I have really been "letting Buck have it."

Mr. Danziger and I went swimming at sunset and thru him I met a party of young people who were in swimming at the same time. I drove them to Ludwig's Hotel when we got out and they had me in for a gin rickey. Then I returned to camp where Buck and I got supper on the table. Had stewed okra, vegetable soup, corn on the cob, fried egg plant, and some pecan flower pralines. Mr. Danziger, Buck, and I were the only ones to partake.

Later Buck and I slicked back our hair and were off on foot to see our girl friends up the island. But they had discovered a Notre Dame student with a car and weren't in the genial, receptive mood we had found them in last night. What matter! We made our excuses and returned down the beach, a bit surprised at the peculiar psychology of the situation. Stopped at the dance pavillion for a look around but the intolerable mosquitos drove us "home" and to bed beneath the canopious mosquito bars.

Sunday, Aug. 19th:

Mr. Danziger, Buck, and I went for a lengthy swim in the surf before our late breakfast, which, by the way, was of fried eggs, bacon, toast and coffee, and orange juice.

Loafed thru most of the day and in the afternoon developed the film of the debutantes with their trout. Mr. Danziger wanted it for the paper, and as he left shortly for the city, he had to take the negative while it was still wet.

Buck and I went frollicking in the surf while the sun was sinking and did not come out until it was well nigh dark.

Otherwise, nothing particular today.

Monday, Aug. 20th:

Buck and I are immensely enjoying the solitude of the Place by ourselves. Slept luxuriously late again this morning. When we arose we reveled in a hearty breakfast and set about to clean up the camp. Kept the Victrola serenading all the while. It took our minds off the work and allowed us to dream away the morning. Before we realized it, the camp was spic and span and we were reclined in easy positions on the back porch reading all the old magazines on the place. Thus the day drifted on. Late in the afternoon, having nothing else to do, we caught a ride to Grand Isle Inn to pay Mrs. Marshall, who runs the place for Mr. Danziger, a visit.

I went to the post office at 5:30 and found an expected C.O.D. from Burke &

James. It contained ray filters and post cards and as soon as possible I set up in the dark room to print the cards. By ten thirty I had sixty one of them drying. Mixed some lemonades before turning in for the night.

Tuesday, Aug. 21st:

Got up about 8:00, slipped into bathing suits, and fought our way thru hordes of man eating mosquitos to the beach. Swam to the third bar where they dared not follow. Lolled there for some time then returned for breakfast. That particularly pleasing ceremony taken care of we went to the coast guard station to try our hand at selling post cards, but we met only indisposition on their part. Started raining so we beat a hasty retreat to the Place, jerked down all the windows, and fell to reading.

During the course of all this deadening drone of rain, Buck busied himself with preparing dinner and I browsed thru the pages of an old Cosmopolitan on the chaise-longue. Soon Buck had a steaming spread on the table, including invigorating drip coffee, and we fell to with hearty abandon.

After I returned from the post office with no mail, we labored over and in the indisposed Locomobile and, finally, with the motor bellowing protests, we throttled down the beach for Cheneire Caminada with the post cards I had promised last week. Sold two dozen @ 75¢ and turned back across the bridge. The western sky was a furious riot of blazing colors; the night was a quarter hour old. We turned up the beach toward the Caminada pass to marvel the more at the spectacle and—ran out of gas. Quite unexpected, this predicament. And the mosquitos, Gad!, they swarmed on us in clouds. We got out and ran to the bridge where I luckily caught a ride across, leaving Buck to wait on the rail. Got two gallons of gas at the place where I had sold the post cards and the proprietor drove me back to our stalled Locomobile, picking up Buck enroute.

Arrived back at the Place in the dark.

Wednesday, Aug, 22nd:

My birthday: Twenty three years old today. Getting to be an old man.

Raining monotonously this morning. Must have started during the wee hours of the night. Woke up with the drone of it in my ears. The sky was a smooth leaden gray and poured a steady fog of rain into the earth and trees. Breakfast of eggs, coffee, and orange juice. Read thru most of the morning and toward noon Buck fixed us an excellent vegetable dinner. Then we rested awhile to let it settle. I smoked a cigarette, my last. Dishes were done up some time later, and still later we went for a bath in the surf.

Once more dressed, we tried with no success to start the Locomobile, lost patience with the damned mosquitos, and caught a ride to Milliet's on a highway truck. Object was to secure some orders on some post cards. At the store got an

order for three dozen then strolled down to the water front and called out to Joe, "Captain of the Eldes", to come ashore. I showed him the shot I had made of the "Eldes" the other day. So pleased was he with it, I presented it to him.

When we returned to the store to hook a ride up the island we came upon the barber and two of his friends getting into a car. He asked us along. Gears clashed and we spun behind shacks and we skidded terrifyingly onto the shell road. We did not have to wonder if our chauffer was inebriated, we knew it, and accordingly hung on tight. But we had not gone far before he ground to a sudden stop at the Grand Isle Inn Cafe.

Nothing would do but for us all to go in and have a drink on him. His was part of the spirit of the day.

A shred of information before I continue: today being the 22nd., outside of being my birthday, is the 50th anniversary of the old Boudreaux couple. Golden wedding! Tonight the ceremonies were to be at the church and, as a sequel to the occasion, their granddaughter was getting married. Being one of the most powerful and oldest families on the island, all of the natives were ramping about in festive spirit. Licquor flowed freely everywhere. To refuse was to insult. So we, too, cele- brated and insulted no one.

From the cafe we repaired to the Place where more drinks were mixed. Then the barber and his friends left with the promise to see us tonight. And here is how it happens:

It is fifteen minutes until six o'clock. Buck is having a hell of a time with his tie and I have just squirmed into my coat and am disappraising myself in the mirror. Buck looks awkward with the tie and starched collar. I feel like he looks.

But never mind about that matter. I shoulder the camera and we are off down Ludwig Lane to join the throng of islanders milling about the church. Everyone is in holiday attire and looking their formalest. The women and children are sporting an appaling variety of gaudy colors. The men stand about stiffly in their mail-order suits. The scene seems unreal; we are used to seeing them in their swashbuckling shrimping costumes, and tattered hats, that are so picturesquely a part of the isle.

There is a general buzz of conversation as they await the coming of the blushing bride and groom. I an acquainted with many of the natives and exchange quiet greetings. My camera is set up before the steps, focused, and I fall to waiting with the rest. Father Arjonilla comes over and we discuss the novelty of the event. A small man, evidently an outsider, joins us and exchanges greetings with the priest then is introduced, to us. He is Andre Lafargue, attorney to the French consul in New Orleans; a very spry and intelligent man and joins readily in the conversation.

While we are waiting on the principals of the wedding a few facts will be of interest:

This is the date of the Golden Wedding anniversary of Visier Boudreaux (born

"Visier Boudreaux and Geolina Chighizola"

Feb. 4, 1864) and his wife, Geolina Chighizola (born May 14, 1854). The grand-daughter of this couple, who is getting married at the same time, is Olga Boudreaux (19) and the groom is Bernard D'Arcangelo (21). There's the story, the like of which has never happened before in the history of Grand Isle and is not likely to be duplicated for a long time to come. The whole island feels the importance of the occasion, and from the suppressed excitement visible in all faces, one knows some-thing is brewing for after the ceremony. The air is charged with the excitement, and festivity penetrates even the tops of the jagged oaks.

In the gathering dusk, a sudden hush drops over the crowd. The crickets and cicadas sing out the herald. It is quiet now; we had not noticed them before. Com-ing thru the gate is the old couple, arm in arm, and moving uncertainly upon the church. Close behind are the bride's maid and the best man (the barber's brother). They are ill at ease and are moving stiffly forward. Following them are the timid bride and her swarthy fiance. They seem the least perturbed of all, in spite of their helpless grins.

Something happens on the step. The priest had spread a strip of snow-white

Olga Boudreaux

Olga Boudreaux (nineteen) and
Bernard D'Arcangelo (twenty-one)

muslin for the bridal parties to tread on and the old couple have arrived there
bewildered, and have halted and are looking at each other with puzzled faces. Then
they move forward, gingerly walking the edge of the cloth to avoid soiling it. The
priest hurriedly sets them aright and they trod warily onward, entering the portals.
The rest of the party follows and soon are in the aisle of the crowded church wait-
ing for the priest to cue their next move. As the organ wails the tingling strains of
Lohengrin's famous wedding march, "Here Comes the Bride, etc.", they march halt-
ingly down the aisle to the altar and the ceremony begins.

I do not get much out of the first part of the program as it is a sermon delivered
in low spoken French, but I surmise at some of the advice and philosophy that's
being passed out to the audience for the young couple's especial benefit.

Buck and I are crowded in on the very tail end of the crowd and are standing
near the door. It is humidly hot and a hundred fans are fluttering in the clammy,
wet air. Sweat pushes out on my brow and drips onto my coat. I have forgotten a
hankerchief so swath my palm across my face.

The sermon stops suddenly and the priest disappears thru a side door and the organ wails once more, mournfully, and accompanies a local singer thru the doubtful strains of some French song. When the priest returns at the end of the song he finishes with the ceremonies in short order. It is over. The crowd surges slowly for the door and chatter rises to a high pitch. Amidst the talk and excitement I dash for my camera and make an exposure of each of the couples as they emerge from the church. I'm hoping against hope that I'm getting the pictures for I had to strain my eyes to focus in the last weak strain of twilight.

The crowd dispenses so Buck and I betake ourselves homeward to rustle up a little grub. From out of the night come wild cheers and shouts. They come from the direction of Boudreaux's whither the party had conducted itself after the ceremony. We had been told to follow but had not considered the prospects exciting. Now we cram down our meager supper and are off for the spree.

The celebration becomes louder and coarser as we near the place thru the dark, winding, lanes and, already feeling the crazy excitement in our veins, we quicken pace. Very soon we arrive among the surging, shouting, throng. In their midst we found an impromptu bar of barrels and boards where everyone gulped freely of countless jugs of claret. Wine for all and all for wine might have been the French cry. Glasses of the dark liquid are shoved at us and we, too, are soon in the spirit. Vivian and her aunt, Miss Minnich are here. They introduce me to some of their kinfolks and tell me about a friend of theirs from "up the bayou" who only last week paid them a visit and is now dead from being run over by a tractor. Rita is here, too, and looking her best. Oh, everyone is here and more, too.

Toward 9:00 the crowd starts winding its way thru the lanes toward Coulon's dance hall, the Sea Breeze Pavillion, where the celebration would terminate in a big free dance. We swing onto a car going that way and are whisked there immediately. The negro band is tuning up and in a moment swings into the gyrating strains of "I'll Be Glad When You're Dead, You Rascal You". I have the first dance with Rita. She is very smooth and supple in my arms. I go into an intricate tango step and she follows without a hitch.

During the course of the evening a party of us retire to the Place to mix up a couple of cocktails and return to the dance shortly. There are several attempts at combat on the floor but the older men put a stop to it. Flo Lanier, of New Orleans, whom I met here last summer, is here. Down to stay for some time to come. Her folks run the Palm Cabins on the isle. I dance with her some of the time.

I suppose it is about 1:00 A.M. when the dance ends. Buck and I retire to the Place where I spend the next hour and a half developing the wedding pictures.

Thursday, Aug. 23rd:
Dr. Engelbach entered the house this morning, wrecking our late slumber. The

Fais do-do at the Oleander Hotel

priest, he informed me, wished that I make an "interior" of the church before the wedding flora was removed. I dripped a bit of coffee, dressed, and in thirty minutes Buck and I were at the church. Exposures made, we wound our way to Boudreaux's, scene of last night's imbibing, and found the old man Boudreaux sitting atop a pile of oyster shells, serenely occupied with opening oysters. There was no evidence of his having celebrated his fiftieth anniversary.

Island church interior

Returned to camp, I developed the several interiors of the church and the one of old man Boudreaux. Later in the day I photographed the newlyweds and their bride's maid.

This evening, I showed my collection of photos to the coast guard captain and got an order to make photographs of the crew this coming Sunday.

Friday, Aug. 24th:

Just loafed around the better part of the morning. Just as we were cleaning up the dinner dishes, Col. Stevens walked in and wanted to know if we would drive him to Milliet's. The Colonel is not so adept at driving and frequently turns his car over to us. I made the trip pay by delivering some photographs there.

"Oysterman." Visier Boudreaux the morning after the double celebration of the wedding of his granddaughter and his fiftieth wedding anniversary with Geolina Chighizola.

Back at camp we washed out most of our clothes, then, later, while Buck got ready to fish in the surf, I went for the mail. Buck got a letter from Baton Rouge and I received the August issue of Southern Home and Garden in which I found my article, "Exploring Louisiana's Flora By Boat". It ran a photo of the "Pintail" in midpage.

I soon joined Buck and the Colonel in surf fishing. The fish evidently were on

a strike just inside the bar so I swam out to the bar and fished on the ocean side of it. Buck followed and it wasn't long before each of us had bagged a trout. Later I caught a beauty but it managed to slip out of my hand as I was removing it from the hook. Pretty soon my line jerked taut and began to zig-zag. It was a large Spanish mackerel. I dangled it on the hook a bit, wondering where I was going to put it as our fish sack was ashore, and finally watched the creature shake the hook loose and dart away into the gulf. What I said didn't bring the fish back, either.

So it was fried trout for supper. We had finally moved back inland to fish, where the trout had just begun to strike, and loaded our sack. Fish! Fish! Fish! I fear I ate so much that I'll suffer a twinge of conscience next time I look one in the face.

Mosquitos intolerable so we made an early retreat beneath the bars and to bed.

Saturday, Aug. 25th:

Slept like a log last night and arose rather early this morning. While Buck still slept I wrote a letter to my great aunt in New Orleans and struck for Ludwig's to mail it. Bought some baking powder, sugar, and eggs, with the best intentions to construct some pancakes for breakfast.

We went for a swim early in the afternoon and later loafed around the camp.

About 4:30 some people from New Orleans drove into the yard, saying that Mr. Danziger had extended them the use of the Place for tonight and tomorrow. We showed them their rooms, acquainted them with the kitchen, etc.

We were all engaged in conversation on the back porch when Mr. Danziger walked in, just from New Orleans. He joined the session for a while then shoved off for the Inn where he spent the night.

As night progressed, Buck and I shoved over to the dance hall. We were broke but that was no novelty. For a while we contented ourselves with watching the couples. Then it was that Buck conceived the brilliant idea of promising to take a photograph of the dance hall for the privilege of dancing whenever we cared. It was a bargain with the proprietor so we spent the whole of the evening dancing with the various native girls. During the evening a blowing rain storm sprung up, whipping spray onto the dance floor. I went to the Place about 12:00; Buck followed an hour later.

Sunday, Aug. 26th:

Up Early. And did I sleep last night! Our guests were up early, too, and hankering to go fishing. The storm was still lashing the tree tops and from the beach came the scream of harried sea. But nothing seemed to daunt their fishing enthusiasm. I went with the men-folks, to Milliet's to get some bait, whiskey, and tobacco. The sky seemed to pound the earth, a merciless rain. We ran thru intermittent squalls of it.

Well, our friends finally had to give up the idea, for the beach road. The only

way to the bridge where they would have fished, was inundated by the onrush of frothing waves. The Colonel dropped by in search of Mr. Danziger, but with Danziger's being at the Inn, I offered to drive him (the Colonel) there. Stayed there some time. When we left, Mr. Danziger accompanied us, he driving. They let me out at the Place and I strode in to find it deserted. Saw Buck's clothes strewn over the floor so knew he had gone for an adventure in the roaring surf. I donned my swim suit and joined him. I tried in vain to make the second bar but the giant breakers foiled any attempt. I finally retreated to shallow water and contented myself with diving thru the crested combers.

While I had been at the Inn our guests had departed for the city, fishless.

Buck and I lay, for the better part of the afternoon, in the chaise-longue and hammock, still plowing thru the three months old pages of the several magazines on the place.

As we are completely broke, with the exception of six bits, we are becoming very dexterious in the culinary arts. For several days we have taxed our abilities in that channel and it seems, or looks, that we shall continue to do so or starve.

Monday, Aug. 27th:

The storm had petered out by now and, for the first time in weeks, one could step from the house unmolested by the avaricious mosquito. I got up a trifle early for I had to get some mail off. The mail leaves at 8:30 A.M. every day in an automobile. I had written to Bob Frederick, my partner in filming the "Pintail Adventure", telling him in no uncertain terms that when I sent for the films I would want them in a hurry. Planning to show my way thru L.S.U. this fall. Also wrote to mother, telling her I would need my sax to help myself thru school by doing dance orchestra work. Then I wrote several post cards.

Yesterday, late, we spent the rest of our fortune—71¢—leaving only enough for the postage this morning. A few spare groceries absorbed it all.

Went in swimming just before mail time and, on getting out, made the post office just before it closed. I had two letters. One was invoice from Burke & James and the other from Bob Anderson, of the New Orleans Item, containing three important negatives.

Later, I closeted myself in the dark room and made some enlargements from them.

Tuesday, Aug. 28th:

Early at the job of mounting the enlargements. Two were of the "Golden Wedding" couples, one a portrait of "yours trully", three of the "Eldes", and a couple of others.

About 10:00, Buck undertook the thankless job of selling the wedding photos

Grand Isle Coast Guard

to its participants. It would not have been thankless if the photos had not been underexposures (due to the bad light after sunset) or had we asked less than the one dollar price we set on each of them.

I went on down to the coast guard station to photograph the crew. They were all decked out in blue serges and looking fit to kill. Ten of them in all. I guess it took me about thirty minutes to dispose of the business.

I fell to reading when I returned to camp and presently Buck returned, victorious, and planted two bucks on the table with a smile. Now we could eat!

This afternoon Buck borrowed the Colonel's car and we drove to Milliet's to show the enlargements of the "Eldes" to Joe, her skipper. Remained at Milliet's for some time talking to some dame, then bought groceries and returned to our section of the island, going to the post office before returning the car. No mail for either of us.

As dark grew on the island I started developing my negatives. Buck went on to the rectory to visit the priest, to whom we've taken a great liking. I was to follow after finishing with my negatives. It was quite late when I finally did get thru, because, even after the negatives are developed, they have to be "fixed" (takes 15 minutes), washed (takes 30 minutes), and hung up to dry.

I arrived at the rectory in pitch dark, after striking several trees and a barb wire

fence on the way. They had just about given me up. The priest immediately set up the chess board for our scheduled game and I trimmed him three times. When Buck and I left, the moon shone brightly thru the wind swept sky and the surf pounded murmurously on the shore. A wild and romantic night. And no mosquitos! But our lot was not on to bed where our wearied bodies yearned to be, but into the dark room to process about five dozen postcards. It was about 1:00 A.M. when the cards were completely washed and put to drying. Then it was the bed for us, and greatly welcomed, too.

Wednesday, Aug. 29th:

Well, Bob Anderson never did send me that sodium sulphite he promised, so there was nothing for me to do last night in developing but to use an old developer of which there was very little left. It was all noticeable on the prints this morning. A sickly sepia had crept over the surface of each print. And I have orders on most of them, too. Guess I'll let Buck pull the salesmanship act on the customers as my concious is very delicate. He did very well by the wedding photos.

On arising, I washed up yesterday's dishes and Buck went to the post office to mail some letters. Dark, rumbling clouds closed over the island this morning and, staying in to read and sleep, we were soothed by the steady drone of rain in the trees and breathed contentedly of the damp, sweet air. Toward noon the downpour ceased, but the dark cloud masses continued to loaf in the heavens.

The hammock we have on the back porch is getting to be a disease. It seems that all I did today was to read and sleep in its slack, but comfortable, pocket. I did not even take the customary dip in the drink. Missed it yesterday, too. What's getting into me? I'm inclined to put the blame on the hammock; it's such a comfortable old thing. Irresistable!

The priest dropped in while we were preparing supper and bought fifteen post cards. Said he could hardly sleep last night after the trimming I rendered him in our three chess games. He's a swell guy, that priest. Just as human as human can be, and affable and humorous.

Fried fish, bread, cheese, and coffee. There's our supper. And capped off with glasses of sparkling lemonade. Ordinary lemonade, but with a bit of soda added to each glass—half a teaspoonful. Gives it a luxurious tang.

As dark crawls on, so do the mosquitos—on us! The dam things come out of nowhere and get on you anywhere. You slap at them unconciously, automatically. Maybe your hand will come away smeared crimson with blood. You think nothing of it. Your clothes have the murderous spots scattered at random from pants cuffs to collar. There's a formula of words that I've taken great pains to work out—a form of mosquito relief. Not that it cures the aggravating itch, but it eases the tension and makes the situation a bit humorous (sometimes) which tends, regardless of the

priest, toward relief. The mosquito problem IS rather acute, tho. To hell with them, every damned one of them. The one that's on my ankle included. And that goes for the one on my neck, too!

Thursday, Aug. 30th:

A tang, zestful and exhilarating, floats in the window on the soft gulf breath. I open my eyes sleepily, draw deep of the wine like air, smile and try to go back to sleep. No use, I feel my very being as an electric charge bursting for action. I lift the mosquito curtain, contemplate the morning's toxic beauties, and remember how good a cup of hot coffee would taste. I go to the kitchen.

Buck wanders in, sleepily and stretching, and joins me in a demi-tasse. He, too, drew deep of the rare air. In no time, thoughts synchronized, we had slipped into our bathing suits and were trotting for the beach. Several heads bobbed in the surf ahead of us, bouncing flippantly in the frothing seas. It was six thirty. Into the surf we raced, chill spray flecking ruffed skin. It was great. Buck reached down and threw a dash of cold water on my back. I returned it. Then we surged farther and deeper and struck for the bar. I arrived ten yards in the lead. He was gargling a salt wave when I looked back. I just laughed out loud. It was not deep on the bar and the brisk air again pimpled my flesh. For some five minutes we talked and splashed and dove thru the combers. Oh, the joy of it! Sharpened appetites; keener thoughts.

Having regained the beach where the waves ran long fingers into the dunes we ran a race to camp. There we cut childish capers while rubbing down and snapped our towels at each other, appetites mounting at the proximity of breakfast. And it wasn't long before we were seated at the table. Golden frilled eggs, cheese, sliced bread, and coffee. It wasn't much in way of variety. Had it been a breakfast of the gods, it could have not been more heartily enjoyed.

After a brief period of relaxation on the drowsy hammock, I descended into the dark room and ran off the proofs of the coast guard photos. Then I took them to the coast guard station for approval and received about a ten dollar order on them. As I am out of a very important developer ingredient, sodium sulphite, I will have to wait until a shipment of it arrives to do the coast guard work. I have been out of the sulphite for some time now.

When I returned to camp I gathered together the photos that had already been spoken for and set out to deliver them and collect. Dropped in at Dr. Engelbach's to show him the two enlargements of the church interior. He wasn't there but Miss Adam, his house-keeper, asked me to leave the photos as the Doc wanted to purchase them. She, personally, bought six post cards. My next route was along dank, tunneled lanes to Miss Minnich's abode. Vivian was on the ground floor in the kitchen piecing together a jig-saw puzzle. I talked nonsense with her for a few moments then joined Miss Minnich in the back yard. She milked "Bessie", the cow,

with one hand and held back her unkempt hair with the other, occasionally letting fall her hair to slap at a carnivorous insect. As she directed the milk jets into the foaming bucket, she deliberated on what a good cow her Bessie was. When the bucket was half full, she liberated Bessie's calf from a rickety enclosure and it came bouncing over to where we were and butted into Bessie's limp bag. Then with an expression of satisfaction and complacence, it betook itself to one of the udders. What ho! All the milk gone? The offspring impatiently butted some more and got little satisfaction for its trouble. It seemed that Miss Minnich had all the milk in the bucket.

Having several postcards for Miss Minnich I traded them for a quart of the fresh milk. And at dinner Buck and I fairly feasted—on boiled cabbage, bread and butter, and glasses of tinkling iced milk. Filled us up, too, and put us to loafing on the porch for a while.

In the afternoon I remembered the postcards to be delivered to the "Eldes", so Buck and I started out of the house to hook a ride to Milliet's. And what should we see in the garage but two horses that had wandered in. We made short work of capturing them and applying halters, rudely constructed of odd bits of rope and string. Then, somewhat skeptical, we mounted, saw that we were safe, and struck for Milliet's by way of the beach. But woe was ours when we urged them to their best, for they would inevitably rush pell-mell into the dunes with no regard for rampant array of formidable drift stumps, or for us. I suppose they might be labeled razorbacks; we wound up at the Grand Isle Inn riding, not astride, but sidesaddle fashion and painfully dismounted. Mrs. Marshall emerged from the cafe and on seeing the doleful expressions of our sorry steeds she brought out sugar for them. After a bit we freed them and set them on their way about the island.

Buck caught a ride on to Milliet's, sold the post cards, and returned. As Mrs. Marshall was going for the mail in a few minutes, we waited to ride with her. In the meantime Buck spotted a chicken that had wandered near and blurted out something about how good it might appear on our table tonight and added, "We haven't had a treat like that for ages." Mrs. Marshall merely remarked, "Well, catch it then." And Buck did, taking her literally. I protested but Mrs. Marshall insisted that she meant it, so I couldn't kick!

At the post office Mrs. Ludwig passed my saxophone thru the window. I had sent for it a week ago. Now to get some practice before school starts and I shall try to get into the band.

And practice I did, but only for a little while. Buck soon had the chicken done and on the table and we proceeded to whittle the bones of the hapless bird. While thus engrossed, Mrs. Marshall entered wanting me to drive her to Golden Meadow to put in a call for Mr. Danziger. I gladly assented, but we dropped in the Oleander before leaving and she made arrangements with some fellow who was going that way to make the call for her. But I drove her on to the Inn where we had several

bottles of beer and smoked and talked until it was 9:00. At that time I got an opportunity to return to the place so I bid goodnite to Mrs. Marshall and the cafe proprietor, Mr. Nealy.

As I got out at the Place I saw a car preparing to leave. It was a boy and two girls that we had invited to the Place for tonight. I had thought Buck would take care of them. They had already hammered on the door, and supposing no one was in, were preparing to depart. I brought them in and awakened Buck. The boy was Allan Couvillon and the girls were Helen, his sister, and Flo Lanier of New Orleans. We danced, talked, and smoked until 11:00 then they had to be going.

I stayed up thirty minutes longer attending to some business correspondence for Mrs. Marshall. It had to be typed and she had no machine. Then to bed, with the alarm set for 7:00 A.M. as we intended to accompany Carabin on the mail to the mysterious little settlement drowsing on an island in the north part of Barataria Bay known as Manilla Village. We had heard incredulous tale of the place.

Friday, Aug. 31st:

At 7:00 the alarm shattered the heavy silence of the morning and we arose sleepily to start breakfast. With coffee, our nerves livened to the prospects of visiting notorious Manilla Village, place of mystery and contraband Chinese.

Buck went to make arrangements while I loaded my plate holders in the dark room. I was still engaged in loading when he returned with the sad news: Carabin was renitent to our going because of high winds blowing and insisted the voyage was dangerous. That was a hell of a note so I dashed to Ludwig's to try my luck. But by this time Carabin was already on his way into the bay. I spread our woes before Mr. Ludwig, owner of the mail boat "Sea Bird", and learned that Carabin had a mind of his own and must be handled very diplomatically, I should have better luck next time, he assured me.

Late this afternoon Buck and I went for a frolic in the frothing surf. So great was the tumult there, the greatest we have witnessed this summer, that I returned to the Place for my camera to make some photos of it.

When I went after the mail, Mrs. Marshall and her sister were coming down the lane in their car and gave me a lift. On returning, we picked up Buck then drove up the beach to Caminada Pass and back. They let us out at the dance hall. But we were very hungry so went on to the Place and fixed up some eggs. After that we returned to the dance hall but did not stay long. We were still sore from the horse back riding. So, to camp for us, and to bed on the wind swept front porch.

Saturday, Sept. 1st:

Bothered a slight bit by some captive mosquitoes last night. But never mind, there weren't more than a dozen.

Along toward noon Buck and I set out down the middle of the island, I with my camera. Had good intentions of going directly to Grand Isle Inn where I had made promises to do some portraits, but the fantastic scenes of the inner isle caused us to tarry. I had only four plates along and could not resist shooting three excellent bits of composition. Wound up at the Inn about 12:30 hungry as wolves but nothing could be done about it until we returned to the camp. Instead of making portraits I photographed the Inn, then after a while at loafing around and slowly starving to death, we decided to return to camp and eat. We tried to buy a dozen eggs from Mrs. Marshall but she made us a gift of two dozen instead, and on top of that, drove us to the Place.

We had fish for tonight's meal. Mrs. Rhody had given them to us. While engrossed in the gourmish pastime of polishing their skeletons, in walked Mr. Buddy Marx and nephew, friends of Mr. Danziger's who had arrived for the week-end. They said that Mr. Danziger was tied up politically and would probably wait until tomorrow to come down.

While we were shaving, Mrs. Marcus and her son, of New Orleans, dropped in to greet us. We talked for some time on various subjects, then later repaired to the dance. All of our island acquaintances were there and a little later Helen Couvillon showed up with her folks. Adequate chaperonage: Danced mostly with Helen but included "Chicky", Vivian, Flo, Rita, Estelle and a couple of others in the course of the evening.

Along toward closing time a scattering of fights broke out between a group of Grand Isle troublists and a knot of Golden Meadow representatives. Much horse play ensued, such as biting, displaying glittery hardware, having your opponent held by one of your faction while you proceeded to remodel his looks which you thought could mightily be improved upon, flying tackles, and the big walloping small. All this highly colored by vituperant flow of pointed French, which I could understand as well as Chinese. It was a great show, nevertheless. One comical incident presented itself when one of the Grand Isle exponents "treed" a Golden Meadower on one of the four by fours that support the roof. The fellow dodged around and up it like a monkey but his a[n]tagonist finally landed one that sent him hurtling inert to the ground ten feet below. And the disgusting part: When they decided there had been enough blood shed, they fell upon each other's necks, apologizing, shaking hands, and laughing it off,—all after so much pony play. Biting, ugh! Was glad to get home and to bed.

Sunday, Sept. 2nd:

Fairly early we were up and went for a swim in the surf. The water seems to be getting chillier as the fall season sweeps on and, accordingly, we are cutting our stays in the water. Eventually, I suppose, ice skates will appear.

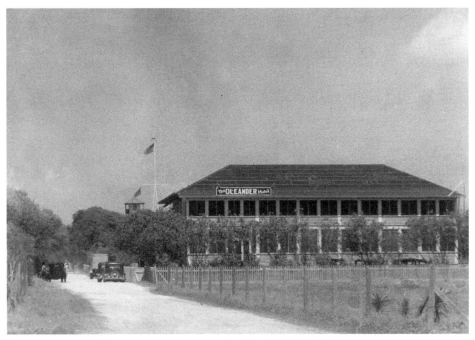

The Oleander Hotel

Breakfast over, we set about to loaf as usual and did so with polish and finesse, too. Conversation and reading. Later I went out with the camera and photographed the Oleander Hotel and also a beach scene, then returned to camp. Before noon I went to the church to secure a photo of the people coming out but the priest informed me that the congregation had dispersed at 11:00 A.M. I met several young men who were visiting the priest and during our conversations the subject of ice cream cropped up and terminated with an avowal to have an ice cream fest tonight. Buck was to come, too.

In the meantime Mrs. Marcus and her son, Peter, had dropped around at the camp. When I returned we sat for several hours on the back porch indulging in various debates and discussions. They had roomed last night at Boudreaux's, but as we had surplus rooming accommodations here we insisted on their spending tonight with us. Peter and I drove to Boudreaux's for their possessions. About 4:30 or 5:00 we prepared a spread and fell to with hearty endeavor as the midday meal had been ignored.

At 7:00 P.M. we all went to the rectory for the contemplated ice cream. The priest and I, after preliminary greetings and conversation all around, fell into the toils of a chess game in which I cleaned his slate. The following game the score was reversed as I unwittingly lost my queen early in the game.

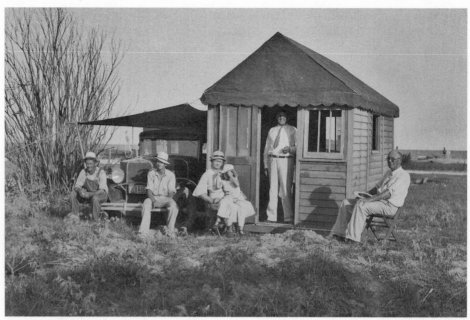

Tent house

About this time the boys brought in the ice cream so we all repaired to the dining room, rendered grace, and fell to. Two helpings were available and not one of us refused the second. After that we settled down to varied diversions—some to bridge, some to reading and whatnot, and the priest and myself to erstwhile conversation, the religious strain dominating. Time passed swiftly, and before we realized it the clock struck eleven . . ., then eleven thirty. We had to be going.

Buck and I shuffled on over to the dance pavillion for a few turns at dancing before turning in for the night.

Monday, Sept. 3rd:

After a bit of coffee we all got in the Marcus's car and drove down the beach to a location opposite the Grand Isle Inn and spent some time frolicking in the vigorous surf. On returning, we served ourselves a couple of rounds of fried eggs, coffee, toast, etc. The better part of the morning was spent with the customary discussions on the back porch where we all sprawled leisurely on the furniture there.

Approaching noon I set out on foot to make some photos while the others went exploring in the lanes. When I returned Peter and his mother were about to depart for the city. I photographed them together then bid them farewell. Later, Buddy Marx and nephew departed for the city. I sent a note by them to Mr. Danziger requesting him to prepare for me a letter of recommendation to L. S. U.

Late in the afternoon I photographed a portable cottage, called a tent house by its contriver, that had been erected near the beach for advertising purposes.

As the sun was setting a newspaper man and his wife drove up to camp, informing us that Mr. Danziger had extended them the license of putting up at the camp for the night. As he had to go to Milliet's for some ice, we let him drop us off at Grand Isle Inn. Mrs. Marshall and her sister, Mrs. Hamel, were in the cafe and we talked for a while.

No rides came by to return us to camp, so after dark had settled firmly over the land, and with some groceries that the Inn had donated, we started plodding the three intervening miles to our place. No rides offered themselves, but as we had lots to talk about, the long hike and the subsequent mosquitoes seemed more like a dream than a reality.

Had just completed construction of a pitcher of orange ade when our guests hove in for the night. With them was another fellow, very likable, and a gentleman of leisure. His dad had left him a neat annuity. They furnished the polish for our orangeade and soon we were all somewhat lacquered. I toppled in the hammock and dozed. The others talked in a sort of monotonous drone. I soon got so sleepy that I tottered to the front porch and went to bed.

(The greatest, most famous director of Hollywood was on the island day before yesterday, all day yesterday, and had left this morning. Who . . . ? Cecil B. De Mille! Had stayed on a yacht in the pass. Caught two tarpon. Was aboard the "Eldes" for some time. All this I did not learn until this morning when I dropped aboard the "Eldes" for a brief visit. That's what I call a tough break.)

Tuesday, Sept. 4th:

Last night a deluge of rain, borne furiously on a shaft of sea wind, struck me full in the face. I was up immediately and awakened Buck. While I jerked the bedding out of range of the onslaught Buck rushed into the house and closed all the windows. Then the torrents settled to a verticle onrush as the wind died down. We returned to our interrupted slumbers.

It remained cloudy the better part of the day, consequently there wasn't much to stir up in a photographic manner. But early in the afternoon I went to the post office to mail some letters and discovered a C.O.D. containing some photo supplies. The amount was $3.30 and that huge sum I did not possess. As I tramped my return up Ludwig lane I was pondering of whom I should proposition for a loan. I decided on Nolty as he was the most convenient but it was much later in the afternoon when I contacted him. Three bucks in hand, I claimed my supplies and returned to camp. The most important item in the package was a tin of Sodium sulphite, a chemical I had been out of for some time and which was causing great loss of business. The following hour I spent in formulating a complete set of new solutions.

The Oleander crew

As dark settled I set up in the laboratory and proceeded to "blow up" the coast guard photos. Made eight of the coast guard and two enlargements of the wedding couples. It was very late when I put the photos to washing. Buck and I played "Casino" to pass away the time and every little while one of us would change the water on the prints.

The September chill has settled on the isle now and before we went to bed we dug out several wool blankets.

Wednesday, Sept. 5th:

Hit a pretty fast pace today. After our guests checked out we got breakfast. Later I went over to the Oleander Hotel and made portraits of Rita, Louie, and Rebecca, laundress, waiter, and maid, respectively. These exposures brought my stack of undeveloped negatives to number about twenty. I hadn't been able to develope because of lack of the sulphite. But soon I was wrapped in darkness in my dark room and was peering intently into a small tray, assisted only by the faint glow of a ruby lamp. And all but two turned out excellently. Imagine how disconcerting it is to find one double exposure and one blank film! It was on the Grand

The Oleander dining room

Isle Inn negative, too, the one Buck and I had hiked down there for the specific purpose of getting.

Well, as soon as I had the negatives all strung up and drying, Buck and I caught a ride to the Inn to re-photograph it. I set the camera up in the marsh on the other side of the road from the Inn, mosquitoes fairly swamping me and drowning out my vocabulary, and proceeded to focus. This was to be a "C" (15 times) filter shot. I stopped the lens down to f.45, inserted the plate holder, closed the shutter and set it on "bulb", withdrew the slide, got out my watch, and made an exposure of eight seconds. It was then that I discovered I had failed to attach the filter. The plate had received sixteen times normal exposure without the filter. I swore at the mosquitoes and set about retaking the scene, taking care that no error should happen again.

When I emerged into daylight from the murkiness of the darkroom sometime later I noticed that both of the Inn negatives were overexposed. I investigated the camera and swore again as I discovered I had neglected to stop down the lens after focussing. These mosquitoes can do it, I tell you! And that makes three exposures of the Inn with no results other than double exposure or over exposure. All due to forgetting one little factor of the proceedure.

Buck Terry Bertha

Before I had returned to the Inn I had made more portraits at the Oleander. Buck, Terry, and Bertha had posed for portraits. Then Buck and I had brought out Aileen Chighizola (Chicky) for a sitting. She's Buck's soft moment.

Tonight, when I was getting out a bunch of prints, the lights went out. Buck rushed over to the Oleander Hotel, where the delco is located, and learned that something had gone blooey. We knew that much as soon as the lights had gone out! Anyway, the situation was detrimental to photographic processes, so we washed up what prints we had made and turned in for the night.

Thursday, Sept. 6th:

Another good pace today. Had to mount a bunch of enlargements—all the coast guard photos. Got the portrait of Rebecca ready for delivery. It is to bring three dollars. A boy friend of her's ordered it. Hope he can pay off. If not, I have a swell portrait of Rebecca.

Before noon the priest and his friend dropped in. He had a photo he wanted me to copy. We all made ourselves comfortable on the back porch and Buck and the priest went tooth and nail into a furious debate on the morals of young America. Buck admitted that the morals were low but went on, "Why try to defy the laws of nature?", to which the priest replied that we are endowed by God with Free Will, which, in itself, raises us above the animals, and with that same Free Will we are able to, if we so desire, to make ourselves REAL men and reap the harvest of a happy old age brought about by clean, straightforward living.

Grand Isle priest with friends

Buck and the priest had been at this for some two hours when Waldo, the "Item" man, dropped in. His face was a cherry red from an all day vigil of fishing in the hot sun. He dropped easily into the conversation. But soon the priest and his friend had to leave and on leaving, extended to us an invitation to have ice cream with them tonight at the rectory.

Waldo went out to his car and returned with a bottle of Sherry wine, and banging it on the table remarked quite casually, as if it were incidental, "Let's kill it."

Buck drank only one small glass, but Waldo and I sat for one hour drinking it glass by glass. And quite before I realized what was what I knew I was a couple of sheets to the wind. And Waldo wasn't!

Anyway, the whole thing winds up with darkness settled on the land. Waldo is gone and it is about time we were headed for the priest's house. A negro from the hotel sidles into the yard and announces that the chef wants to bestow upon

us some gumbo and would we come over for it. We would! Both of us were about to starve for food as we had had neither dinner nor supper. So we make our way to the hotel kitchen where the cook ladles us out a pitcher full of gumbo for us to return to camp with and consume. It was very dark and the lights were still off so Buck made a lamp by stuffing rags into a bottle of kerosene. We polished off the gumbo by that smoking and flickering light. Then I got on the hammock and closed my unstable eyes. The hammock rocked gently. I seemed to soar and to zoom and to reel. Something within revolted. I seemed to have gone into a dive. I yelled for Buck but he arrived with the bucket too late. He leaves the room laughing so hard that I laugh a little bit, rather weakly though, for my sense of humor is dampened by another emetical performance. Wow! What a feeling! I know full well that I can't go to the rectory and get all that good ice cream, and play those chess games with the priest. So somehow I get to bed. Buck tucks the bar (mosquito net) around the mattress and sets out for the rectory to express my regrets. I fall quickly into a dead sleep.

Friday, Sept. 7th:

It seemed I was awakening into eternity. Everything was dark. I could see a few stars twinkling in the window. I wondered why the night was so long and why it wasn't dawn. A burning thirst posse[s]sed me and I got up, stumbled across the chair-strewn back porch into the kitchen, fumbled for a cup and found the faucet. Three cupsful afforded some relief so I found my way back to bed and tried to sleep. I did, somewhat fitfully, until dawn. Then I got up. The day was very still, and cool, and revivifying. My inexplainable thirst was still with me and I mixed an orangeade with a little lemon juice. It was like sipping of Life. It felt swell. A couple of aspirins, a demi-tasse of coffee then I put on my bathing trunks and was soon saturated in the soothing sea. The water was chilly but I swam vigorously and reached the bar in scintilating spirit.

All day long I kept busy at making and selling photographs. For the best part of the day the lights still remained out of order but Buck and I worked out a system of daylight printing for the contact prints that didn't consume too much time. Buck developed while I printed. For each dozen postcards, twenty minute's time was required to expose and develop and put to fixing in the hypo.

I can truthfully say that today'[s] work was the hardest I've ever put in on photography. I've got to work hard, though. I want to start school at L. S. U. when it opens and if I do not get some money beforehand an embarrassing situation will result. My collections for the past two days have amounted to over $11.00, $3.00 of which I owe to Nolty. But he has been in New Orleans and I haven't been able to pay him off. [C]ounting my chickens before they hatch, I estimate that I'll collect at least $10.00 more before leaving. That will mean that I can get off this island and quit playing Robinson Crusoe.

Saturday, Sept. 8th:

Woke up roaring hungry this morning but delayed breakfast a bit in order to catch up on some photo orders. As Buck and I worked at this we kept getting hungrier and my mind insisted on reviewing the fact that the larder was nigh cleaned up. Work aside I got to swinging a fork thru some pancake batter and managed to get some water heated for coffee. We got hungrier all the while but could not look forward with enthusiasm to the prospective pancakes—they contained no eggs, only flour, water, and baking powder, and salt and sugar.

A resonant sound pierced the still morning air. We had long ago become familiarized with that sound. It was the meat truck stopping at the Oleander Hotel. The piercing sound of that horn beat on my tympani, which in turn transmitted the message to my bread basket. The latter growled only once as I dashed out to the meat truck, a prospective customer. In the bed of the truck was displayed an array of iced meats among which were some gangly sausages of notable length and some very tempting steaks. I bought a steak and a yard of sausage and ran gleefully into the house to display the trophies of the morning's shopping before Buck's glutinous eyes. His mouth watered as I put aside the pancake dough and curled that yard of sausage into the hot skillet. And I felt very much at peace with the world after devouring half of its length. A bit of coffee and a pancake or so topped the morning repast very well, then I had a smoke in comfort while swinging in the hammock.

Buck went off with Waldo on a fishing spree and I set about the isle to do a little collecting and delivering. Called first at the rectory to give the priest some photos and we had thirty minutes of delightful chatting. A call at Dr. Englebach's place was scheduled next. I found him emerging from his littered office and told him I had the photos ready for his house-keeper, Miss Adam. We talked for a while then he took me into the garden to show me their patch of guava trees, the fruit of which Miss Adams transforms into succulent, red jelly. The doc plucked some of the yellowish-green fruit of which I delightfully partook. Three of them were enough for me. They were very tasteful and reminded me of something I had eaten before but I could not remember what it was. Sold my enlargement of the Grand Isle bus on the beach to the doc before leaving and made an appointment to do his portrait later in the day. Then I called at Ludwig's to show Mrs. Ludwig and the old man some of my views of the island. They thought my prices exhorbitant and looked at me as they might have upon a pirate, although every time I bought cheese there, I bought half the weight of his hand. Pirate!

I returned to camp, and noticing that it was one o'clock, I set my path for Waldo's, where I was to have lunch. But they had not returned from fishing yet, so I retraced my steps to camp. Went over to the hotel to while away some time and to pass out some postcards among my friends there. Just creating a bit of good will as it is almost inevitable that I'll return here next summer.

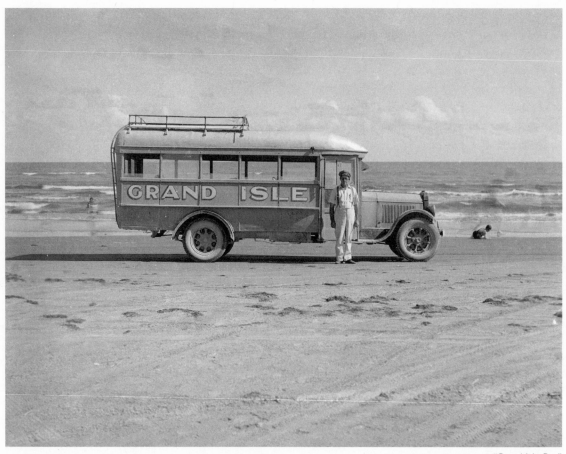

"Grand Isle Bus"

It was about three thirty when the fishing party (Mr. and Mrs. Waldo and Buck) returned to camp. They had caught no fish but while Waldo and Buck had tried to catch some, Mrs. Waldo got busy with a string and a piece of meat and captured almost a bushel of crabs. Nobody had any use for the crabs so I volunteered to sell them to the hotel. At the hotel I was informed that all of their purchases were transacted through old man Ludwig at the store so I caught a ride on a truck, putting the crabs in the back, and went there. Mr. Ludwig like to have thrown a fit when I quoted my price on the crabs at fifty cents. He went into the store to revive himself. I followed shortly and again queried if he would purchase the crabs. He had a look of exasperation and his attitude was a mingling of aloofness and surprise.

"Man", he said, "surely you were joking when you said you wanted fifty cents for those crabs, weren't you?"

I assured him in all seriousness that I was very sincere in my demand for fifty cents for the crabs. Crabs generally sold for at least ten cents per dozen and I esti-

mated the basket to contain about eight or ten dozen. If I wasn't offering a bargain, I was kidding myself. Still I was dealing with old John Ludwig and I fancied not the prospects of toting the crabs back to camp in the hot sun.

"Surely," he continued, "you are not up on the price of crabs, and after all there is very little demand for them now. Why, I might even have to throw the whole lot of them away."

I was becoming impatient with all this quibble and wished I had thrown all the crabs away myself before coming to Ludwig. "What will you pay?", I ventured.

Then, for the first time, I was aware that he was smiling faintly. I wanted to be done with the affair. I told him that maybe I was wrong and wasn't up on the price of crabs.

"What will you pay", I ventured.

"Why, only a quarter—and I'm being robbed at that!" He wiped his brow again, and started arranging some wares on the shelves, as if to dismiss a bad bargain.

"They're yours," I said resignedly. I was licked—by a pirate born.

Loftily, he tapped the cash register for my quarter, flipped it on the counter, and returned to his task of arranging wares. I angrily struck for camp. There I told of the transaction with Mr. Ludwig and we all had a laugh. But in my perplexity I conceived that the laugh was on me. I know that my share of the laughter was.

Waldo said they had a lot of things to eat waiting for us at his camp so we got in his car and went there. In a while we were all seated to a table of steaming gumbo, iced tea, and devilled crabs. After what I had done, I could hardly look the stuffed crabs in the face. Oh my! Oh my! But I ate them, and with finesse, too.

The time passed swiftly and the sun sank low. Gracious, what had I forgotten? That's it! I was to have made a portrait of the Doc. Waldo and I got in his car, stopped by the camp for the camera, and arrived at the doctor's a few minutes later. It developed that Waldo was the grandson of a very dear friend of the Doctor's, so they had quite a talk on that score.

Finally I got them separated and made the portrait of the doctor. On bidding our host goodbye, Waldo and I drove to the post office. I had a letter from Helen Couvillon, of Araby, Louisiana. A couple of cokes, then we returned to the camp. Picked up Buck there then drove along the beach sniping at sand pipers with a .22 rifle. We only succeeded in scaring a few of them, doing no damage at all. By the time we decided to go swimming the sun had set. I had to dash to camp for my suit. Buck and Waldo had theirs. At camp I discovered that Mr. Danziger had just arrived with some friends from New Orleans. They had all just gotten into bathing suits and were starting for the beach. The guests were Mrs. Nelkins and her two daughters, and a Mr. Danziger, Al's cousin. I joined them on their way to the beach.

One of the daughters, the eldest, proved to be eligible! If you get what I mean. A good swimmer, a good sport, and as I later learned at the dance, a good partner. We had a swell time in the surf and returned to camp in the last strain of twilight.

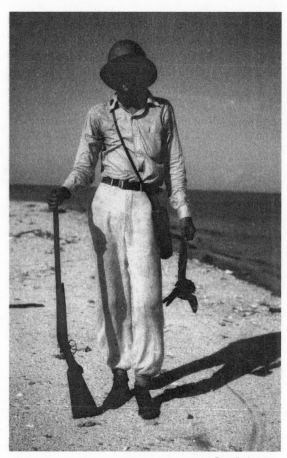

Fonville hunting

While the rest of the party repaired to the Oleander for supper, Buck got dressed for the evening. I had promised the priest I would call on him tonight to play chess so I set out in that direction. Stopped by the coast guard, on my way, to do a little collecting. Found the priest and his guest reclining restfully on the veranda and we conversed a while before entering into our chess session. While we were putting the men into place, his guest prepared some very agreeable fruit salad of which we partook later. It was about nine thirty when I departed their company to go to the dance, but in passing the camp the racked strains of our victrola floated toward me. There I knew I would find Buck and the Nelkin's girl dancing. I persuaded them to accompany me to the dance pavillion and there we rocked and reeled to the rhythmic excuses for the latest song hits until it was quite late and the mosquitoes had become annoying. We sought refuge back at the camp and reclined on the back porch for light conversation.

Later Buck and I went to bed on the front porch between fresh linens. Ah, what glory, Sleep!

Sunday, Sept. 9th:

We were all up early and went swimming. The surf was exhilarating and I came out feeling brisk and healthy. Breakfast came at 9:30 and a neat dozen eggs were rounded off with lots of bacon. While the water was heating for the dishes we all sat on the porch and smoked, that is, several of us smoked, the rest busying themselves with the funny papers. Dishes over, Buck went for the Colonel's car in order that we might show the girls over the island.

About this time I felt for my wallet absent mindedly and did not find it. I searched the place in a feverish sweat but with no results. All the money I had was in that wallet, all the photo proceeds, and I tried to be nonchallant about its missing. I mentioned it in a casual way to Buck who immediately began to help me sweat. I remembered a dozen places I had been the night before—in Waldo's car, at the priest's, at the laundry woman's, at the dance and other probable places. The first place I wanted to look was in Waldo's car. We drove to his place to learn that he was fishing on the bridge so there I drove, putting the Colonel's car at its best. There was Waldo and the car but—no wallet. Almost resigned to being marrooned the rest of my life on this isle, I proceeded on the proposed pleasure tour of the Place, first driving down the length of the beach to that part of the isle opposite Ft. Livingston. There we basked, perched upon a huge piece of drift wood, in the living sunshine and breathed the zephers of the sea. It helped me forget my worry.

At 5:30 we all went into the surf for about an hour's exercise then returned to camp and prepared a supper fit for the hungriest of gulf soaked swimmers. The dishes were left to Buck and me while Al and the guests prepared to depart for the city. They were gone as the dusk dwindled into starry night.

Earlier in the day Buck and I had made arrangements with Captain Coyne to leave the island with him tomorrow. He was transporting his portable tent house to Larose and we had agreed to help him load it on his truck for our own passage. So late into the night I worked, packing my equipment and personal belongings and at 11:30 P.M. I had almost finished the job. Went to bed full of the excitement of getting away from the isle and of embarking upon the adventure of entering Louisiana State University with no capital and lots of nerve.

My dreams were made sweeter by my finding my wallet where I had undressed the night before. It lay in the seat of a chair that was pushed up to a table.

Monday, Sept. 10th:

Captain Coyne had said he would be leaving at 9:00 A.M. so Buck and I worked in a frenzy to finish preparations for leaving. I was through before Buck so I went

on over to where Captain Coyne and his helper, Steve, were getting ready to dismantle the tent house for loading. It took us 29 minutes to dismantle the structure and we had it loaded by 10:30. Fifteen minutes later, everybody and their luggage aboard, we bid "goodbye" to Grand Isle—and hordes of mosquitoes!

For some hours we bounced along thru the rugged marshland and hugged the banks of Bayou Lafourche for Larose. Nearing Larose we stopped at Steve's house for a very welcome dinner of soup, fried chicken, cornbread, buttermilk, etc., then drove on in to Larose where we unloaded the truck. It was here that Buck and I parted company, he to hitch hike on to his home in north Louisiana and I to await the 5:30 bus for New Orleans. We were to meet again the following week at the university.

I found my way to the bus station, which title is mighty presumptuous as the place is only an ill thriving filling station. This was about 1:30 and the bus was due at 5:30. So there I sat all that time—and at that the bus was thirty minutes late. My ticket cost me $1.65 and my luggage, consisting of seven articles and weighing in the neighborhood of 200 lbs. was loaded aboard. Arrived in Raceland at 6:45, and changed busses for New Orleans. Thunder, lightening, and rain ushered us into the Crescent City of New Orleans. Otherwise the trip was uneventful. The only exception: the bus was so crowded I had to sit in an aisle seat and I developed a crick in my neck trying to get comfortable.

Thinking that I might put up at my Great uncle's place for the night I asked the driver to let me off at the 5000 block on St. Charles Avenue. I could walk a block from there and be at his place. But the driver made a mistake and let me off three blocks past. Not knowing of this mistake because of my unfamiliarity of the city I almost lost myself walking the misty streets in that neighborhood. Then I happen-to think that maybe the driver had let me off at the 500 block instead of the 5000. I returned to St. Charles Ave. and caught a streetcar for that direction, telling the conductor where I wanted off. He evidently knew as much as I did about the city for he drove three blocks past my destination before letting me off. Well, to make a long story short, I arrived at my Uncle's very much soaked in sweat. And inside, I sweated even more. The humidity was terrible. We all talked for a while then they asked me where I was spending the night, which was just what I wanted to happen! I said the Y.M.C.A. and they said that was a very nice place to stay. So I caught a car for the "Y" a little later.

The clerk wanted to charge me a dollar and a quarter for the night but when I said I had stayed overnight two months ago for one dollar he came down, then got quite friendly. We were calling each other by first names by the time I had finished registering. But I wasn't ready to turn in yet. I thought I might stir up something. I called Mrs. Marcus and she said Peter would call me at 8:30 in the morning to make arrangement to see me. Well, that was that, so I trotted up the four flights of

stairs to my room and went to bed. From my window, the monument of Lee's Circle reared it[s] majestic height into the murky fog, its summit barely discernable by ghostly lights striking upward thru the gloom from the base of the monument. I fell asleep and dreamed of exciting things ahead.

Tuesday, Sept. 11th:

Up at seven, I washed and shaved and found a restaurant around the corner where I breakfasted for fifteen cents. Back at the "Y" I await the call from Peter Marcus. I get it at exactly 8:30. He tells me that he'll be by at 10:15 so I retire to the library of the "Y" to smoke and read until that time.

We go first to the bus station where I get a few of my things. Then after an hour's sight seeing he drops me at the New Orleans Bank Building where I have an appointment with Mr. Danziger. He is to give me a letter of recommendation to L.S.U. I tell Peter to meet me in front of the building in thirty minutes and I catch an elevator to the twelveth floor. Mr. Danziger is very busy and tells me to write the letter, saying he will sign it. So I write the letter of recommendation that is to get me a job with the university.

Dr. James M. Smith,
President, La. State University,
Baton Rouge, La.

Dear Doctor Smith:

This letter is for the purpose of introducing to you a young man who has already applied to the university for a working scholarship. He will need assistance in getting started but after that, with his several talents, he will be able to take care of himself.

His four years of experience in photography has made him quite expert in both motion pictures and "still" work. He has been photographer for three issues of his high school year book, one of which won second in a national competition; and he has worked on the Fort Worth Press as photographer.

Another of his accomplishments is music in which he has had ten years experience. The sax is his instrument and he is desirous of entering the band. In his senior year at Central high school he performed well in the pole vault, reaching an unofficial record of 11' 4" and an official of 11'. All this with very little training.

He graduated from Central High, second largest in the South, with good standing, but due to financial reverses of his family was not able to start college. He worked for the Texas Flying Service as aerial photographer for a

short while; left to work as carpenter in central Louisiana on construction of bridges. His next job was with the Texas Electric Service Company as meter tester. In 1932 he organized an expedition and cruised the Louisiana coast making movies. He spent the following fall and winter exhibiting in schools and lecturing. He conducted another expedition in 1933, which met with financial reverses but in which an excellent film was produced. He intends to combine the two films for exhibition in Louisiana schools to help him through school.

He also worked as C.W.A. photographer in Fort Worth for five months.

Anything you can do to facilitate his entrance and acquisition of work will be appreciated as all he wants is a start.

With kind regards, I am

Sincerely yours,

A. D. Danziger.

The letter business finished, I bid Mr. Danziger goodbye and beat it down stairs to meet Peter. We go to his home for lunch then later go to the "Y" for a swim. There we have a swell time racing and diving. On getting out we grab a bite to eat then try our hands at ping-pong. We read some, too, in the library and at 5:30 Peter leaves.

As dark drew on I got restless and set out down St. Charles, walking leisurely. Dropped in at the St. Charles theater to see Richard Barthlemess in Midnight Alibi. It was my first show in some time and I thoroughly enjoyed it. Had a milkshake before retracing my steps to the "Y".

There I got into a chess game with the clerk. One game led to another with myself getting whitewashed each time. I later learned that he held second place in a recent state chess tournament. Played with another fellow and won only the first game, that with a trick opening of mine. Went to bed at 12:30 feeling I had better give up chess or improve my game.

(The air was charged with the election today. Everybody talked it. Tonight there were huge groups of people standing on the streets watching results projected onto screens. Even the picture show I attended stopped every now and then to announce the latest results. It's Long vs. Walmsley.

This morning while I was in Danziger's office I telephoned Waldo. He said he was driving to Baton Rouge on the morrow and that I could ride with him. It would save me bus fare.)

Wednesday, Sept. 12th:

Waldo came for me thirty minutes late this morning. We rushed to the bus station, loaded my stuff on and went for his wife. They were driving to Baton Rouge to attend a wedding.

LSU campanile tower

Arrived in Baton Rouge at 10:30 A.M. and boarded a street car for the university. Arrive there in a daze, a total stranger in a strange place. And a few moments later ran into David Bell, a fellow I had met on Grand Isle last summer. We had had great times together. He piloted me over the campus and named a few of the impressive buildings. The huge tan edifices and spacious lawns bewildered me. When I parted his company I went to the post office where I collected several pieces of mail. Next I went on an unsuccessful search for the band master and ended up by inquiring where the Gianelonis lived. I had met them on Grand Isle and told them of my plans to attend L.S.U. They had graciously offered to help me out. So I called upon them, and it was here I truly ended up. For the Missus agreed to let me work for any board and room until I should get lined up at the university. In the

afternoon Waldo brought my stuff out and I moved into an upstairs room. I could see the campanile from my window. It had a clock on it which chimed the hours as they swiftly passed.

Thursday, Sept. 13th:

Up early this morning and fairly consumed, in a consumating manner, a breakfast that listened to the confidences of my construction. All this is confidential, understand.

And after that a change into rough clothing, there being necessity to haul some furniture for my landlady. I drove a truck of ancient vintage and had with me three negroes. The piano was the most difficult to handle but with perseverence we soon had it at the house and moved it inside. Then I chopped weeds 'til 12:00 at which time I could hardly wiggle the hoe.

Repaired to the shower and soaped up luxuriously. About this time the water mysteriously shut off and I couldn't open my eyes. Oh, the torture of it. I found a towel and cleared my lamps and began to wonder what the hell. Ten minutes later the water came on again and I rinsed off and dressed and went down to dinner. Did I eat! I blush.

Rested and smoked my pipe for an hour or so afterward then went with the truck to a plantation and loaded up with hay. Had a blowout on the way back which caused lengthy delay. At the house I unloaded the hay, showered, and ate supper, being the last one to leave the table.

Got in touch with Helen Gilkison, a girl I met on Grand Isle. She is the Item-Tribune correspondent here and has her desk at the Capitol. I am to see her tomorrow. Phoned Charlotte Levert, girl I met in Lake Charles last Easter. I am to see her at 8:30 in the morning. She lives just off the campus and volunteered to usher me around the school while getting lined up.

Friday. Sept. 14th:

This morning I dressed for business. First time I have felt or looked civilized in two months.

I did justice to my breakfast then ambled over to Charlotte's. We went first to the president's office where I made an appointment for 9:00. On coming out we ran into Capt. Wickboldt, the band master. Charlotte introduced us. We joined him to the band hall. There Capt. Wickboldt introduced me to Max Marx, who has a dance orchestra. Of course I recommended myself as a sax player, the same as I had done to Wickboldt. When he left, Wickboldt told me to come back later and try out for band scholarship.

By this time my appointment with the president was close at hand so we returned in that direction. I had only waited a few minutes when I was called into his office, I

introduced myself and handed him Danziger's letter. He read it and said, "I can give you a fellowship at $40 per month, is that alright?" I was astounded. I was expecting a job of some sort at $20 or even $15. I assured him that it was alright with me. I couldn't kick. Then it developed that he had misunderstood or mis-read the letter and had divined that I was a college graduate. He had to laugh when I told him I was only a high school graduate. It was in the letter; I don't know how he missed it. Anyway he gave me a photographic job at $20 per month, which is the maximum for freshmen. His secretary wrote out the following letter and handed it to me:

Mr. T. F. Winans,
Campus—

Dear Sir:
 This is to confirm your appointment to a working scholarship at $20.00 per month for the session of 1934–35. Your duties will be assigned by the President's Office.

 Very truly yours,

JMS:H J.M. Smith, pres.

Late this afternoon I had my band tryout and acquired the scholarship. It amounts to $20 per year. Band uniform will be furnished.
 Called on Helen Gilkinson at the capitol. Found her in the press room looking more dreamy eyed tha[n] ever. As she had to meet a bridge engagement presently she dropped me off in town. I walked out to the school, a distance of about three miles. Back at the house I changed into work clothes and labored until supper time.
 At 7:00 I reported to band hall for the first rehearsal. It lasted an hour. I got wind of a sax that hadn't been issued, and as my sax is in very bad condition, I signed for the school sax and took it home. Practiced on it a bit to ascertain its perfect condition. It had just undergone an overhaul job and looks like new.
 Well, must go to bed now.

Saturday, Sept. 15th:
 Do not get to work around the house at all today because of the band. Drilled without instruments from 9:00 'til 12:00. Was dog tired from marching in the hot sun and was nursing a headache, to boot. In the afternoon we drilled from 3:00 'til 5:00 and tonight had band practice from 7:00 to 9:00. I left in time to meet Max Marx down town in front of the Istrouma Hotel. We played for a dance from 10:00 to 2:00. Got home at 2:30. Made $3.50.

LSU orchestra. Fonville is in front row, fourth from right.

Sunday, Sept. 16th:

Cloudy and cool. Worked in the yard until dinner time. Worked some more after dinner. At 3:00 reported to band practice. As we were all getting tuned I noticed a large, fidgety man pacing the floor. Once in a while he would wink at somebody and laugh. A lot of visitors were watching him. He looked very important. Presently Wickboldt introduced him. "Boys", he said, "I want you to meet a man who is quite influential around here. Huey Long!" Huey jumped upon the rostrum, waving his arms. "Influential, hell!", he retorted, then grinned slyly, "I'm boss of this outfit!" From then on he was the show. Every eye was glued on him and his little antics and witticisms handed us many a laugh. He did not remain long, however.

I had a date with Helen tonight. We went to a card party that her friends gave.

Buck got in today. Didn't see much of him as both of us were very busy.

Monday, Sept. 17th:

Drilled with instruments today, both morning and afternoon. Got a room in the barracks. Fellows wanted to cut my hair but I put them off. All freshmen are running around with heads like billiard balls. Tonight is my last night at Gianeloni's.

Tuesday, Sept. 18th:

Although I moved out of Gianeloni's I still work there for my meals. Had band drill this morning which ended at 11:30. Today I waited on the tables at Gianeloni's. They cater to student roomers and boarders.

Drilled again in the afternoon. Spent some time with Buck after that.

Tonight, just as I was clearing the table of the supper dishes, I glanced at the

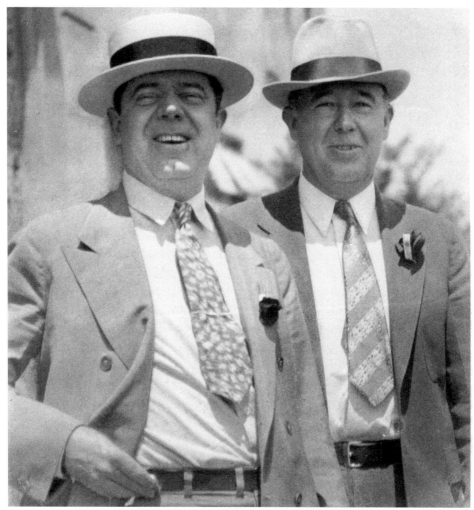

"Huey and President Smith"

clock. It was 7:30. Band practice had started at 7:00. I arrived there forty five minutes late. Stayed in the barracks tonight.

Wednesday, Sept. 19th:
 At 8:00 the entire body of freshmen lined up in the gymnasium to fill out personal history cards. After that I strolled a bit then went to see Business Manager Jackson about making, or signing, a note for my registration, but he was very discouraging. Said that the fees had to be in cash. Toward noon I wandered by the music building and bumped into a job playing in the L.S.U. cafeteria for my dinner. One of their sax men was missing.

Early in the afternoon I went into the Peabody Bldg. with. the rest of the freshmen to take the English placement examination. It was pretty hard.

Joined Buck later and we went in search of the Farquhars. They drove me to town so that I might buy a blanket but I couldn't find a bargain. I gave it up for the time being. We all had dinner together at the Green Lantern, just off the campus.

Got back to the campus at 7:15 and joined the band at the Greek Theater where we played for some addresses to the freshmen. Returned to the barracks after that.

Thursday, Sept. 20th:

I was up early this morning. I wanted to see Jackson as soon as possible about the note for my registration fees. While waiting at his office door Mr. Culpepper wandered by. I had met him quite accidentally. He runs the Brass Choir. All the members of the Cafeteria orchestra belong to the Brass Choir. It makes up a sort of a combination outfit. Anyone belonging to the Choir gets a $100 scholarship and if he is a dance musician too, he gets to play in the cafeteria orchestra for his meal. I had already discussed my joining the choir with Culpepper, but he hadn't given me any encouragement. Now he talked business. He needed more musicians, and besides, the cafeteria orchestra needed a sax man. So we talked on that score and I decided to resign from the band and sign up in the choir. That would end my worries. And I wouldn't have to take military, either. After I resigned from the band I sought Culpepper in the Music Bldg. He gave me the following note to take to Jackson:

Mr. Jackson:

I am adding Fonville Winans to my Brass Choir. He will be number 21 on the list I gave you this morning.

Thanks,

A.V. Culpepper.

The list he referred to was one entitling each of us to a $100 scholarship. That meant registration would cost exactly nothing.

Started my registration this afternoon but did not finish. I had to leave in time to play in the cafeteria.

Friday, Sept. 21st:

Got a room in town today with the Cobbs, having met Carleta Cobb on Grande

Isle during my stay there. Have to vacate the barracks because I am not in military. Tonight the Farquhars moved me and my luggage to my new abode, 245 Royal St.

Saturday, Sept. 22nd:

Slept well last night in my new quarters. Arose early so as to get breakfast at the cafeteria at 7:30. I caught a ride to school.

Visited Gianeloni's to see how construction was coming along on the apartment house that Roy Gianeloni has just begun on. When finished he will rent out rooms to students. I have already reserved one.

Ran across Mr. Farquhar after dinner and we drove around a while discussing the advantages of my working my way through. During the course of our drive we parked and smoked cigarettes. He reached in his pocket, and, extracting a check book, wrote me a check for twenty five dollars in spite of my protests. He said he didn't want to see me have difficulties getting started in school. I really did need the money and thanked him best I could.

Tonight I played a dance from 9:30 to 11:30. Made $2.00.

[A later, unknown date:]

I ended my diary there. My time was now being taken up with school. On Monday I finished registering and soon started attending classes, settling down resignedly to the turmoil and school routine of being a college student. I registered in the Lower Division of Arts and Science, majoring in journalism. My other subjects are Speech, English, Social Science, and Spanish. I don't know how this way of existing will affect me—dropping to subsistence under the obligations I have incurred, from the exciting life of following one's own bents. I strangely suspect I shall become restless, dreaming of boats and adventure and exciting places where the humdrum of civilization is just a faint memory. However, as things are, this going to school is just a new adventure, the end of which I cannot fathom. Life is such a gamble and I have nothing to lose. So I'll gamble!

CODA

The Pintail *died near Fleming Plantation, where one of Fonville's unrequited loves was to mourn the loss of this talented, lanky boy from Texas for the rest of her life. Avoca Island absorbed the* Pintail's *bones, and Fonville went on to Louisiana State University and the fame so well deserved in Louisiana's history.*

The cruise of the faithful Pintail *and the diaries so clean are placed on a shelf to be revisited seventy-seven years later. Freedom and growing up were to fade into another story. What is most charming, indeed poignant, is how we leave off. In Fonville's own words, "Life is such a gamble and I have nothing to lose." Only a twenty-three-year-old college freshman with another whole life yet ahead of him could have been so cocksure and carefree.*

A NOTE ON *VOYAGE OF THE "PINTAIL"*

In 1995, three years after Fonville Winans's death, his heirs placed many of his surviving negatives on deposit in the LSU Libraries' Special Collections, including not only the images reproduced in this book but also images that run the gamut of his work. From high society headshots to scenes of wild Louisiana, Winans captured it all. In addition to wedding pictures and portraits, he photographed opera stars, showgirls, debutantes, and politicians. In several series, he recorded the agricultural and industrial aspects of cotton, sugar, and rice, as well as their social sides, with the blessing of the sugarcane harvest in Loreauville and the Crowley Rice Festival. The new State Capitol and the LSU campus were frequent subjects, and many aerial shots documented Baton Rouge and the coastline.

Amid all these photographic riches, one treasure of a different kind stands out. Included with the thousands of negatives of still shots were two reels of 16mm film marked "Pintail 1" and "Pintail 2." Silent, in black and white, the film begins with credits: "Photography by Fonville Winans, continuity by Bob Frederick, titles by Raymon Orren." For the next twenty-six minutes, the viewer tours a Louisiana that seems familiar and yet has mostly vanished. Although Winans edited the film to create a good story line, some scenes are easily recognizable in the diaries. For example, we see the sailors battle with thickets of impenetrable water hyacinth, like those described in the diary entry for June 11, 1932. Adventures in New Orleans, recorded in the diary entries for June 15 through 19 of that year, appear on screen, as donning their *Pintail* uniforms, the crew visits "Lafitte's Rendezvous," Jackson Square, and the market, where they buy bananas and other supplies. Other scenes pass unmentioned in the diaries, as the photographer commented with his camera on what seemed "picturesque and quaint" to him: a one-eyed man eating melon,

long braids of garlic, black women nonchalantly balancing huge bundles on their heads, and New Orleans's courtyards with their palms and fountains.

Later, after crossing Barataria Bay in a storm, they visit the Grand Terre lighthouse, recorded in the diary entry of June 26, 1932, where the lighthouse keeper makes coffee, and the photographer's camera admires the lighthouse keeper's wife. The stay at Grand Isle is omitted from the film, which segues into more exotic scenes of the swamp and its inhabitants. A gap-toothed man poses with his two young sons, and chickens, dogs, a pig, and a pet coon make appearances, along with a couple of alligators. Adventures with a pirogue follow, as well as scenes of clam shucking and Spanish moss being picked and baled, mentioned in the diary entries for August 6 through 8. Finally the film and the voyage of the *Pintail* both end, as the diary describes, with a picturesque sunset.

In 2003, Winans's heirs donated the *Pintail* film to the LSU Libraries. Recognizing the value of this rare visual record of Louisiana in the 1930s, the Libraries immediately contracted with Colorlab, a company specializing in film restoration and preservation, to conserve the original film and transfer the images, for preservation, to VCR and DVD, both of which are available for viewing. Because we lack a copy of Fonville Winans's narration of the silent film, the publication of his diaries is particularly welcome, shedding new light on the visual record of the *Voyage of the "Pintail,"* now preserved for posterity in the LSU Libraries.

Elaine Smyth
Head, Special Collections

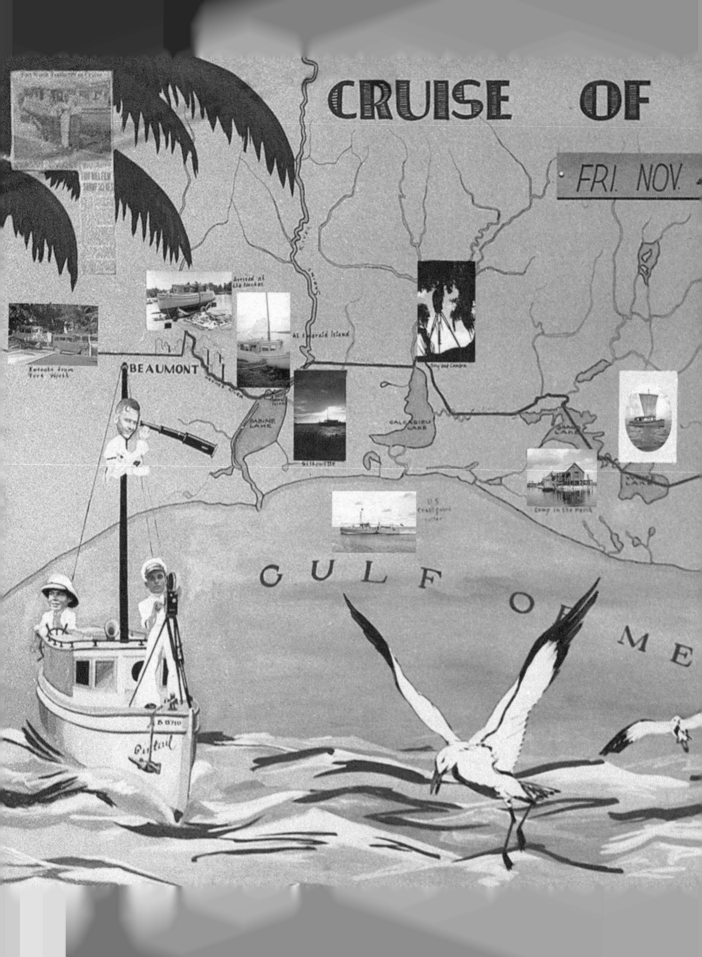